P9-DBK-045

THE DIGITAL DESIGNER

THE DIGITAL DESIGNER

THE GRAPHIC ARTIST'S GUIDE TO THE NEW MEDIA

**STEVEN HELLER
AND
DANIEL DRENNAN**

WATSON-GUPTILL PUBLICATIONS / NEW YORK

WITHDRAWN
NORTHEASTERN ILLINOIS
UNIVERSITY LIBRARY

Copyright © 1997 Steven Heller
and Daniel Drennan

First published in 1997 in the
United States by Watson-Guptill
Publications, a division of BPI
Communications, Inc.,
1515 Broadway,
New York, New York 10036

Library of Congress
Cataloging-in-Publication Data
Heller, Steven
The digital designer : the graphic
artist's guide to the new media /
Steven Heller and Daniel Drennan.
 p. cm.
 Includes index.
 ISBN 0-8230-1346-4 (pbk.)
1. Multimedia systems.
2. Computer graphics.
3. Graphic design.
4. Electronic publishing. I.
Drennan, Daniel. II. Title.
QA76.575.H39
1997
006.6–dc21
97-10638 CIP

All rights reserved. No part of this
publication may be reproduced or
used in any form or by any
means--graphic, electronic, or
mechanical, including
photocopying, recording, taping,
or information storage and
retrieval systems--without written
permission of the publisher.

Manufactured in Malaysia

First printing, 1997

1 2 3 4 5 / 01 00 99 98 97

The digital designer is an individual who collaborates,
and in that spirit the authors of T*he Digital Designer*
want to acknowledge the close collaboration we enjoyed
with our editor at Watson-Guptill, Marian Appellof, without
whom this project would never have been shaped, formed,
and completed. We also express our deep gratitude to our
designer, Mirko Ilić, who gave this project concrete form and
produced a design to be proud of. Thanks to senior
editor Candace Raney for her invaluable encouragement and
continued support. We are grateful as well to
production director and managing editor Sharon Kaplan,
and to publisher Glenn Heffernan.
 We would also like to thank Laurel Sutton for her
assistance with the research for this book. Thanks must go
as well to the interviewees for their patience and coopera-
tion as the book moved forward. We especially would like to
thank all of the artists and designers who contributed
material to the book, particularly those whose work we were
unable to include in these pages due to space constraints.

ABOUT THE AUTHORS

Steven Heller, a senior art director at *The New York Times,*
is the editor of the *AIGA Journal of Graphic Design* and the
author or coauthor of more than sixty books, most of them
about visual communications. For the School of Visual Arts
in New York City, he recently developed an M.F.A. program
that emphasizes the designer's role as both author and
director, with a strong tie to the new media. In addition to
The Digital Designer, Heller has authored several other
books for Watson-Guptill: *Low Budget/High Quality Design*;
The Savage Mirror; *Designing for Children*; and *The
Business of Illustration.*

 Daniel Drennan received a B.F.A. in illustration from
Parsons School of Design in Paris, France, and an M.P.S. in
interactive telecommunications from New York University.
He formerly worked as an art director at iGuide, News
Corporation's Internet venture, and currently teaches CGI
programming at the nonprofit Fund for the City of New York.
He has written about art, design, and technology for the
AIGA Journal of Graphic Design and *Print* magazine, as well
as for his self-published zine, *Inquisitor.*

1-23-98

Ronald Williams Library
Northeastern Illinois University

CONTENTS

新しいデザイナー
専門 翻訳

In "Little Girl Lost," a classic episode of *The Twilight Zone,* a father hears his daughter crying in the middle of the night. Upon entering her room he finds no trace of her, but the girl's terrified pleas for help continue. As he frantically searches for her, he stumbles upon a physical anomaly: a radical shift in molecular structure has inexplicably caused a portion of the bedroom wall adjacent to the bed—just large enough for a young child to fall through—to turn into mist. The once-solid wall had become a gateway to a netherworld, perhaps a fifth dimension. While the trapped little girl floated through the miasma farther and farther away from the sights and sounds of the familiar world, her father cautiously stalked the terrain in search of an entry point. In the end he pulled her through the rapidly closing hole, thus saving her from an eternity of wandering through time and space.

In the early 1990s, during the primitive stage of screen-based media, graphic designers fell into a similar "twilight zone," where their profession was no longer concerned only with type and image, but also encompassed sight and sound, becoming time-based and calling for imagination and pre-science. It was in this new media zone where the future of design purportedly was to be found—or at least, that was how traditional designers experienced the shock and threat of the new. The revolution in the new media exposed graphic designers (and graphic artists in general) to a netherworld of design in which conventional concepts of two-dimensional space and image making were challenged by new dimensions in technology. Although a few pioneers brazenly leaped through the mist, forsaking the familiar, others, like the father in the above plot, cautiously reconnoitered the territory before deciding how and whether to enter.

Few who entered returned. As twilight gave way to daylight, the pioneers found viable ways to expand their businesses by adding digital design to their repertoire. Like intrepid printers at the beginning of the twentieth century who offered typographic and graphic design services as incentives to new customers, early 1990s graphic designers offered new media design as a loss leader against future commissions. As corporations and institutions of all kinds were led to the so-called information highway, ambitious designers hawked digital design as being useful to marketing, image, and message communications. Design firms issued promotional CD-ROMs and launched sample sites on the Internet's World Wide Web that gave prospective clients a glimpse of the potential that lay ahead. Many of these attempts were artful, clever, and functional applications of the high-tech (though curiously primitive) new media, while others were little more than poor translations of print onto the screen.

In the 1930s the Bauhaus master László Moholy-Nagy argued for a mechanical art suitable to a mechanical age, referring to the then new methods of montage and *typophoto* (a seamless marriage of type and picture) as radical substitutes for antiquated commercial arts. In the 1990s, digital design for the digital age has become the mantra both for veteran graphic designers and for those who were not weaned on the traditional forms. *The Digital Designer* examines the nexus where print and multimedia meet, but even more importantly, it addresses the transition from paper-based to screen-based media. This is where the most radical changes in the art and craft of design will be found.

In "Little Girl Lost," a classic episode of The Twilight Zone, a father hears his daughter crying in the middle of the night. Upon entering her room he finds no trace of her, but the girl's terrified pleas for help continue. As he frantically searches for her, he stumbles upon a physical anomaly: a radical shift in molecular structure has inexplicably caused a portion of the bedroom wall adjacent to the bed—just large enough for a young child to fall through—to turn into mist. The once-solid wall had become a gateway to a nether world, perhaps a fifth dimension. While the trapped little girl floated through the miasma farther and farther away from the sights and sounds of the familiar world, her father cautiously stalked the terrain in search of an entry point. In the end he pulled her through the rapidly closing hole, thus saving her from an eternity of wandering through time and space.

In the early 1990s, during the primitive stage of screen-based media, graphic designers fell into a similar "twilight zone," where their profession was no longer concerned only with type and image, but also encompassed sight and sound, becoming time-based and calling for imagination and pre-science. It was this new media zone where the future of design purportedly was to be found—or at least, that was how traditional designers experienced the shock and threat of the new. The revolution in which the new media exposed graphic designers (and graphic artists in general) to a nether world of design in which conventional concepts of two-dimensional space and image making were challenged by new dimensions in technology. Although a few pioneers brazenly leaped through the mist, forsaking the familiar, others, like the father in the above plot, cautiously reconnoitered the territory before deciding how and whether to enter.

ND SCREEN

Few who entered returned. As twilight gave way to daylight, the pioneers found viable ways to expand their businesses by adding digital design to their repertoire. Like intrepid printers at the beginning of the twentieth century who offered typographic and graphic design services as incentives to new customers, early 1990s graphic designers offered new media design as a loss leader against future commissions. As corporations and institutions of all kinds were led to the so-called information highway, ambitious designers hawked digital design as being useful to marketing, image, and message communications. Design firms issued promotional CD-ROMs and launched sample sites on the Internet's World Wide Web that gave prospective clients a glimpse of the potential that lay ahead. Many of these attempts were artful, clever, and functional applications of the high-tech (though curiously primitive) new media, while others were little more than poor translations of print onto the screen.

In the 1930s the Bauhaus master László Moholy-Nagy argued for a mechanical art suitable to a mechanical age, referring to the then new methods of montage and typophoto (a seamless marriage of type and picture) as radical substitutes for antiquated commercial arts. In the 1990s, digital design for the digital age has become the mantra both for veteran graphic designers and for those who were not weaned on the traditional forms. The Digital Designer examines the nexus where print and multimedia meet, but even more importantly, it addresses the transition from paper-based to screen-based media. This is where the most radical changes in the art and craft of design will be found.

WANTED: DIGITAL DESIGNERS

Just when it seemed that graphic design had come to be recognized as a cutting-edge profession, the winds of progress blew designers back into the cultural shadows. For the past decade it appeared that popular interest in design, and especially in fonts—which transformed the likes of Neville Brody, David Carson, Rudy VanderLans, and Zuzana Licko from mere practitioners into veritable media gurus—signaled a new era for graphic design as a cultural force. But the velocity of graphic design's forward thrust, like that of comet Kohoutek, has been severely thwarted by gravitational pulls toward the real world. Digital technology promised a new awareness of, indeed role for, graphic design. In light of critical advances in the new media, however, the new age has become a period of realignment and readjustment.

Veteran and neophyte graphic designers alike have reason to be nervous about the future. Will traditional methods be viable, or will new technologies and media change the definition and standards of graphic design? Most important, to what extent will the design of multimedia function as an adjunct to graphic design, or vice versa? *The Digital Designer* examines the designer's present and future roles in a world of new media where the conventional practice of graphic design is but one component of an expanding field that includes sound, animation, live action, and interactivity.

"Interactive media have introduced a new visual language, one that is no longer bound to traditional definitions of word and image, form and place," wrote the designer and critic Jessica Helfand in *Six Essays on Design and New Media* (New York, 1995). Graphic designers have the ability to bring more to new media than their tried-and-true skills and talents. But first some hurdles must be overcome. The definition of a graphic designer will come into question; the answer will perhaps forever change the foundation of the field.

THE TIMES, THEY ARE A-CHANGIN'

Graphic design has traditionally been a service to business, not an art in its own right. Designers do not, as a rule, develop ideas from scratch, but are hired by clients to solve problems of packaging and positioning for the ideas and products they want to sell. When designers do create for themselves, it is often a respite from the rigors of problem solving—in other words, projects that translate as design for design's sake, in the form of self-referential endeavors like paper company promotional brochures and self-promotional cards and posters. Although a few prominent graphic designers are also entrepreneurs who create such consumables as clothes, watches, and furniture, most professionals are content to follow the traditional practice of client-want/designer-do. In the multimedia environment, however, this may no longer be enough.

As Bob Dylan once wrote, "The times, they are a-changin'." In that spirit, we might add that technology is advancin' and media are expandin' into realms where graphic designers are required to shift their conventional methodologies so as to be content producers rather than just service providers. "In a world where information plus technology equals power, those who control the editing room run the show," charged Hugh Gallagher in *Wired* magazine (August 1994), in reference to trends in online music in which digital sight and sound wed the style of music videos to a graphic design component. This segment of new media is but the smoke spewing from a multimedia volcano whose lava flow could leave the graphic design profession as ossified as the ancient city of Pompeii after the eruption of Mount Vesuvius if designers ignore the attendant issues and implications of the changing field. The editing room is not a mere metaphor, but the key to where the future of the profession is heading. It is here that designers can potentially have a more active, if not more entrepreneurial, role in the business of creativity.

Neither this chapter, nor this book in general, prophesies gloom or doom. For now, the new media do not herald the printless society. For the foreseeable future there will continue to be an incomparable need for traditional print design, including corporate identities, packages, advertisements, magazines, and that so-called endangered species, books. Indeed, many designers prefer the tactility of print to the ethereal nature of the new media, which, despite their sophistication, are in many respects inferior to traditional forms of typography, particularly in terms of qualitative nuance.

Graphic designers are, however, facing a transition similar to a major one that occurred in the advertising industry three decades ago, when the best and brightest "creatives" shifted their energy and focus from print to television. As that scenario played out, the remaining print designers were subsequently pushed lower down the hierarchical ladder. As multimedia (CD-ROMs, interactive television, online services, and the Web, for example) aggressively compete with certain print media, graphic designers who pursue the digital will become integral to the future of communications. Those who ignore it entirely run the risk of becoming vestigial. Or, as a sage once said, "If you're not part of the steamroller, you're part of the road."

This is not conjecture. State-of-the-art software programs currently enable users to create a range of multimedia projects at desktop workstations. Even small children have access to PC-compatible multimedia authoring and animation programs, and some have done very creative work. So, a designer with the right training (or support personnel) should be able to create multilevel and multisensory presentations, just as he or she first began to compose QuarkXpress documents. Adding motion and sound to otherwise static design is the first step in breaking the constraints of convention. The next is rendering ideas, or authoring (see "Auteur, Auteur," below), which involves the mastery of a variety of skills. This does not mean, however, that all graphic designers have the ability to shift effortlessly from making static design to making kinetic design. Like those actors in the 1920s who were unable to make the leap from silent to talking pictures, not all graphic designers are capable of thinking in interactive or multi-navigational terms—just as not everyone in the visual arts can be a filmmaker or every writer a novelist. Yet there are many ways of easing into multimedia and testing the waters. ✍

AUTEUR, AUTEUR

The term *auteur,* dating back to French film studies of the 1960s, refers to a director who takes the lion's share of creative control over the making of a motion picture. This word has achieved a certain currency in contemporary graphic design, too. As opposed to mere service providers, graphic design "authors" are creators of ideas and the contexts that frame them. This does not exclude a client's presence—the majority of graphic designs are commissioned, not pulled from thin air—but it suggests an intimate involvement in the overall process.

The writer and designer Michael Rock defines graphic design authorship as emanating from "those circles that revolve around the edge of the profession, the design academies, and the murky territory that exists between design and art" (*Eye* magazine). This is the territory of avant-gardists, adventurous students, and practitioners who push the envelope. By definition this includes designers who have entered the digital environment and have found new outlets for expression. But Rock adds, "The question of how designers become authors is a difficult one, and exactly who are the designer/authors, and what authored design looks like, depends entirely on how you end up defining the term and the criterion you choose to determine entrance into the pantheon."

The multimedia field provides graphic designers with opportunities for more total authorship, more self-expression as artists, than do print media; the tools for controlling the creative process are in the editing room or at the workstation. Just as the New Wave directors once took creative control of their films, graphic designers can do the same by establishing themselves as the creators of content and deciding what form it will take—pictorial narrative, documentary, digital magazine, and so on. However, no author in this field is going to create in solitude, in the manner of a novelist or painter; multimedia projects are simply not conducive to one-man bands. As in filmmaking, collaboration is imperative, and in fact, working in concert with programmers, sound technicians, and production artists will add to the richness of a project. 🖥

DESIGNERS AND SELF-PROMOTION

Self-promotion is the realm where designers can really strut their stuff. Free of the constraints imposed by a client, self-promotional work need only answer to the designer's own budgetary limits and imagination in making clever, creative use of the digital media.

Digital self-promotion takes advantage of the nature of multimedia, which makes it easy to distribute promotional materials via diskette, online download, or Web site. At the same time, many firms are starting to use their multimedia delivery systems—CD-ROMs, internal Web networks or intranets, and diskettes—to give their employees universal access to company documents and information. ◓

IN ITS DISKETTE-BASED SELF-PROMOTION, CURIUM DESIGN AVOIDED THE USE OF "PRESS HERE" BUTTONS ENTIRELY, CREATING A KINETIC AND LIVELY ANIMATION LOOP THAT WAITS FOR A USER CLICK TO MOVE ON TO THE NEXT PART OF THE PRESENTATION.

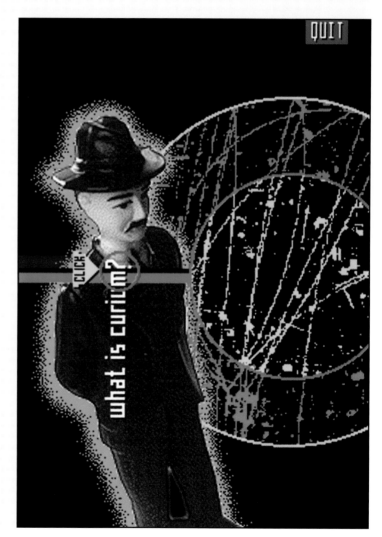

FRONTPAGE
THIS ISSUE'S QUOTE
MARKETING NEWS
TECHNOLOGY UPDATE
BULLETINBOARD
FUTURETHREAD
EXIT

Being there...

futurethread

Much of my dialog consists of inside jokes and had-to-be-there scenarios—no wonder people have problems following me.

The way I tell stories, exchange information and get on with my everyday self has taken a turn toward being excluded. Much of my dialog consists of inside jokes and had-to-be-there scenarios—no wonder people have problems following me. Are you with even me right now? I seem to be far removed from interacting with the actual. So much of my work requires the abstract relationship of the computer interface to make tangible things.

I believe we're reaching one of those landmark periods in time which people will forever historicize—don't have a "tag" yet but I'll let you know when I come up with one. Virtual reality—and O.J.—aside, the key factor in this period is our relation to each other. You and I, here... in the same point in time. *We are caught* being there. I guess using the word *caught* isn't quite right. All communications seem to be in the air, on the wire or on the disk.

Great tools. Yet they require a particular amount of attention and maintenance, not to mention the time spent on learning these tools. To be fully utilize them, more often than not, we need to singularly focus on each respective task with the tool. Any deviation results in some sort of user error... just ask Aldus.

And the immediacy of information access, coupled with the quality of content, undercuts any infonaut riding that fine line between illumination and infoglut. With the added promise of interactive TV, couch and computatoes alike will have the world at their mouses and remotes. It may be true that no man is an island but it's becoming difficult to distinguish the people from the satellite stations.

@ rodneysheldenfehsenfeld

THE TEAMDESIGN INTERNAL NEWSLETTER IS DISTRIBUTED TO PROVIDE EMPLOYEES WITH UPDATES ON TECHNOLOGY, COMPANY DOINGS, AND OTHER ITEMS OF INTEREST.

PINCH, A SELF-PROMOTION BY BRAD JOHNSON, JUXTAPOSES SCREEN DESIGN ELEMENTS WITH PACKAGING FEATURING LETTERPRESS PRINTING ON COMPOSITION BOARD IN A WAY THAT BELIES THE WORK'S HIGH-TECH CHARACTER.

THE WOODS

DAWN OF THE DIGITAL

As early as 1994, primitive CD-ROM "magazines," such as *Nautilus,* combined low-budget graphics with crude multimedia techniques. These experiments allowed print designers a chance to test the digital medium comfortably. Today, designing a digital magazine is one way for designers to acclimate themselves to the new media through, shall we say, a virtual traditional form. Although digital design is ultimately different, beginning with certain print analogs can be useful for building a digital vocabulary.

The digital magazine is a growing genre. Despite typographic constraints, these electronic publications build upon certain existing print conventions, such as a cover, table of contents, departments, and features. Yet being a decidedly unique medium, the electronic magazine forces the designer to readdress issues of time and space, since page turning is no longer an option. In the digital counterpart to a conventional print magazine, there is no real front or back of the book, features are not interrupted by advertisements, and there are no jumps or runovers. At this stage of development, the interactive environment is still not conducive to the typographic nuances to which skilled print designers and typographers are accustomed. But the digital magazine poses its own set of challenges, requiring new sets of skills. As with any developing medium, those committed to this one must learn through trial and error. The learning curve is steep, which is how progress is measured. But graphic designers will also have to learn that accepted definitions of good design do not necessarily hold true in the digital realm. This is perhaps the most difficult part for a designer to accept in the process of adaptation. ✎

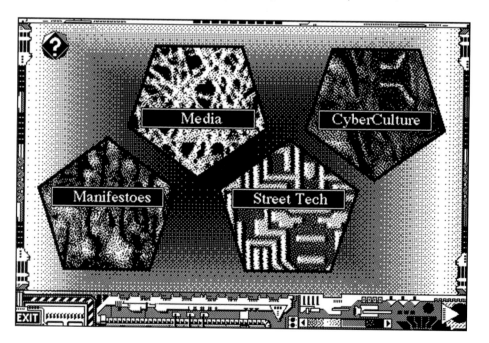

THE DISKETTE-BASED *BEYOND CYBERPUNK!* USED TO GOOD ADVANTAGE THE BLACK-AND-WHITE CONSTRAINTS OF HYPERCARD, RESULTING IN A GRAINY, GRITTY FEEL WELL IN KEEPING WITH THE MAGAZINE'S SUBJECT MATTER.

Graphic designers have demonstrated both timidity and restlessness about catching this new wave. Those schooled in conventional print media are somewhat reluctant to shift gears, while those not yet indoctrinated in print are eager to engage in what appears to be a hip new form—or what they perceive as the future. Those veterans who anticipate many more years of practice ahead are eager to be involved by providing homepages and other digital designs for the growing number of clients who, like sheep, are being led in droves by the zeitgeist to establish themselves on the World Wide Web. The fact is, there's an awful lot the graphic designer can do to help elevate and improve this field. For example, increasingly there is a need for graphic designers to influence how programs are written so that good design has a fighting chance from the outset.

The race to fill the screen—and the marketplace—with digital products has produced a surfeit of electronically sophisticated but aesthetically wanting materials rooted in a variety of clichés born of Photoshop and other emblematic software programs. After an initial period of accepting ostensibly default design, the field truly needs an infusion of designers to develop both aesthetic and accessible user interfaces and graphic, textual, and other navigational components.

It is, therefore, incumbent on graphic designers to master the new media and take an active role before others with less aesthetic and conceptual ability—including visually unattuned programmers— further dominate the field.

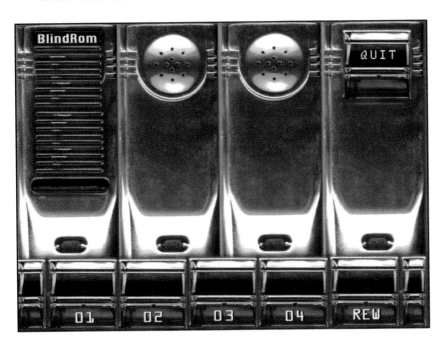

THE CD-ROM *BlindROM* WAS DISTRIBUTED WITH *MEDIAMATIC* MAGAZINE, FROM THE NETHERLANDS. IT INTRODUCED SUCH CONCEITS AS THE AVATAR, OR ANIMATED PERSONA, AND SENT UP THE USE OF REAL-WORLD DEVICES TO DRIVE NAVIGATION.

ELECTRONIC MAGAZINES

The digital magazines of today, whether Web-based or on CD-ROM, fight hard to escape the gravitational pull of the traditional print magazine. With departments, features sections, and advertising, most online magazines would be equally viable in print; ironically, in fact, some provide printed versions. Web-based efforts such as *Epicurious, Slate* (and its parody, *Stale), word,* and *Feed* strive to bring added value to pages that reflect (often heavily) a paper paradigm. What is gained in savings on printing and distribution costs, however, is at the expense of audience, since a large number of potential readers are effectively cut out for lack of access to the Internet. It remains to be seen whether brand identities will successfully carry over to the interconnected Web, and where static online magazine pages will be as the Web moves up the interactive ladder. These magazines are also fighting

THE DIGITAL NATURE OF THE MEDIUM ALLOWS FOR PARODIES THAT EQUAL (OR BETTER) AT LEAST TECHNICALLY THEIR TARGETS. THE ONLINE MAGAZINE *STALE* TAKES A SIDEWAYS LOOK AT THE MICROSOFT-SPONSORED *SLATE.*

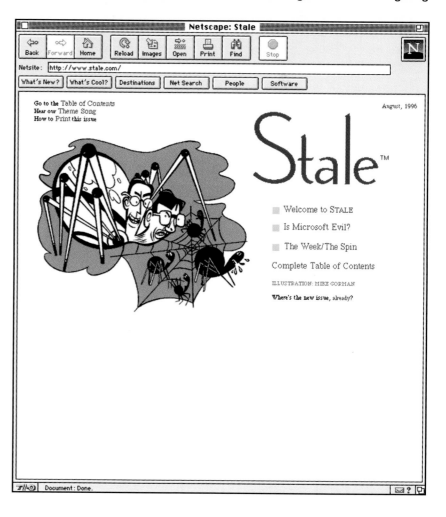

WEB-BASED MAGA-
ZINES ALLOW AND
ENCOURAGE THEIR
READERS TO BECOME
PART OF THE MES-
SAGE, AS IT WERE.
FEED MAGAZINE FEA-
TURES DISCUSSION
AREAS FOR READER
FEEDBACK.

what for most people is an unnatural process: reading off a computer monitor. Those who work with computers all day may not find this troublesome, but whether reading off the screen will resonate with consumers who actually pay for their connect time is another story.

The format of CD-ROM magazines has changed little since the days when the earliest of them, such as *Nautilus* and Mediamatic's *Blind,* hit the virtual newsstands. *Digital Culture Stream, Medio,* and *Blender* represent perhaps the last in a line of CD-ROM–based magazines now that the World Wide Web has come to the fore.

Some online magazines concentrate on offering an adjunctive experience to their offline print counterparts. *Paper* magazine ties its Web site to the printed version by the use of department icons that work well in both realms. The cleanly designed Web site is updated daily, providing a valuable online resource for its readers.

One of the better experimental digital magazines isn't a commercial venture, but comes from the Interactive Telecommunications Program at New York University. *Review,* as it is known (see page 20), provides a metadiscussion of the ins and outs of online publishing, and covers other topics of interest to those working in the multimedia field. Its spare design works well within the constraints of HTML, and the content is equally appropriate to the online realm.

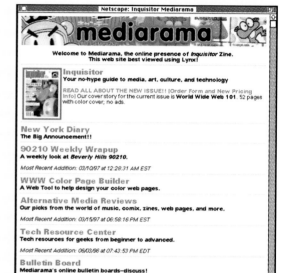

MEDIARAMA IS THE WEB-BASED ADJUNCT TO *INQUISITOR* MAGAZINE. THE SITE STARTED AS A STATIC ONLINE REFLECTION OF THE PRINT PUBLICATION, BUT IS NOW A MORE DYNAMIC WEB COUNTERPART.

In the same vein is *The Sober Witness,* a Web-based publication that bills itself as a "no-hype" look at the Web. It offers up tips and tricks for Web designers, reviews sites, and provides editorial excursions that have a decidedly philosophical bent. As with all good Web design, there are no huge image maps or other graphic downloads here; the look is clean and the focus is on information, not bells and whistles.

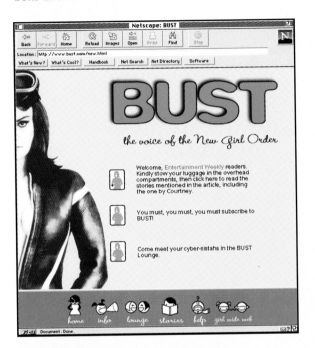

ANOTHER PRINT PERIODI-CAL WITH AN ASSOCIATED ONLINE VERSION IS *BUST*.

Sunday, October 13, 1996

R E V I E W

ITP

2.0

Interactive Telecommunications Program
New York University

| settings | contents | mailing list |

WELCOME

R E V I E W

focus | profile | place | scape | critique | journal | tech | census

Letters to the Editors | Masthead

*

CONTEST

(Dynamic Illustration Contest)

Contest Gallery

*

FOCUS

{ Beyond the Box }

Open House
Mark Weiser
Visits "Smart Homes"

responses

Almost Real
Miles Kronby
on VR We've Got

responses

Electronic Body
Robert Knafo Dances
With Troika Ranch

responses

Pins and Feathers
Ian Kerner
Does the Voodoo

responses

FOCUS
LIBRARY

*

PROFILE

The Meeting Place
A Profile of Joseph Squier

responses

THE WEB-BASED MAGAZINE *REVIEW* IS PRODUCED BY N.Y.U.'S INTERACTIVE TELECOMMUNICATIONS PROGRAM.

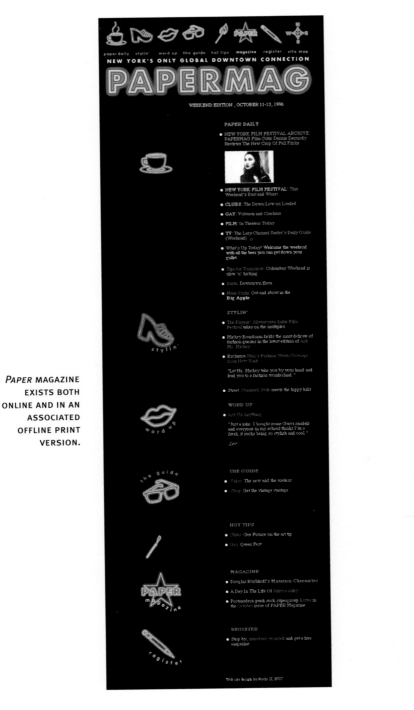

PAPER MAGAZINE EXISTS BOTH ONLINE AND IN AN ASSOCIATED OFFLINE PRINT VERSION.

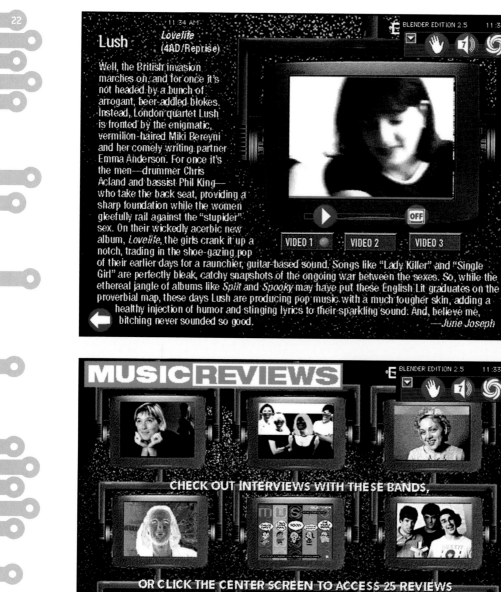

Lush
Lovelife
(4AD/Reprise)

Well, the British invasion marches on, and for once it's not headed by a bunch of arrogant, beer-addled blokes. Instead, London quartet Lush is fronted by the enigmatic, vermilion-haired Miki Bereyni and her comely writing partner Emma Anderson. For once it's the men—drummer Chris Acland and bassist Phil King—who take the back seat, providing a sharp foundation while the women gleefully rail against the "stupider" sex. On their wickedly acerbic new album, *Lovelife*, the girls crank it up a notch, trading in the shoe-gazing pop of their earlier days for a raunchier, guitar-based sound. Songs like "Lady Killer" and "Single Girl" are perfectly bleak, catchy snapshots of the ongoing war between the sexes. So, while the ethereal jangle of albums like *Split* and *Spooky* may have put these English Lit graduates on the proverbial map, these days Lush are producing pop music with a much tougher skin, adding a healthy injection of humor and stinging lyrics to their sparkling sound. And, believe me, bitching never sounded so good.

—*June Joseph*

VIDEO 1 VIDEO 2 VIDEO 3

MUSIC REVIEWS

CHECK OUT INTERVIEWS WITH THESE BANDS,

OR CLICK THE CENTER SCREEN TO ACCESS 25 REVIEWS

SECTION EDITED BY DAN CATALANO. Sample: Vernon Reid.

Blender USES THE CD MEDIUM TO BEST ADVANTAGE, FEATURING MUSIC, DIGITAL VIDEO, AND PROPRIETARY GAMES TO AUGMENT ITS POP-CULTURE FOCUS. IT ALSO ALLOWS READERS TO LINK TO WEB RESOURCES.

Graphic designers must develop new paradigms that are specifically relevant to working in the digital media. Designing a multimedia project is not like designing a traditional printed piece such as a book or magazine; for one thing, in the digital realm, the time-honored convention of starting on page one and ending on page 200 does not apply. And for another, until recently the integration of moving pictures and sound has not been a common function of graphic design. Hence, the challenge for design professionals today seems to parallel one that affected printers in the early days of graphic design: how to adapt the tenets of typography, composition, and pacing to new formats and new ways of reading and seeing. To work in digital media, graphic designers need not reject everything they learned in Design 101, because in fact, a high level of traditional design expertise is imperative. However, the actual rendering of typography, illustration, and layout must be reassessed so that the kinetic as well as the interactive possibilities of multimedia projects can be fully exploited. To accomplish these goals does not necessarily mean that one must adopt a radical or revolutionary approach; it does mean, though, that the conventional wisdom that fills scores of design handbooks is no longer entirely appropriate. In fact, at best such conventional design wisdom is inadequate in the sense that it does not address the particulars of the media that have come to the fore today.

In the late 1970s April Greiman, one of graphic design's early digital pioneers in both print and video, blew the trumpet heralding that change was on its way, and proffered new approaches that influenced many graphic artists, if only stylistically. During the mid-1980s to mid-1990s, experimental design has tiptoed around the inevitability of a media revolution and manifested itself through often confusingly layered typography that has been meant to symbolize the interplay between print and screen media. For better or worse, computer technology has allowed designers to make two-dimensional forms appear kinetic, even when they are not or should not be. Interestingly, most of these experimental ideas have surfaced on paper; and so, even though they have inspired fashionable changes in graphic style, they haven't been adapted effectively in a true multimedia environment.

Print design is to multimedia what checkers is to chess. The forethought required in charting a design course for new media projects is invariably multilevel, involving nonlinear progression: back-and-forth, sideways, and under-and-over navigational pathways, which can be so complex that accessible graphics are essential to reader and viewer understanding. It must be said that in real cyberspace, simplicity is its own reward. No matter how tempting it is to use the numerous programs that morph type and image (going from blurry to clear is one such overused animation trope, as is embellishing logos and marks with metallic highlights), the designer should avoid letting a novel medium lead him or her around by the nose. The designer's responsibility is to transcend the inherent clichés, not to slavishly follow them. Good design in the digital environment means knowing when it's time to leave well enough alone—when to step back from all the "cool" things that can be done and, instead, to think in practical terms. ✑

HOME ON THE HOMEPAGE

Build a medium and they will come. And they did: hundreds of graphic designers and illustrators recently found themselves Internet service providers and launched personal "homepages" on the World Wide Web. Most are promoting their wares through electronic portfolios that can be frequently updated and quickly disseminated. Others are selling specific products, and still others have created virtual salons that include galleries, newsletters, chat rooms, and additional links.

The New York–based designer and illustrator Daniel Pelavin (http://www.inch.com/~dpelavin/) was one of the first artists to work with now primitive imaging programs and cumbersome computer systems, and one of the earliest to go online. Pelavin's Web site is also one of the most ambitious. Included on a score of screens are an index of his own stock cuts and stock fonts (with optional full-page examples); a menu to view full-page portfolio samples (book jackets, posters, magazine covers, and the like); a "Robot Location," which features renderings of quirky robots by other digital artists; and an illustrated autobiography.

THROUGH THE USE OF WELL-DESIGNED GRAPHICAL DEVICES AND ICONS, DANIEL PELAVIN HAS CREATED A GLOSSARY OF FORMS THAT ARE BOTH EASY TO DECIPHER AND ENJOYABLE TO NAVIGATE ON HIS SELF-PROMOTIONAL WEB SITE.

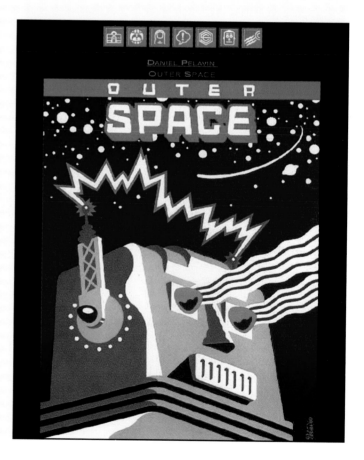

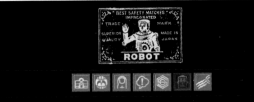

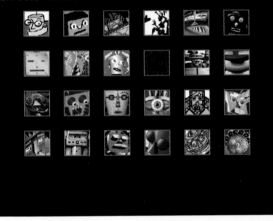

PELAVIN'S WEB SITE FEATURES A PAGE WITH AN INVENTORY OF ROBOT IMAGES BY VARIOUS ARTISTS; CLICKING ON ANY OF THE SMALL VERSIONS SHOWN HERE BRINGS UP A FULL-SIZE VIEW OF THE ROBOT SELECTED.

What makes this site exemplary is that Pelavin has used the constraints of the medium to his advantage. While confined to using the default text typefaces the Web supports, he has composed and enlarged them in such a way that the poor inter-letter spacing and coarse resolution are ignorable (even to the type maven). Home and menu pages have solid black backgrounds, with white and gray type dropped out. Hot buttons (or keywords) are colored red, which is sometimes too dark against the black, but more appealing than the default blue common to the Web. A master of graphical devices and icons, Pelavin has created a glossary of forms that are both easy to decipher and enjoyable to navigate.

Many designers' and illustrators' personal Web sites are perfunctorily businesslike—for example, a homepage leads directly to a few samples of work—or ethereally experimental—a bunch of "cool" graphics that are an end in themselves. Pelavin's site is a little of both yet a lot of neither. While not truly interactive, his offers enough unique graphic and text material to grab and hold the browser's attention. It is not on the edge, but it is entertaining. In his thankfully concise (most Web sites suffer from a surfeit of verbiage) introduction to the site, Pelavin notes that there is a range of accessible highlights for the prospective client, kindred practitioner, or curious browser. Pelavin's site is also a model for graphic designers who are looking for ways to thwart the problems inherent in designing for the Web, challenge the conventions, and communicate efficiently. ▯

COLLABORATION IN AN AGE OF SPECIALIZATION

Controlling design in the new media is ultimately more difficult than controlling print design, because there are many more variables and components to juggle. Like filmmaking, which is dependent on many talents and craftspersons, multimedia requires considerable support personnel to oversee a project from start to finish—an interdisciplinary group that may include producers, programmers, designers, and editors, as well as people familiar with cognitive psychology, linguistics, and other specialized areas of study. A graphic designer cannot be expected to know or do everything required to create a multimedia project, and so this field is a highly collaborative one. However, the nature of the collaboration is much more stratified than it is in print media. Technical specialties abound. The intuitive language of design could very well be at odds with the counterintuitive language of technicians, and the separations between the various areas of expertise involved in the creation of a multimedia project could potentially diminish the graphic designer's role if he or she does not learn to cope with the entire process. In making the move from print-based media to interactive media, many graphic designers have found themselves in a role similar to their position in the print world—that of designing only the topmost level of the project. But multimedia is not simply about the decorative; design decisions need to be made at every level of the project, requiring the designer to assume a more pivotal role in the production process. Yet with all that the graphic designer must know to master multimedia, in the end, developing ideas is the answer to controlling creative integrity.

The world of multimedia is varied and extensive, and is in a constant state of flux; for example, the CD-ROM, long the medium of choice for multimedia projects, possibly will be eclipsed by new disk technologies on the horizon. Beyond technological trends there are also usage trends to be taken into account, witnessed by the current emphasis on the World Wide Web. Navigating this changing design landscape is a difficult prospect; however, a designer with an open mind, a desire to learn, and a grounding in the basics of what goes into a multimedia project will be well equipped to take on the challenges presented to him or her.

Not everyone entering this field will become a "superstar." Not everyone is destined to be a content provider. But the digital environment is ostensibly democratic and its gateways are open to everyone, including both trained and untrained designers—anyone who can master its programs. The measure of one's success, however, will depend on the levels of understanding and expertise that will develop over time. Graphic designers must take a very active role in form and content. Multimedia will either force a new stratification of the graphic design profession, just as TV became a creative wedge in the advertising industry, or it will force a fusion of abilities that will transform graphic design into the larger realm of visual communications. The marriage of graphic design and the digital media will forge a more vital—a more powerful, meaningful, and influential—discipline, one in which the new graphic designer is a significant participant whose contributions will include form, function, aesthetics, and imagination.

Perhaps a more timely question is, "What *was* graphic design?" At the turn of the century it was a service provided by printers (usually free of charge) to prettify advertisements, bills, flyers, and stationery. In the 1930s it was both a system for ordering complex information and a manner of applying style to commercial products. By the 1950s it had become the profession it is today, the purpose of which is to package ideas and products in various print media. Throughout history, graphic design has meant composing, aestheticizing, and styling components on a page, package, or sign to attract visual attention and convey a message. A graphic designer is a navigator who strategically positions signposts for the reader to follow. On paper, headlines and body type, decorative and functional rules, images, colors, and the like are landmarks, integral elements in the architecture of a page. One naturally reads a page by following these organizational hierarchies until a destination is reached, or uses them as touchstones for referring back and forth from one passage to another.

On the screen, graphic directionals that somewhat parallel their print counterparts guide the viewer and reader from display to display. But the screen is not a printed page, and the experiential pathways the new media offer are very different from those we're accustomed to following on paper. Thus, the process of graphic design in the screen-based environment is not the same as it is in the print media, and the tenets of good print composition do not always apply. Because the digital media are not exclusively linear, this "new" graphic design must address two separate but equal concerns: the look and feel of the electronic "page," and the signposts themselves.

In print these signposts are seamlessly wed to the total page. A page is a total unit of information. In screen-based media the signposts must be distinct from the basic overall design. They could be agents (icons that guide) or metaphors (images that inform as they decorate), but they must be obvious tools that the "user"—the reader/viewer—can easily access. There is nothing worse than being trapped in an electronic environment without any clear route out; the inability to change screens or exit a program at will is a major design defect. With a book or magazine, such imprisonment is impossible; with digital media it happens all too frequently.

Plotting the flow of a group of contiguous pages (even when there are tricky printing press configurations) is easy compared to what the digital designer must face when plotting an electronic document with many pathways and culs-de-sac. Digital graphic design involves considerably more options than print, but the digital designer has more tools: significantly, animation, motion graphics, and sound, in addition to the traditional print forms. In the early stages of development these digital novelties were used more to brighten up the screen than illuminate the pathways; nevertheless, graphic designers working in new media use these tools to complement or enhance text and image.

In the past, graphic design has served as a frame for concepts. Although it still functions as such, in the new media it must be dedicated to navigation—to where devices are deployed and how user interfaces are styled for optimum efficiency. This is the most important aspect of multimedia design; if the navigation doesn't work, the rest is just surface.

DEFINING MULTIMEDIA

The word *multimedia* is one that through sheer overuse approaches meaninglessness. Thus, the first task of any book that hopes to speak about multimedia should be to define the term. Back in the early part of the 1980s, with the advent of the window-based metaphor in computing, "multimedia" was used to describe the convergence of the various new media—digital audio, video, animation, text, graphics—in the communication of information. Early multimedia applications were looked upon at the time as a new paradigm; just as a word processor assembled text into documents and a spreadsheet program crunched numbers into meaningful data, so, too, would multimedia applications assemble a new kind of computer-based data type. This convergence has deeper roots, which tap into various efforts to use existing technologies such as telephone lines or television airwaves to disseminate information in a new way. Much of what was forecast for these media in the past has not come to pass, however, and the successful implementation of multimedia design is becoming much more specialized. On the horizon is a new kind of design professional: the information architect, whose job it will be to make sense of this unprecedented flood of information. Nonetheless, underlying all the different technologies and media is the basic idea that *multimedia is communication.*

Not long ago the advocates of these "new media" were predicting the end of print. Somehow, two-dimensional communication was decided to be "old media," and sights were set on the new media and the completely digital future. Instead of focusing on fads and fashions, however, we need to view multimedia according to the way it differs from its two-dimensional precursors. Print is still exemplary in many ways, especially in terms of resolution, display, random access of its component parts, accessibility without requiring specialized equipment, and communication—but what makes multimedia different?

What print lacks is dynamism and a dimension of time. For all of their admirable qualities, broadcast and most print media are essentially linear, and have a decidedly finite limit of viewing or reading variations. Digital information, on the other hand, is mutable, flexible, updatable; it is "on the fly" and often random. To distinguish it from static media, therefore, we need to be able to say that *multimedia is dynamic*.

Added to the idea of bringing various kinds of media together in order to communicate is the concept of interactivity. The juncture where humans and machines meet has a history as well, a history that changed dramatically with the arrival of desktop computing. The creation of metaphorical representations of data (pictorial icons of files, folders, hard drives, and so on) that a computer user could then manipulate on screen was the first attempt to bring a complete design sensibility to computer displays, and was a radical departure from the previous ways of working with computers—namely, through command-line programming, punched cards, and wired plugboards. Of course, people "interact" with books and televisions as well, but this is a one-way process. Interactivity, then, is the dynamic exchange of information between a user and a machine, usually with the purpose of accomplishing a set task. To differentiate multimedia from other, "one-way" media, we add to the definition that *multimedia is interactive.*

AS MULTIMEDIA INTRODUCES CONCEPTS SUCH AS LAYERED INFORMATION LEVELS AND HYPERTEXT, PRINT DESIGN OFTEN ATTEMPTS TO PROVIDE THAT SAME LOOK AND FEEL, AS IS ILLUSTRATED BY THIS SPREAD FROM *WIRED* MAGAZINE.

ANOTHER EXAMPLE OF PRINT DESIGN THAT MIMICS THE LAYERING OF ELECTRONICALLY DELIVERED INFORMATION IS *MONDO 2000,* AS THIS SPREAD FROM THE MAGAZINE CLEARLY SHOWS.

INFORMATION DELIVERY AND TECHNOLOGY

Precursors to modern multimedia are as old as the written word itself. The Talmud, with its integrated text, commentaries, oral mnemonics, codes of law, and navigation aids, might very well be the first attempt to bring together various types of information to one data space in one medium. The basic design problem of representing a multidimensional information space on a flat page or screen is not much different today than it was centuries ago in creating a multimedia project.

It is easy to be taken in by the hype surrounding any new technology, but the history of new technologies in general is enlightening, if only because it shows that we've been down this road before; platforms of information delivery have a much longer history than one might expect. Every new technology offers a new paradigm to work within, but the basic, underlying concepts of design—effective communication, hierarchies of information—remain the same.

Information delivery systems continually evolve, sometimes so rapidly that keeping abreast of the latest advancements seems impossible. Nonetheless, designers can only benefit by gaining a grasp of the technologies past and present that affect their work in the digital realm. To that end, presented here is an overview of the information delivery systems multimedia designers should be aware of. ▭

HYPERTEXT

One example of a multimedia concept that has evolved along with changing technologies is hypertext. As implemented today in the exploding use of the World Wide Web, hypertext involves the layering of information and embedding of links within a text document. Words and pictures within a hypertext document are highlighted as links to more information by an indicative color or other style. Clicking with the mouse on a given link brings up information pertaining to the word(s) or picture highlighted.

Hypertext is a term originally coined by Ted Nelson (the author of, among other works, *Literary Machines*) in 1962 to describe a system in which information is dynamically created and linked to allow for unlimited browsing of a pool of data. First conceived in the 1960s and still in development is Nelson's Project Xanadu, envisioned as a global library of linked information. Conceptually it is perhaps based on earlier musings by the electrical engineer Vannevar Bush that appeared in a 1945 *Atlantic Monthly* essay entitled "As We May Think," in which Bush describes a hypothetical mechanical extension of human memory. ▭

THE WORLD WIDE WEB

Whereas Xanadu has never been fully realized, a version of hypertext as conceived in 1989 by Tim Berners-Lee, a researcher at CERN (Conseil Européen pour la Recherche Nucléaire, or European Laboratory for Particle Physics) in Geneva, Switzerland, was set up as a protocol—a standard means of exchanging information between computers—that made the Internet's World Wide Web possible. This standard, known as hypertext transfer protocol (HTTP), which relies on documents encoded using the

hypertext markup language (HTML, a subset of the standard generalized markup language, or SGML), was developed to allow for universal, non–platform-specific file transfers of information—text, graphics, audio, video, and small applications—between computers with Internet access. In other words, no matter what kind of computer or software browser (an application that displays markup language–encoded documents) you used, a correctly encoded document would be viewable. In a world of differing operating systems, types of computers, user languages, and software capabilities, the concept of documents being easily read across all of these barriers was enticing indeed.

This rather simple and elegant idea has quickly evolved into the means that is pushing the Web as a true multimedia network, with animations, digital video, audio, and software mini-applications added to the mix. The problems with the current hypermedia model, including static links with fixed URLs (uniform resource locators; i.e., addresses for Web pages), the limited data types in which links can be embedded, and the inability to follow links backward, are being addressed with second-generation hypermedia systems such as Hyper-G, currently under development at the Graz University of Technology in Austria. Adding to the up-in-the-air feeling about much World Wide Web work is a proposed new standard currently being proffered by Sun Microsystems called the Web Network File System (WebNFS), which is meant to speed up file transfers and allow for the editing and viewing of files; also problematic is the growing divergence of standards among competing browsers and other Web-based programming languages, such as Java and ActiveX. Where the future lies for the implementation of new hypertext systems remains to be seen.

THE ORIGINAL IDEAL OF HYPERTEXT WAS THAT INFORMATION SHOULD BE BROWSEABLE ACROSS TECHNICAL BARRIERS. THESE TWO IMAGES SHOW THE SAME HYPERTEXT DOCUMENT AS IT APPEARS IN THE NETSCAPE BROWSER (AT LEFT) AND THE LYNX BROWSER (BELOW.).

DISK-BASED MEDIA

Before the explosion of the Web in recent years, the leading means of distributing multimedia materials was the CD-ROM, and before that, the diskette; in fact, it is perhaps hard to believe that at one time software applications were delivered on single diskettes. As the original data storage medium, the diskette was an easy way to distribute early forays into multimedia, and today it remains an effective distribution medium (the proprietary service America Online being a cancerous example of this) because it is compact and floppy drives are ubiquitous. Some artists and designers are still using diskettes to distribute portfolios and small promotional pieces. For larger projects, however, a disk-based medium with greater capacity was required.

Enter the CD-ROM, a read-only optical disk that can store vast amounts of digitized text, audio, and video, as well as the application(s) needed to present these data to the user. The storage capacity of this medium makes it possible to deliver large amounts of information (including software applications) easily and cheaply. One reason the market for CD-ROMs arose was the arrival of multimedia personal computers shipped with CD-ROM players built in. Many early CD-ROM titles came to be known as examples of "shovelware"—repositories of mediocre content gleaned from other sources, whose purpose was to open up new revenue streams rather than to take better advantage of the medium's potential. Unfortunately, computer owners weren't buying enough disks to make large-scale CD-ROM production worthwhile. With a new media industry refocusing on the Web, the CD-ROM has probably seen its heyday, just as it is coming into its own.

On the horizon are digital videodisks, or DVDs, which promise a data storage capacity of 4.7 to 17 gigabytes, as opposed to the current 682-megabyte capacity of CD-ROMs. Also in the works are CD-erasable disks (CD-Es), which will allow users to erase and reuse compact disks so formatted. Much of the standardization of these new formats is still being worked out, however.

THE DESIGN TEAM AT MACKEREL PRODUCED THIS SELF-PROMOTIONAL PIECE ON DISKETTE TO CONVEY THE FIRM'S CAPABILITIES. WITH A SENSE OF HUMOR THAT POKES FUN AT ITSELF (BUTTONS THAT "BREAK," A GAME OF VIRTUAL BUBBLE-WRAP POPPING), THE MACKEREL STACK IS A KINETIC AND LIVELY DISPLAY OF WHAT MULTIMEDIA CAN DO.

Before the advent of digital video (and QuickTime, a means for encoding it), displaying video on the computer screen was a complicated process that involved pressing analog video to laserdisk, which was then accessed by a laserdisk player controlled by a computer. Most titles in the laserdisk category were educational, and included footage from television broadcast stations. Interaction was limited to the back-and-forth selecting of video segments that went with a given text or voice description. Laserdisk technology was also used extensively in information kiosks, but the arrival of digital video saw the demise of this medium. ▣

DESPITE THE LARGE SIZE OF DIG-
ITAL AUDIO FILES, IT IS POSSIBLE
TO CREATE MUSIC-BASED WORKS
ON DISKETTE. DESIGNED BY BOB
AUFULDISH, THE SOUL
COUGHING INTERACTIVE PRESS
KIT PROVIDES A BIG PUNCH,
COMBINING PITHY QUOTES WITH
MUSICAL SAMPLES FROM THIS
BAND'S REPERTOIRE.

An outstanding title in the hybrid CD-ROM/audio genre is *Freak Show,* Jim Ludtke's CD-ROM for the band The Residents; it employs a circus theme that combines animation, comix, music, and narrative in a unique and original way.

The *Earth* LASERDISK WAS PRODUCED BY WGBH IN CONJUNCTION WITH NASA, AND WAS INTENDED FOR MIDDLE-SCHOOL STUDENTS OF EARTH SCIENCE. NINETY MINUTES OF VIDEO ON LASER DISKS ILLUSTRATE THE "HANDS-ON" EXPERIMENTS AND CONCEPTS DESCRIBED IN THE SOFTWARE.

USING FOOTAGE FROM CBS NEWS AND NEWS STORIES FROM *THE NEW YORK TIMES,* THE WAR IN VIETNAM CD-ROM PROVIDES A HISTORICAL PICTURE OF THE VIETNAM WAR, PUTTING MAPS, WEAPONS, NEWS STORIES, AND FOOTAGE AT THE USER'S FINGERTIPS.

VIDEOTEXT

Online services and the Web owe a tip of the hat to videotext, introduced commercially in 1976, and its companion technology, teletext. Teletext was a one-way broadcast system for transmitting information via an unused portion of a television signal and displaying it on a television set equipped with a decoder. Videotext is a data retrieval system in which information is sent over either telephone or cable-television lines to a stand-alone display terminal. In the heyday of this medium there were numerous incarnations of videotext services, including Qube, Viewtron, Prestel, and Ceefax. The most successful was Minitel in France, which started out as a way to save the cost of printing telephone directories. Its success is attributable to the terminals that France's PTT (Post, Telegraph, and Telephone) company gave away with basic phone service, as well as to the messaging services—mostly risqué—that sprang up soon thereafter. Early incarnations of the online service Prodigy were videotext; *New York Newsday*'s online service was based on such a system, as is the current Bloomberg proprietary information service. ▭

Whereas much videotext runs off proprietary terminals, concurrently there has been a focus on turning the television into a multimedia terminal as well—one that would allow communication between the home user and the source of the television signal. The concept of the television becoming a two-way vehicle for information—the convergence of TV and PC—has long been heralded; technological, cultural, and economical problems, however, stand in the way of this goal. For television viewers used to the seamless motion and animation of TV programs and advertisements, the klunky world of multimedia is not of great interest. Trying to bridge this gap is a difficult task for designers, especially because of limited screen resolution, color, and workable area.

Experimental two-way television programming was successfully tested in Reading, Pennsylvania, in the mid-1970s, and a New York–based public-access television show run from the

THE NEWS EXCHANGE, DESIGNED BY IKONIC FOR TIME INC. NEW MEDIA, WAS AN ATTEMPT TO CREATE AN INTERACTIVE TELEVISION APPLICATION; OPERATED VIA A TV REMOTE CONTROL, IT WAS MEANT TO ALLOW A VIEWER TO BROWSE, SELECT, PRINT, OR WATCH NEWS STORIES FROM VARIOUS TELEVISION SOURCES. THE DESIGN INCLUDED PROPRIETARY NETWORK SYSTEMS AND CONTENT DATABASES.

Interactive Telecommunications Program at New York University was on the air for close to eight years. On a much larger scale, AT&T and, separately, Time Warner, are two of the latest companies to test the waters of interactive television, albeit problematically, mostly due to the bandwidth limitations of current cable systems. The major consideration in the realm of interactive TV is the scope involved in serving multiple viewers requesting video information simultaneously; current technological limits prevent a true back-and-forth communication between users and source on a massive scale. Now being tested is Intel's Telecast service, which provides a television feed combined with hypertext-added information embedded in the video signal. ▢

THESE TWO SCREENS FROM NEWSDAY DIRECT ILLUSTRATE THAT DESPITE THE CONSTRAINTS IMPOSED BY THE NAPLPS ENCODING SCHEME OF VIDEOTEXT (SEE PAGE 44), IT IS STILL POSSIBLE FOR A SKILLED ARTIST TO CREATE SOPHISTICATED IMAGES.

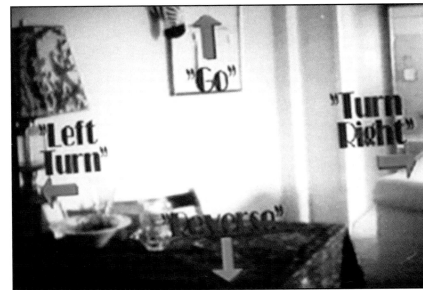

A LONG-RUNNING SHOW ON CABLE TV IN NEW YORK, *YORB* WAS AN EXPERIMENTAL MODEL FOR INTERACTIVE TV. USERS CONTROLLED ON-SCREEN MEANDERINGS WITH THEIR TELEPHONE TOUCHPAD; N.Y.U. STUDENTS PROVIDED CONTENT. DAN O'SULLIVAN CREATED THESE EXPLORABLE SPACES; THE CONCEPT WAS LATER IMPLEMENTED IN APPLE'S QUICKTIME VR.

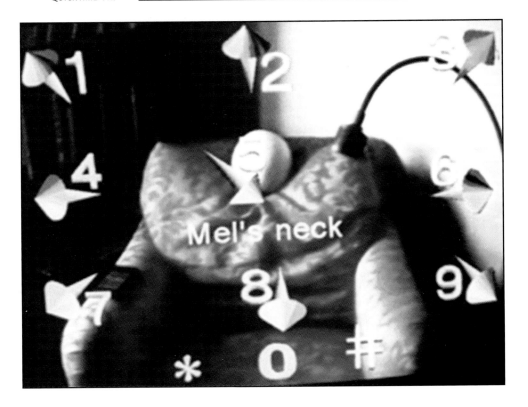

VIDEOGAMES

Much of what is considered interactive television involves connecting separate devices to the TV. Early personal computers, such as Commodore's VIC20, connected to the television, which acted as a display monitor. *Pong* and other first-generation videogames were supposed to bring about a huge new market for makers of home videogame technology in the late 1970s, but Atari, the company that led the field at the time, dropped the ball and the market went bust. A few years later Nintendo and Sega introduced their gaming systems and revived the market.

Videogames have always provided users with highly dynamic and interactive experiences, albeit with limited capacity for communication. Most games are created on proprietary systems that use very low-level programming to provide quick action and reaction to user inputs, and the ever-evolving game consoles constantly push the limits of technology in terms of 3-D rendering, interaction, graphics, and sound. Today's gaming systems come close to being low-end computers; they run from CD-ROMs, and have modems and other communication hardware built in. The myriad TV-top boxes currently on the market offer everything from simple game playing to potential Web browsing, as witnessed by the TV-Web hybrids that are now available. Many game systems are moving online, such as Sega, which has proposed an interactive cable channel that would provide pay-per-play gaming, and Sierra Online, which formerly allowed multi-user games to take place over its proprietary network. ◎

MULTIMEDIA GAMES COME IN MANY VARI-ETIES, OF COURSE; CURRENT POPULAR GENRES INCLUDE SEEK-AND-DESTROY GAMES SUCH AS *DOOM* AND ENDLESS PUZZLES SUCH AS *MYST*. SHOWN HERE IS *BURN:CYCLE*, AN UPDATED VERSION OF THE TEXT-BASED ADVENTURE GAME, WITH VIDEO-BASED CHARACTERS, 3-D–RENDERED SCENERY, AND A FULL-LENGTH MUSICAL SCORE.

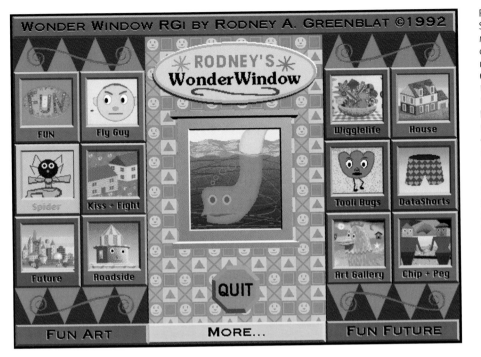

WONDER WINDOW RGI BY RODNEY A. GREENBLAT ©1992

RODNEY'S
WonderWindow

FUN
Fly Guy
Spider
Kiss + Fight
Future
Roadside
QUIT
Wigglelife
House
Tooli Bugs
DataShorts
Art Gallery
Chip + Peg

FUN ART
MORE...
FUN FUTURE

REFLECTING SATURDAY-MORNING CHILDREN'S TV IS RODNEY GREENBLAT'S *WONDER WINDOW* CD-ROM, WHICH BRINGS ITS CREATOR'S KINETIC AND CARTOONLIKE SCULPTURES TO THE DIGITAL REALM, PROVIDING KIDS WITH FUN GAMES AND ANIMATIONS.

NETWORK COMPUTERS AND BEYOND

The latest technological buzzword in new media circles these days is the network computer. A simplified device that effectively leaves much of the hardware of the personal computer behind, this surf-optimized box is being touted as the Next Big Thing. The software that one would need to run such a system would be distributed over the network, as would content. Essentially "dumb" terminals like those used in videotext applications, coupled with the World Wide Web protocol for viewing information, these low-cost boxes are being marketed to consumers who do not see the need to own a home personal computer. At the same time, a new chorus of voices is proclaiming the PC/TV merger once again.

Do we see a pattern emerging yet?

It is important to remember that the design and structure of information systems and multimedia depend in many ways upon the delivery medium or technology one is working with. Any given technology imposes certain constraints that must be addressed, but technological advances are such that locking oneself into a particular information delivery system can be catastrophic if that system becomes obsolete. There is much in the history of multimedia technology that can be learned and applied to interactive media design; ideally, design principles must be applicable and adaptable over a range of technologies, as well as to changes in them. ▢

MAKING MEDIA DYNAMIC: ENCODING SCHEMES

The data formats (the ways information is stored on the computer digitally) that are used in the digital realm to describe text, graphics, and other building blocks of multimedia have become standards over multiple computer platforms. For various reasons unique to the digital world, each format comes with certain limitations that must be understood if it is to be used properly; just as it behooves a painter to know about pigments and brushes, so, too, must digital designers understand the components of their media. Working with multimedia technology requires a knowledge of one's tools that goes beyond what is necessary in other media. Creative implementation of tools is something of which artists have always availed themselves; tools are often invented to satisfy aesthetic (as well as practical) needs. For reasons that include a steep learning curve, this can be a bit more difficult in the digital realm; it is, however, necessary if artists and designers are going to control their tools and not the other way around. The more technically based a given medium, the more knowledge of its particulars is required of the user who hopes to create effectively with it. A software program designed by someone else imposes limitations on how you can bring your own ideas to life; for that matter, inherent limits are imposed by hardware as well. Multimedia design is more than just graphics imported into a Macromedia Director project, or QuickTime movies included in a Web page. The more the artist understands a medium—as well as how to handle and fabricate the necessary tools—the freer he or she is to create.

Every digital building block used on the computer is based on a certain scheme for encoding information. The various schemes have been developed for different reasons. Most of these fall into one of the following categories: optimization for travel over data communications media; for storage and size constraints; for display limitations of a given display device; and, in certain cases, for output to a printer or other device. In terms of encoding information, some of these reasons take precedence over others, depending on how the data are to be used. Equally important is that digital data are made up of not only the information that represents the text, graphic, sound, or video files, but also the information that describes and refers to the data themselves. The inclusion of this "metainformation" will be seen as integral to our description of interactivity later in the chapter.

Some encoding schemes can be tied to a specific display or hardware platform, such as videotext. NAPLPS (North American Presentation Layer Protocol Syntax), developed in the late 1970s, is a system for storing the data of an image in a small file. The NAPLPS image is sent over data lines with no reference to the display capabilities of the receiving terminal. The display terminal receives instructions on how to re-create the image sent, and contains additional information concerning data error correction, session status, and other instructions describing the actual transmission of the image, as opposed to the drawing of the image. The display algorithm is based on a mathematical model in which lists of objects are rendered on the screen one at a time and on top of previously drawn objects. The basic rendering of objects is handled by graphical primitives (think of a primitive as a set of instructions for doing one defined task), each of which can handle a certain object type (point, line, arc, polygon, rectangle)

The Digital Designer

```
%Postscript Program

/circle
      {      0 360 arc      }
      def

/inch
      {      72 mul      }
      def

gsave
newpath
1 .25 scale
0 17 inch translate
4 inch 5.5 inch 120 circle
0 setgray
fill

grestore
/Times-Bold findfont 24 scalefont setfont
2.6 inch 5.5 inch moveto
(The Digital Designer)
1 setgray
show

copypage
```

ADOBE'S POSTSCRIPT PRO-
GRAMMING LANGUAGE
MAKES IT POSSIBLE TO
DESCRIBE IMAGES INDEPEN-
DENT OF THE DEVICE USED
TO RENDER THEM.

or environment variable (select color, text, texture, set color, reset, domain, and blink). In this way a graphic image can be sent as a list of instructions, not a large bitmap file. Parts of the screen can be redrawn without others being disturbed, allowing for dynamism and further savings in terms of bandwidth.

Some encoding is optimized for a certain type of printing or output, such as PostScript. PostScript is the computer language supporting all current electronic publishing, allowing for mathematically precise placement of graphics and text on a two-dimensional printed page or, in the case of Display PostScript, for rendering graphics and text on a computer monitor. One important aspect of PostScript is that it is device independent, meaning that the resolution of the PostScript device on which the document is output is irrelevant to the creation of the document; it is also vector-based, meaning the PostScript primitives describe mathematically the rendering of a page, as opposed to keeping track of the state of every possible point on a printer's output page. A page can be proofed on a low-resolution output device for later printing on a high-resolution device with no changes required to the actual file being proofed. The PostScript language also allows for a dynamic work environment, providing feedback as to the status of a given document or execution environment.

Some codes are optimized for a given method of communication. Everyone knows that Morse code is a means of communication between a machine and a human being. The marvel of Morse code is its efficiency of transmission. Letters of greater frequency are encoded with fewer dots and dashes. The letter *E*, the one most commonly used in the English language, is represented by a dot, *T*, by a dash. In this way transmissions are optimized to save bandwidth. When machines started communicating with each other, newer codes were devised, such as Baudot (International Telegraph Alphabet), EBCDIC (Extended

Binary Coded Decimal Interchange Code), and ASCII (American Standard Code for Information Interchange). Developed in 1963, ASCII is the most widely used communications code in the U.S., and is a government and military standard. It provides for the transmission of alphanumeric information, as well as the characters needed to control information display on the receiving terminal. ▨

ASCII ENCODING PROVIDES TYPOGRAPHIC CHARACTERS AND CONTROL CHARACTERS WITHIN THE LIMITS IMPOSED BY COMPUTER MEMORY.

1	1	1	1	0	0	0	0	7	BITS			
1	1	0	0	1	1	0	0	6				
1	0	1	0	1	0	1	0	5	4	3	2	1
p	\	P	@	0	SP	DLE	NUL	0	0	0	0	
q	a	Q	A	1	!	DC1	SOH	0	0	0	1	
r	b	R	B	2	"	DC2	STX	0	0	1	0	
s	c	S	C	3	#	DC3	ETX	0	0	1	1	
t	d	T	D	4	$	DC4	EOT	0	1	0	0	
u	e	U	E	5	%	NAK	ENQ	0	1	0	1	
v	f	V	F	6	&	SYN	ACK	0	1	1	0	
w	g	W	G	7	'	ETB	BEL	0	1	1	1	
x	h	X	H	8	(CAN	BS	1	0	0	0	
y	i	Y	I	9)	EM	HT	1	0	0	1	
z	j	Z	J	:	*	SUB	LF	1	0	1	0	
{	k	[K	;	+	ESC	VT	1	0	1	1	
I	l	\	L	‹	,	FS	FF	1	1	0	0	
}	m]	M	=	-	GS	CR	1	1	0	1	
~	n	^	N	›	.	RS	SO	1	1	1	0	
DEL	o	_	O	?	/	US	SI	1	1	1	1	

ENCODING GRAPHIC IMAGES

Most encoding schemes for graphic formats fall into the category of raster graphics, or bitmaps. These images are made up of an array of colored dots, or pixels. These formats include PICT, a method of rendering a graphic image in terms of QuickDraw primitives on an Apple Macintosh computer (PICT is one of the various four-letter names the Mac system assigns to certain resources); GIF (Graphics Interchange Format), a highly compressed format developed by the online service CompuServe that uses indexed color (a minimal color palette) and is optimized for file transfer over telephone lines; TIFF (Tagged Image File Format), which uses the same compression scheme as GIF but allows for image types other than indexed color; and JPEG (Joint Photographic Experts Group), which economically stores graphic data, but also discards information beyond what the eye can perceive (this is referred to as "lossy," meaning that some information is lost in the process and is not recoverable). There are many more formats, including PCX, WPG, JIFF, TGA, PhotoCD, BMP, RIFF, PIC, and Scitex, which are optimized for particular platforms or software applications. Graphics encoding is often interchangeable; a graphics program, for example, is able to save a given image in any number of different formats. ▭

Encoding digitized sound files involves recording an analog sound and saving the data that represent the sampled points of the original sound wave. Sampling involves breaking down the smooth analog sound wave into discrete points; the speed at which this occurs is referred to as the sampling rate. The resolution of the sound sample refers to the number of possible values that a given sample can hold. For example, eight-bit resolution would be two to the eighth power, or 256 possible values. To preserve as much of the original sound wave as possible, it is necessary to sample the sound at a high rate; CD-quality sound is sampled at 44,000 times a second, with each sample having one of more than 65,000 possible values, or 16-bit resolution. Sound file formats such as AIFF and WAV, as well as proprietary formats for specific software applications, contain the data representing the sound file along with data describing its attributes, such as pitch settings, spectral data, cue and loopback points, and so on.

A separate method for encoding musical information is MIDI (Musical Instrument Digital Interface). MIDI is a standard method of representing time information, tempo, time signature, sequence, note, velocity, aftertouch (how sound is affected by how long a key is pressed), pitch, and other musical attributes as serial data, which are transmitted to MIDI-enabled synthesizers, sound modules, and other devices. In this way large groups of various devices can be controlled centrally and easily. Because data files for MIDI contain information about music that is understood by external MIDI instruments—as opposed to digitized music sounds themselves—they are very small, and allow for editing and other manipulations using MIDI software programs.

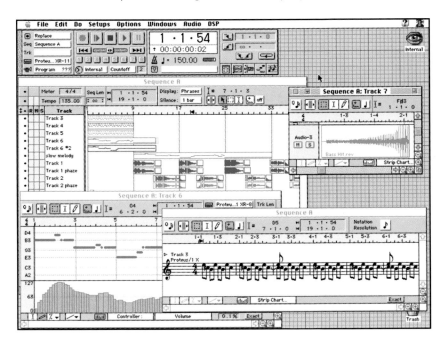

DIGITIZED SOUND AND MIDI INFORMATION ARE COMBINED FOR PLAYBACK IN SOFTWARE PROGRAMS SUCH AS STUDIOVISION, PICTURED HERE.

ENCODING VIDEO FILES

Storing video digitally is a complex process that involves a few levels of encoding. These include proprietary algorithms for coding and decoding (referred to as codecs); MPEG (Moving Pictures Expert Group) compression; and data format encoding such as QuickTime, which allows for the control of time-based data such as animations, video, and sound. ▣

TOUCHSCREEN KIOSKS HAVE BECOME FAMILIAR FEATURES OF BUILDING DIRECTORIES, SHOPPING MALLS AND STORES, AND INDUSTRY CONVENTIONS AND CONFERENCES. GTE'S PAVILION AT TELECOM '95 FEATURED NETWORKED KIOSKS (TWO SCREENS FROM WHICH ARE SHOWN HERE) THAT PROVIDED INFORMATION ABOUT THE COMPANY IN THE FORM OF MPEG-ENCODED VIDEO RUNNING ON VIDEO CARDS OPTIMIZED BY THE DESIGNERS TO IMPROVE VIDEO THROUGHPUT.

Certain protocols used in the digital realm add another layer over already encoded data. Most common perhaps are compression and other space-saving algorithms, which compress data to save storage space or transmission time over data lines. Also common are email protocols, such as SMTP (Simple Mail Transfer Protocol), which encodes ASCII text as email and breaks email data into chunks that email gateways can handle, and MIME (Multipurpose Internet Mail Extensions), which allows for email encoding of non–U.S. character sets, images, sounds, PostScript, and other definable file types. The Internet is based on a large set of protocols that you may be familiar with already; they include IP (Internet Protocol) and TCP (Transmission Control Protocol), used for routing all Internet traffic; Gopher, used to set up menu structures of viewable data files; FTP (File Transfer Protocol), used to download and upload files via certain transmission methods; and HTTP, which, as discussed above, is used to access data types via browser software regardless of machine, language, or network. ▯

DATA STRUCTURES

Some encoding sets up other data types in a new structure. Data structures are the lowest level of encoding data digitally, and describe certain ways of handling data, including arrays, lists, trees, sets, queues, stacks, and so on. Up one level from basic data structures are databases and other means of linking and cross-referencing information. Often these data structures are invisible to the user, but sometimes they are very obvious. For example, the directory tree structure of how files are set up on a computer is a direct representation of the data structure underlying the file system. This tree structure is more obvious on computers that don't use a windowing system of representing data. Certain hypertext documents and expert systems (an expert system narrows down an answer based on a series of questions), which offer the user a simple choice at each branch of the document, reflect the binary tree structure underlying the document. Likewise, some implementations of discussion areas on the Web reflect closely the branching directory structure of how the data are stored. ▯

ABSTRACT DATA STRUCTURES SUCH AS DIRECTORY TREES, ILLUSTRATED BY THIS GENERIC MODEL, FORM THE UNDERPINNINGS OF MOST COMPUTER FILE SYSTEMS.

THE DIRECTORY TREE STRUC-
TURE IS REFLECTED AND
ABSTRACTED AT THE SURFACE
LEVEL OF DESIGN, AS SEEN
HERE IN THE MACINTOSH (AT
LEFT) AND WINDOWS (BELOW)
REPRESENTATIONS OF COMPUT-
ER DIRECTORIES AND FILES.

Above all of the low-level data structures and data types is usually an authoring program for assembling data into a multimedia experience. It became possible to author multimedia projects easily in 1987 with the release of HyperCard, which essentially brought computer programming to the layman's level. HyperCard, a scriptable software application developed by Bill Atkinson and Dan Winkler, was originally distributed free with every Macintosh sold, and was an easy first step into the next level of multimedia development. Using a metaphor of a stack of cards, HyperCard allowed for the navigation of information in much the same way someone might browse index cards. Later came SuperCard, which included basic HyperCard functionality but moved beyond the card metaphor to allow for the use of windows and other aspects of Mac-like application building. Shortly thereafter, Macromedia's program Director, using a time-line metaphor, came on the scene and made it possible to create kiosklike multimedia projects.

Early software applications often reflected the predigital incarnations of multimedia, such as the use of multiple slide projectors cued to sound, voiceover, or music to create a dynamic audiovisual presentation. Today, the numerous authoring programs available are heading toward a seamless integration of various digital media along the lines of the original promise of a true multimedia application. They do, however, impose a particular way of thinking on an interactive project. Director, for example, is essentially linear, in that the score used to set up a project has a beginning and an end, while programs for authoring Web projects reflect the document-based nature of the HTML code that underlies Web documents.

HYPERCARD BEGAN RATHER HUMBLY AS A BLACK-AND-WHITE SCRIPTABLE APPLICATION USING AN INDEX-CARD METAPHOR.

Authoring software provides a buffer between the artist and the underlying programming code that the computer runs on. However, this means that control of the digital environment is wrapped within yet another layer of programming (with its own learning curve), which in many ways limits what one can do with a given application. Programming languages such as C++ for the computer or UNIX workstation, or CGI (Common Gateway Interface) for Web-based applications, allow greater control because they are a layer down in the programming hierarchy.

So far we have seen how data representation can be the very straightforward storage of data (graphics and sound files), or very complex, low-level descriptions of data (PostScript, MIDI, NAPLPS). The choice of media, data formats, and authoring software—the decisions that determine how data are organized from the bottommost level to the topmost—affect the designer's ability to manipulate those data, to create a dynamic user environment, and to communicate, all of which are basic to our definition of interactive multimedia. ✎

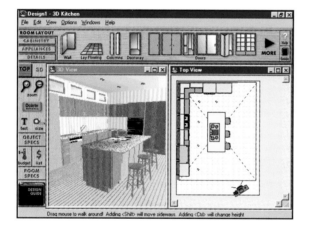

BASED ON A SIMPLE CAD (COMPUTER-AIDED DESIGN) APPLICATION, THE *BOOKS THAT WORK: 3-D KITCHEN* CD-ROM MAKES IT POSSIBLE FOR A USER TO SET UP A KITCHEN USING A FLAT PLAN, AND THEN TO SEE THE SPACE RENDERED AS IT MIGHT APPEAR IN REAL LIFE.

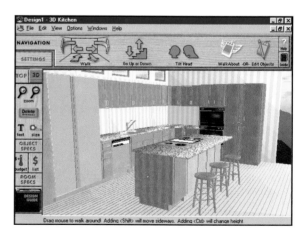

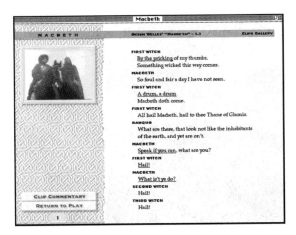

The *Macbeth* CD-ROM shown here, created with a later-generation version of HyperCard, gives a full reading of the play, annotated and cross-referenced with color maps, QuickTime movies, and a character index, along with note-taking tools and search capabilities.

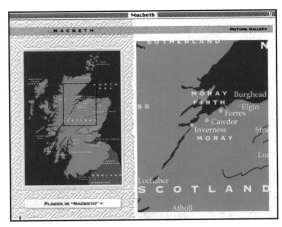

INTERFACE

Up to this point we've been describing the internal workings of the computer side of the multimedia equation. The other side of that equation is, of course, the human user of an interactive media project. The points at which human interacts with machine are collectively referred to as the interface. Creating an interface design involves abstracting the data discussed earlier so that they can be represented in a way that makes sense to the human user, much the way information graphics organize raw information (such as statistics) and present it in visual terms the human mind can grasp easily. In screen-based media such as software applications, informational kiosks, automated teller machines, and personal digital assistants, for example, the structural and surface design of features like menus, palettes, cursors, and other devices determine how a user communicates with the machine or application.

While the human mind is great for making abstract connections and finding patterns amid seeming chaos, the computer, because of its hardware and hardwiring, is unable to make such cognitive leaps. Despite the fact that computer interfaces are designed to make working with machines easier, more labor is required of the human user than of the machine: making sense of abstract representations of data, as well as translating the abstractions of the human mind into concrete data that the computer in turn can work with. A learning curve is always a factor in using the computer on any level; even the most "intuitive" interface demands effort on the part of the user.

The human-computer interface must therefore be defined in terms of the weaker of its two components—namely, the machine; at present, it is the human mind that takes up most of the slack. Yet many who proclaim the computer to be a revolutionary tool have attempted to redefine human thinking in order to qualify the computer as a "thinking machine." Chomskian linguistics defines language as a set of rules; artificial intelligence reduces cognitive function in a similar way. As a result, much writing about the computer, especially trendy "cyber" writing, anthropomorphizes the machine: computers "think," "decide," "act," "choose." In the most extreme examples of this genre, some trend-following writers paint the computer as the next step in evolution—stating, for example, that videogames teach children how to "multitask"—when in fact the human brain remains far superior to the nearest chip-based competitor in its ability to process multiple sensory input and act thereon.

Some say it is computer technology that is bringing on a new age of interactivity, and to a certain extent this is true; the ease of putting together interactive, or nonlinear, works on a computer is unmatched. It must be remembered, however, that the computer is not a model for how humans think or create. In fact, there are predigital works in theater, music, and literature that do not follow a linear structure, while many current multimedia titles are very strictly linear. That we can point to such examples says more about human creativity than about the computer as a catalyst of interactive works. Getting beyond the linear is an ability of the mind, not the machine—which, with its directory-tree structures, time-line metaphors, and binary logic, can just as easily restrict as release one's creative potential.

Having assessed the machine's limits, where, now, do we go from here? What, in concept, does "interactive" ideally mean? Levels of interactivity vary greatly from medium to medium, and the usefulness of any particular interactive experience has everything to do with the task or application that's being worked on, or the information that's being explored. The concept was perhaps best expressed by Andy Lippman of the Media Laboratory at the Massachusetts Institute of Technology. He likened the interface between man and machine to a conversation that may or may not involve working toward a common goal. He breaks down his definition into a series of corollaries, which include the following:

Interruptibility. Mutual and simultaneous communication (such as a conversation), instead of back-and-forth alternation (such as a debate).

Granularity. The smallest interruptible element of a given interaction. In a human conversation, this might be a word; in a play, a scene; in a book, a chapter.

Graceful degradation. The ability to put aside a current task, or to end the task altogether, without losing track of the interaction.

Limited look-ahead. A given interaction cannot completely foresee the path to the given goal; as the interactive experience progresses, possible paths are calculated on the fly.

Apparent infinity. The user must have a maximum of choices at the smallest level of granularity to give the impression of infinite explorability of a given project.

High-level interactive experiences, such as videogames, provide constant feedback to constant input, with no two user experiences being exactly the same. At the other end of the spectrum are low-level interactive experiences, which approach one hundred percent linear movement, with every user experience being exactly the same. Higher-level interactive experiences are closer to the way humans work; lower-level experiences are closer to the way machines work, which can be rote and boring.

One of the current drawbacks to the computer is that only one person at a time can interact with the machine. This is again contrary to the human experience of interaction, where community, team, and group efforts are often the best way to achieve a task or discuss information. Also, most of the input devices in existence require the human user to learn how the computer best handles interaction. This also runs contrary to how humans work, which is usually with tools determined according to the task at hand. Yet for much of what we do with the computer, we force our standard tools—keyboard, mouse, etc.—on the task. The other drawback to computer-based tools is that they are used sequentially, meaning that only one can be used at any given time.

In studying the various computer input and output devices discussed below, keep in mind this interesting aspect of multimedia: that these are tools not only of creation, but of implementation as well. In other words, keyboards and their kin are used to create multimedia projects *and* give access to them. ✍

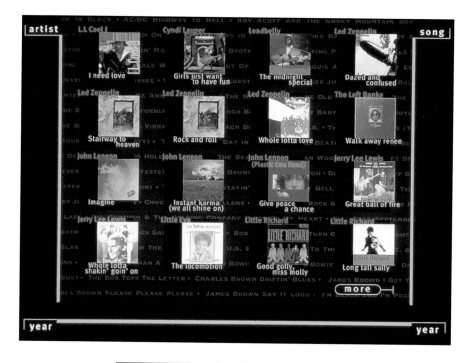

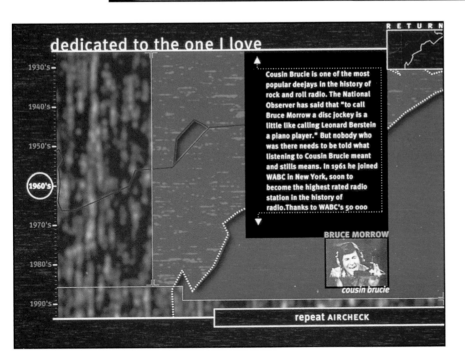

BACKGROUND

Mick Jagger on The Rolling Stones

The Rolling stones began calling themselves the "World's Greatest Rock & Roll Band" in the sixties, and few disputed the claim. The Stones' music, based on Chicago blues, has continued to sound vital through the decades, and the Stones' attitude of flippant defiance has come to seem as important as their music. In the 1964 British Invasion, they were promoted as the bad boys , but what began as a gimmick has stuck as an indelible image, and not just because of incidents likecome to seem as important as their music. In the 1964 British Invasion, they were promoted as the bad boys , but what began as a gimmick has stuck as an indelible image, and not just because of incidents

audio ▶
video ▶

The Rolling Stones

DISCOGRAPHY

1967 The Rolling Stones (Decca, U.K.). England's Newest Hitmakers (London).
1968 Rolling Stones Two (Decca, U.K.) 12 x 5 (London). 1969 Aftermath, High Tide and Green Grass, Got Live If you want it.
1970 Between the Buttons, Flowers, Their Satanic Majesties request.

a b c d e f g h i j k l m n o p q **r** s t u v w x y z

dedicated to the one I love

RETURN

1930's
1940's
1950's
1960's
1970's
1980's
1990's

Cousin Brucie is one of the most popular deejays in the history of rock and roll radio. The National Observer has said that "to call Bruce Morrow a disc jockey is a little like calling Leonard Berstein a piano player." But nobody who was there needs to be told what listening to Cousin Brucie meant and stills means. In 1961 he joined WABC in New York, soon to become the highest rated radio station in the history of radio. Thanks to WABC's 50 000

BRUCE MORROW

cousin brucie

repeat AIRCHECK

THE INTERACTIVE TOUCHSCREEN KIOSKS AT THE ROCK AND ROLL HALL OF FAME ADD INFORMATIONAL DEPTH TO THE MUSEUM'S EXHIBITIONS. LARGE DATABASES HAD TO BE MADE ACCESSIBLE AND OF INTEREST TO ALL USERS; THE INFORMATION IS CROSS-REFERENCED BY SUCH CRITERIA AS STYLE AND DATE.

INPUT DEVICES

The primary—and long-standard—computer input device is the keyboard, which is designed with alphanumeric keys for the input of text and numbers, function (macro) keys to specify particular tasks (such as cutting, copying, and pasting elements of a document), cursor keys for directional movement, and deletion keys.

The advent of the window-based graphical user interface saw the introduction of the mouse as a pointing device, which is used to access menu options, select button options, place the cursor, and manipulate online representations of data types. On its heels came the trackball, in essence an inverted mouse; the device is stationary and the user manipulates the rolling ball inside. Akin to the mouse and the trackball is the touchpad, a flat, touch-sensitive pointing device that obviates any rolling parts.

Specialized or high-end graphics computer systems are controlled by input tablets that use a mouselike device called a puck. The puck has a transparent crosshair that is used to plot data points from a two-dimensional drawing. To a large extent, today the puck has been replaced by the stylus, a pressure-sensitive tool that allows the user to input data by means of a penlike device. Certain types of handheld personal computer devices rely on the stylus as well, allowing the user to input information in his or her own handwriting. (Typically, this involves adapting one's penmanship to work within the limits of the recognition software.)

In the early days of computer use, a light pen was employed as a pointing and selecting/dragging device. It was eventually replaced by the touchscreen, which allows a user to interact directly with elements on a screen display simply by touching them.

The joystick, used primarily in game environments, is composed of a positional stick or wheel and a base with function buttons, and permits two-handed control of screen position, movement of objects on the screen, and action.

Another input device is the scanner, which makes it possible to enter written or printed information directly into the computer; the text is then read by means of optical character recognition (OCR), hardware and software that match scanned text to letterforms stored in memory. In the past, readability depended on specialized fonts; today's systems rely on descriptions of the letterforms in terms of strokes and curves.

Many attempts have been made to introduce voice recognition as a method of data input; however, the numerous idiosyncrasies of human speech and language remain a great obstacle to this approach. Most current implementations of voice recognition limit the user to a few specific words or a particular way of speaking.

A computer's various input ports make it possible to attach external sensory hardware such as light and motion detectors, data gloves, joysticks, and other game-related devices. All such tools require an added level of programming to function within a given multimedia environment; this is usually accomplished via a programming language or authoring software. Much in the way of current multimedia art involves setting up such hardware sensors. ⬚

The computer monitor is the most common means for information display. Early models were small and monochrome, and permitted only pixelated representations of text or vector graphics; today, however, monitors come in a large variety of sizes, color bit depths, and output capabilities. Designers usually need to decide on a minimum display capability for a given project, since a simple change in palette, color depth, or size can wreak havoc on the look of one's work.

Sound output is provided for by speakers, which nowadays are built-in components of most computers. Current multimedia PCs generally provide for CD-quality audio output. Voice output is provided for by algorithms that "read" text; technological advances have brought increasingly natural-sounding synthesized speech.

And finally (though not especially relevant to multimedia), there is hard-copy output, produced via a printer; these machines run the gamut from the ink-jet variety to black-and-white laser and color thermal, toner, and dye-sublimation printers.

WHERETO, INTERFACE TECHNOLOGY?

As technology progresses and becomes ubiquitous, it tends to fade into the background, eventually becoming second nature. The promise of seamless human-computer interaction is still a long way off, if only because forays into artificial intelligence and sensory research over the years have shown the human mind to be much more complex than previously imagined. Current interface technologies all require a reduction or restriction of human capability. Until this playing field is level, the notion of the invisible interface will remain a distant dream. In the meantime, designers need to keep in mind what humans are capable of, as well as what the computer does best. All interface design involves a compromise. A designer who concentrates on the communicative and informational nature of multimedia, understands the building blocks of the digital media he or she is working with, and aims for a perfect interface paradigm will be well on the way to creating a successful multimedia project.

THE WINDOW-BASED METAPHOR THAT APPLE INTRODUCED WITH THE LISA COMPUTER, SHOWN HERE, HAS BEEN WITH US FOR ALMOST A DECADE AND A HALF. WHAT THE FUTURE OF INTERFACE AND MULTI-MEDIA DESIGN WILL BRING IS LARGE-LY UP TO DESIGNERS WORKING IN THIS EVOLVING REALM.

DESIGNING FOR MULTIMEDIA

Graphic design is but a single component of multimedia design; many more factors come into play in making the transition from paper to screen. Designing for the print realm requires a technical knowledge of the printing process, typography, print design conventions, color theory, and materials such as paper and ink. Multimedia design, however, involves several other kinds of layers that make up the user experience, including linguistics, cognitive psychology, cultural studies, computer programming, information theory, and more, all of which must be integrated. A designer should have, at the very least, an awareness of the numerous issues involved in creating a worthwhile multimedia project. Any new media project must be looked at from the users' (plural) and user's (singular) perspective, as well as from technical and design perspectives.

Ideally, interactivity can be defined as a user's engagement and involvement with a dynamic system, which in turn changes and adapts to the user. In the early days of computing, users had to learn arcane code and communicate in the binary language of the machine. As technology progressed, different ways for human and machine to communicate with each other emerged, from binary switches to command-line interfaces, then to menus, windows, cursors, buttons, and everything else we associate with the modern graphical user interface. Today we face a paradox of sorts: as we learn more about how the mind works, and as computer technology becomes more sophisticated, the concept of "machine intelligence" moves farther away from our notions of what makes for cognition. How, then, do we approach the process of designing for human/computer interaction? An interface modeled too closely after the way the machine works proves frustrating for human users; attempts to bring the machine up to a human cognitive level underscore the huge difference that exists between the human mind and the computer. 🖫

ANALYZING THE LAYERS OF MULTIMEDIA DESIGN

What a designer brings to the interactive experience is his or her ability to provide a translation from a machine's digital data to a human's "analog" sensory input and output (and vice versa): in other words, to create a buffer between a blindingly fast machine that processes information sequentially and a human who can't crunch numbers quite as quickly as that machine can, but who can handle multiple perceptual input extraordinarily well—a filter between a machine that is not at all equipped to deal with culture, semantics, and shades of meaning, and a human user who, in a media-saturated and "designed" world, is particularly attuned to finding patterns, corollaries, meaning, and subtext in various forms of information. To best handle this role, designers must learn to appreciate the various layers of design that make up the interactive multimedia experience. These can be defined as follows:

> **Surface design.** The way underlying design levels of a project reflect up to, and are perceived at, the topmost level; in other words, the graphic representation of data and information as they are perceived by the user.
> **Systems design and information theory.** The ways in which dynamic systems are structured and messages are coded.
> **Structural design.** The archetypal conventions used in designing information.
> **Technical design.** The hardware and software underlying all of the above.
> **Human factors.** The human end of the process, including such studies as cross-cultural design, linguistics, cognitive psychology, and access issues.

We have already discussed how the various layers of any medium reflect their structure upward to the level of the end user. In the same way, we will see that the design decisions that are made on the technical, structural, system, and surface levels also have an impact on the final design of a particular project.

How, specifically, does a designer come to the decisions that will yield a successful new media work? It of course would be very easy to prescribe exact steps to follow in designing a multimedia project, and in fact, today much of what is written about new media design tends to devolve into sets of rules based on prevailing norms or ideas that are currently in vogue. Yet, although such "rules" might benefit a designer who needs to set up a project quickly, or who seeks a template approach to multimedia development, in the long run, guidelines that pass for prescribed standards are detrimental to the thinking process that is necessary for designing successful interactive projects. By focusing instead on the overall picture and on the multiple layers that new media works entail, a designer will be better equipped to size up the parameters of a given interactive project, and thus produce an appropriate and useful result.

Perhaps the most critical level of design in a multimedia work is its surface, this being the window through which a user perceives the project. At present, a good many multimedia projects are characterized by surface design that is divorced from what underlies it. The beveled buttons, simulated high-tech dials and switches, and other such clickable gadgets that feature in much current surface design, clichéd as they have become, are nonetheless looked upon as workable interface elements, when in fact they serve no real design purpose. Forays into trendy and overwrought motifs bring a design dangerously close to being more about itself than about the application it is meant to serve, thereby adding no value to an interactive project. In an ideal multimedia world, the surface design of an interactive system would integrally reflect the nature of the underlying layers of technical, structural, and systems design.

Working digitally is radically different from working in print, as are the end products of either medium, especially with regard to information design. Whereas print design adheres to a strict system of matching and proofing, digital design is a bit fuzzier, due to variables in the hardware and software involved, and the nature of digital design itself—as we shall see in this chapter.

SCREEN RESOLUTION

One major limitation in digital design is screen resolution. Whereas printed pieces can have a high resolution if desired, on-screen renderings are limited to less than 100 pixels per inch. This means that one's ability to create finely rendered graphics or typography is severely curtailed. Also, monitors for different computer systems vary in their resolution capacity, and differ as well in pixel shape. Thus, two monitors of the identical screen area can show two—sometimes radically—different versions of the same design.

COLOR

As with screen resolution, so, too, are there limits to handling color. In print design color is pigment-based, and the primary colors—those from which all other hues are mixed—are cyan, magenta, and yellow, plus black (hence the acronym CMYK, the *K* standing for black). Digital design, however, because it is screen-based, uses not pigment colors but the colors of *light,* whose primary components are red, green and blue (hence the acronym RGB). Furthermore, computer color comes in bit depths, which describe the number of different hues the machine can display at the same time. Eight-bit color gives a maximum of 256 hues; 16-bit color yields thousands of hues; 24-bit color gives a maximum in the millions. This means that the number of colors a designer can use in a screen-based project depends on the bit depth of the monitor on which it will be displayed. A project created for 24-bit color display will not look the same when it is displayed on a screen with only eight-bit color capabilities.

TYPOGRAPHY

Typography as it is displayed on a computer screen is limited by the number of pixels used to describe a letterform; graceful curves are rendered as stairsteps, and fine serifs end up looking like slabs. Computer fonts are designed in two versions, one that is meant to be printed out on a high-resolution PostScript printer, and the other only for screen display. At the same time, the appearance of a given font will vary according to the computer system on which it is displayed, further reducing the designer's chances of achieving typographic nuance. Print concepts of kerning, letterspacing, and the use of extended character sets are often not considered in the design of computer-based media; this is due to technological limitations (the maximum number of characters in a font is 256, determined by the limits of computer memory) or to the fact that with the advent of digital typography, designers have assumed the role once played by typographers.

THIS CD-ROM SAMPLER FROM MULTIMANIA ILLUSTRATES THIS MULTIMEDIA COMPANY'S PHILOSOPHY OF A "LIVING SCREEN." MULTIMANIA PUSHES THE INTERACTIVE ENVELOPE BY USING LAYERED TEXT, GRAPHICS, AND SOUND IN OFTEN SURPRISING WAYS.

Time-honored standards in print typography have been more or less adhered to for centuries. But in the digital environment, good typography is a virtual impossibility. Type resolution on the computer screen is still too coarse for fine reproduction. Many typefaces have been either designed or adapted from the classics specifically for screen use, and type-making programs for the personal computer, like Fontographer, have given life to hundreds of unique letterforms, but even these are reproduced from high-resolution output devices. So what is a multimedia designer to do? The answer is, typographers are lost in cyberspace—especially on the Web, where existing document-encoding programs, such as Java and HTML, are incapable of typographic nuance. This may change with the advent of Bitstream's TrueDoc type-encoding protocol, which downloads a representation of a font for use with a given Web page. Many typographers, however, worry about the copyright issues of such distribution. ◎

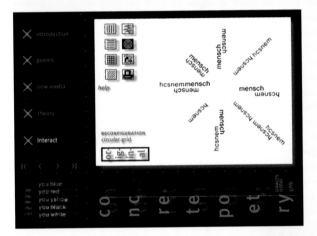

THOMAS MÜLLER (SEE INTERVIEW ON PAGE 119) EXPLORES THE ROLE OF TYPOGRAPHY IN THE NEW MEDIA. HIS PROJECT "UNDERSTANDING CONCRETE POETRY" ENABLES THE USER TO EXPLORE A WORK OF POETRY WHOSE CONTENT IS REVEALED THROUGH ITS FORM.

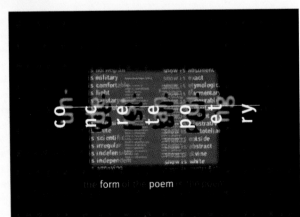

JONATHAN HOEFLER ON THE EVOLUTION OF TYPOGRAPHY

We interviewed Jonathan Hoefler, a typographer who specializes in the design of original typefaces and whose work is steeped in the history of letterforms, about various evolutionary aspects of type. Our questions focused on how the letterforms we consider traditional have been shaped by past and current technologies; how fonts designed for print versus screen differ; and on how on-screen type has dimensions of time and motion that its print counterpart does not.

"'Traditional' typography ceased to be a valid term more than a century ago, when the first of the serious cross-technological revivals was undertaken. Even the most conservative digital typeface, even one intended exclusively for printing, is typically a digitization of a photographic design, which in turn was derived from a metal type, usually made from brass matrices mechanically adapted from drawings, inspired by photographs of inked impressions of lead types, cast from brass matrices made from steel punches, and made from counterpunches, which are shafts of steel filed down to the inverted shapes of the parts of letters that never get printed. And all of this is based upon a set of ineffable standards that constitute the alphabet, which is handed down from calligraphy, which is ultimately a shorthand for inscriptional lettering and, in turn, is a rarefied form of calligraphy again.

"Certainly 'screen typefaces' differ from 'print typefaces,' probably as much as newspaper types continue to differ from book types. But even this distinction, which may have been rooted in the technological origins of these types, now has far more to do with familiarity and cognition than with the rigors of type manufacture. All media imply certain expectations about the typography they carry, and since we're really in the infancy of a culture that is beginning to read on screen, it's hard to say what form screen typography will take. My suspicion is that the strictures of backlighting and monitor resolution, which are really pretty ephemeral, will have very little to do with the ultimate result.

"I suspect that the new dimensions of typography as it appears on screen, such as time and motion, are going to affect readership, which in turn will influence typography. I don't think it's a direct route. The rise of the university system in the Middle Ages gave us the need to differentiate between texts and exegeses, which meant books with grids, and centuries later, typographers responded by alloying romans and italics to demonstrate these kinds of distinctions. The Industrial Revolution brought the need to promote consumer goods through advertising, which brought the advent of posters and handbills, and typographers responded by creating the first bold types.

"I bring this up because it illustrates that typography is, more than anything else, a response to changes in reading habits, and that changes in reading will come about through changes in culture. Once we start thinking seriously about how time and motion can add a semantic dimension to this experience, instead of a merely stylistic one, I suspect that we will find new ways of articulating ourselves through a new kind of typography." ✑

THE HOEFLER TYPE FOUNDRY SAVVILY GRABBED "TYPOGRA-PHY" AS A DOMAIN NAME FOR ITS ONLINE CATALOG OF TYPE-FACES. ALSO TO BE FOUND AT THE WEB SITE ARE LISTINGS OF EVENTS OF INTEREST TO THE TYPOGRAPHY COMMUNITY, ALONG WITH A GUEST REGISTRY.

THE HOEFLER TYPE FOUNDRY

HOME
NEW
CATALOG
ORDERING
REGISTRY

RrRr
Ziggurat
HTF Ziggurat

$RrRr$ RrRr
Didot
HTF Didot

RrRr
The Fell Types
Historical Allsorts

RRRRRR
CHAMPION GOTHIC
HTF Champion Gothic

RrRr
Leviathan
HTF Leviathan

HTF Gestalt

Scripts
Historical Allsorts

RrRr
Acropolis
HTF Acropolis

Rr
Saracen
HTF Saracen

METAPHOR

Certain metaphors are intrinsic to their applications; think of the spreadsheet of Lotus 1-2-3, or the card stack of HyperCard. Perhaps the most familiar is the "desktop" metaphor the Macintosh computer first introduced as a screen interface. Based on work done at Xerox PARC (Palo Alto Research Center), the Mac desktop was modeled on a real-world environment such that documents, folders, and the like were represented by icons simulating these typical office paraphernalia. The beauty of the Macintosh was the standardization of the interface for all application programmers; the look and feel of the Mac is part of, and reflective of, its underlying software and hardware layers. Such interface elements as windows, menus, buttons, scroll bars, and icons reside in the machine's read-only memory and are called up by an application's software routines, meaning that the designer of any Mac application does not have to render these elements. For the user who has become accustomed to the way the Mac works, however, what this setup does not allow is the ability to bypass the "hand-holding" aspects of the interface—for example, multiple dialog boxes that ask the user if he or she is sure about executing a particular action each and every time—or to execute commands simply by typing them in.

When the authoring program HyperCard first appeared, many of the visual options it gave users for representing navigational devices and other controls within the project were modeled after real-world switches, buttons, gauges, dials, and other such devices. Subsequently, software evolved that made it

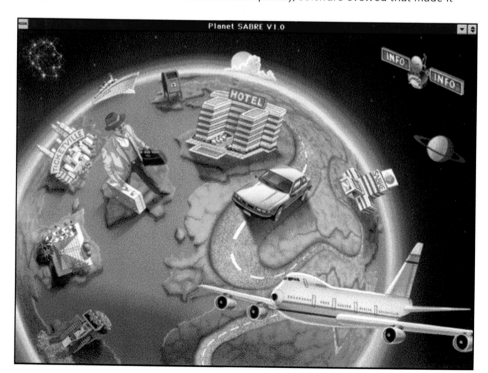

PLANET SABRE, DESIGNED AS A GAME TO TEACH USERS HOW TO BOOK TRAVEL PLANS, IS A GRAPHICAL INTERFACE VERSION OF THE TEXT-BASED PRO-GRAM TRAVEL AGENTS USE. IT EMPLOYS A CONSISTENT METAPHOR, COMPLETE WITH ICONS, MENUS, AND POINTERS.

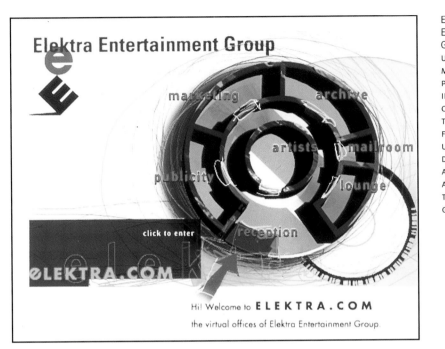

Elektra Entertainment Group

click to enter

reception

ELEKTRA.COM

Hi! Welcome to **ELEKTRA.COM**
the virtual offices of Elektra Entertainment Group.

ELEKTRA ENTERTAINMENT GROUP'S WEB SITE USES AN OFFICE METAPHOR TO PRESENT PUBLICITY AND MARKETING INFORMATION. BUT CURRENT LIMITS IN WEB TECHNOLOGY MEAN, FOR EXAMPLE, THAT USERS' MOUSE CLICKS DON'T RESULT IN VISUAL OR AURAL FEEDBACK, AND IMAGE MAPS AND TEXT ARE NOT INTEGRATED.

possible to add sound effects to program interfaces to make them more "realistic." Continuing in that vein, multimedia clip art, plus Photoshop and other applications that allow the user to create and manipulate visual material, have enabled designers to further—and more easily—mimic real-world objects in the metaphors they devise for multimedia projects, so that (especially with regard to navigational elements) the trend toward such metaphor-driven models as the beveled button has become entrenched.

In many ways, a metaphor provides an easy entry into an unknown environment, but it also can be unnecessarily limiting. A current trend is to design metaphors for virtual-world settings that imitate real-world spaces—maps and "towns," for example, or the architectural renderings that can be created with VRML (virtual reality modeling language), or the "avatar chat spaces" of such software as The Palace. (In the latter conceit, the user chooses a visual impersonator, or avatar, that then "interacts" with other users in virtual chat rooms in online Palace sites.)

The drawback of tying on-screen meanderings to real-life spaces is that once the digital version ceases to correspond to the real-world model, the metaphor is broken, resulting in confusion, or worse. One of the most famous examples of a misconstructed metaphor is the trashcan icon on the Apple Macintosh interface screen. In the Macintosh system, dragging a file to the "trash" is the means for eradicating data, but the same action of dragging a diskette icon to the trashcan icon simply ejects, rather than erases, the diskette.

Furthermore, the same metaphor that helps a user adjust to an online space can then become an encumbrance as that user's skills progress, particularly in not allowing shortcuts to getting a task done. For that reason, key-sequence macros—shortcuts that use option, control, command, and shift keys in combination with specific character keys—were an ironic, mouse-defying return to the keyboard, and were a welcome addition to the Mac interface.

A metaphor is gratuitous when the user has to spend more time navigating it than reaching and actually working with the data he or she desires to access. Real-world metaphors sometimes can be an easy out for graphic designers hard-pressed to solve a multimedia design problem, but multimedia projects are often better served by more abstract representations of data that do not confine information space to three-dimensional real-world objects.

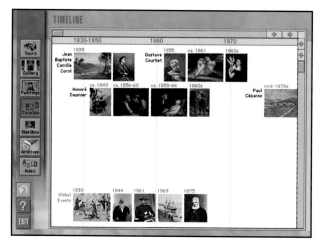

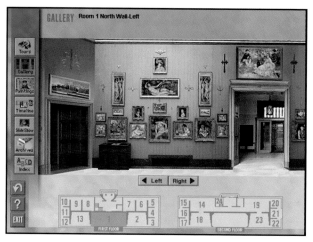

A PASSION FOR ART IS A VIRTUAL MUSEUM ENVIRONMENT DEVOTED TO THE COLLECTION OF THE BARNES FOUNDATION. IN THE METAPHOR'S DESIGN, THE FOUNDATION'S WALLS WERE RE-CREATED FOR CONTEXT, BUT VISITORS ARE NOT LIMITED BY THEM. IMAGES CAN BE BROWSED VIA A VISUAL INDEX; A TIME-LINE FEATURE GIVES HISTORICAL RELEVANCE TO THE WORKS DISPLAYED.
© 1995 CORBIS

The study of the organization, structure, growth, and determination of systems, ranging from human societies to celestial bodies, is as old as human knowledge itself, and some of the ideas that have come down to us can be applied to the study of interactive design. Most fundamental are the concepts that a dynamic system is flexible; that it is made up of smaller parts that may operate independently of the greater system; and that it strives to maintain state or order, and is able to recover from great fluctuation of its components. Individuals in a migrating flock of birds or a school of fish, for example, may veer or even scatter from the group, but by instinct will return to it, despite having a limited sense of the scope or size of said group.

WITH *STAR TREK*'S DEVOTED FAN BASE, THERE COULD BE NO STINTING ON DETAIL IN MIMICKING THE GADGETS AND JARGON OF THE SERIES. *THE STAR TREK OMNIPEDIA* INCLUDES VIDEO STILLS AND FOOTAGE FROM THE TV SHOWS AND MOVIES. THE INTERFACE ADAPTS TO THE TYPE OF DATA DISPLAYED; LINKED INFORMATION ALLOWS USERS TO CROSS-REFERENCE THE ENTIRE DATABASE.

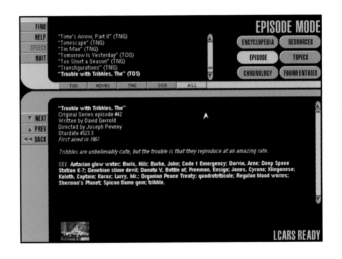

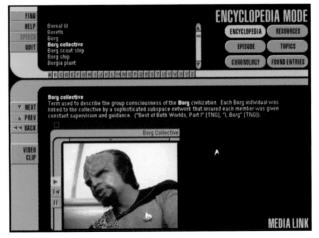

ASSESSING VARIABLES

A designer working on a book takes the entire book into account and structures it appropriately. Although it is possible to design a book page by page, the result of such an approach is almost guaranteed to be a garbled, inconsistent mess. A multimedia project poses an even bigger challenge to the designer in many ways, since unlike a book, which, by its size, heft, and makeup, readily allows us to judge the extent of its contents, such a project usually offers no overt clues as to its scope or depth, making it difficult to get a sense of all that it encompasses. The ability to bring order and sense to even the most seemingly chaotic system is inherent to the information designer's job. 💾

A CD-ROM BEAUTIFULLY DESIGNED BY F2 CO., LTD., *THE LANGUAGE OF KOGA HIRANO* SHOWCASES THIS ARTIST'S TYPOGRAPHICAL WORK. MULTIPLE LAYERS OF INFORMATION ARE VISIBLE AT ALL TIMES, WITHOUT RESULTING IN A "NOISY" SCREEN. THE INTERFACE AND VIEWING AREA ARE BLENDED SEAMLESSLY FOR AN EFFORTLESS TOUR OF HIRANO'S WORK, AND NAVIGATIONAL DEVICES ARE BLURRED OR BROUGHT INTO FOCUS TO DISTINGUISH, RESPECTIVELY, GLOBAL FROM LOCAL CHOICES.

ESTABLISHING HIERARCHIES

Think of the complex system that is an automobile. The driver is not required to know everything about the engine, but the engineer is; the engineer provides, in the form of readouts, information about the parts of the system the driver must know to work with it properly, such as rate of speed, level of fuel, distance traveled, and so on. Furthermore, these readouts are prioritized—for example, the speedometer is larger and more centrally located than the odometer, because it is more important to know how fast one is going than how far one has gone.

To take this analogy one step further, imagine traveling along an interstate highway system. The driver is given directional signs indicating both immediate and, if you will, global location. The signage that refers to nearby destinations is denser and more information-laden than the signage that refers to points farther away. For example, a quick succession of signs might point out local streets or tourist spots with very specific directions on how to get to them, whereas more general navigational indicators would be provided for upcoming highway junctures and distant cities. The driver is given an *awareness* of what is going on systemwide, but the emphasis is on navigating the immediate surroundings, since an excess of information about faraway destinations is confusing and unnecessary. Without the hierarchical order of such signage, the highway system would be as perplexing as a maze.

THE SIGNAL-TO-NOISE RATIO

The study of systems is filled with numerous surprises, such as these: how open systems are able to organize themselves, as well as to increase in complexity, as time goes on; how seemingly chaotic systems actually have organizing principles on a mathematical level; and how certain systems, such as those based on fractals (very irregular shapes or curves that repeat themselves at any scale), reflect an organizing principle both in the smallest component as well as in the whole of the system itself. It is important that the information designer take phenomena like these into account, and that he or she never lose sight of the fact that systems are fluid and dynamic in nature, and thus, that they require flexible design solutions to make them comprehensible in terms of both their component parts and their entirety.

One of the defining concepts of a system is entropy, or randomness. The more entropy that exists in a system, the less information is conveyed. For example, a completely random array of pixels conveys no information whatsoever; but as order is brought to those pixels, an image starts to emerge. Similarly, a completely random television signal appears on the screen as snow, whereas television signals that carry pictures are highly ordered. Claude Shannon, working at Bell Laboratories at the time, instituted these ideas in 1948, applying his information theory to such things as television-signal transmissions and communications with distant spacecraft.

Information theory, simply put, propounds that anything that brings disorder or randomness to a signal is noise. Outside the field of communications, information theory has been applied to the psychology of visual forms, notably by Rudolf Arnheim in his book *Entropy and Art* (Berkeley, 1971); Jeremy Campbell, in his book *Grammatical Man* (New York, 1982), extended the theory to other systems such as language, DNA, and cognition. The idea that noise is contrary to the throughput of information is applicable to all means of communication, including design.

By virtue of their choices, designers decide how hard a user will have to work to extract useful information from a design. Certain amounts of noise are allowable, and are even desirable. One can even decide that noise is the raison d'être of a work; an example that comes to mind is *Ray Gun* magazine. Usually, though, the imparting of information takes precedence. Once a body of information is deemed important, gratuitous surface design elements (which play an essentially cultural, decorative, or referential role) that are added to it are considered noise. The signal-to-noise ratio determines how successful information throughput will be, both on the purely mathematical level described by Shannon and on a more esoteric level of meaning, with the highest noise levels rendering communication impossible. The greatest hurdle for a designer to overcome is ridding the signal of as much noise as possible.

All of that said, the information designer must move beyond thinking in terms of discrete, concrete elements arranged neatly on a page. Information design involves creating a system of data, with hardware and software, that is mutable and dynamic, that is structured enough to have meaning and value, yet is not so dominated by structure that restrictions are placed on the information the project is meant to communicate. ◒

5

GEARHEADS, A GAME ON CD-
ROM FROM PHILLIPS, USES
SIMPLE LOW-LEVEL RULES TO
CREATE A LIVELY INTERACTIVE
EXPERIENCE. WIND-UP TOYS
RENDERED IN 3-D ARE
ENDOWED WITH SPECIFIC
TRAITS, ALONG WITH BASIC
RULES THAT GOVERN THEIR
ACTIVE LIFE AND INTERACTION
WITH AN OPPONENT'S TOYS.

BREAKING AWAY FROM THE SHARP AND CLEAN DIGITAL LOOK OF MUCH MULTIMEDIA ART, *SCRUTINY IN THE GREAT ROUND* OFFERS AN EXPLORATORY SPACE THAT CHANGES AND MORPHS BASED ON USER SELECTIONS.

Conventions that have evolved in print design over its long history have become second nature to readers. Except for occasional detours into the experimental realm, print design has a built-in set of standards a designer can rely on to help structure information. This way of presenting information has become part of our cultural and perceptual worldview. Veering too far afield from these standards can cause confusion, yet at the same time, the underlying structure of magazines, books, and other two-dimensional printed matter is not so rigid that publishers lose their ability to be creative within the print paradigm.

Multimedia's relatively short history and rapid evolution, however, mean that its structural design paradigms aren't clear-cut, and that they often borrow heavily from their media forebears. Significantly, the content and navigation of a multimedia project must be active, mutable, and flexible.

STRUCTURE IN PRINT DESIGN

The underlying structure of print design is for the most part implicit. Whatever the design application, whether editorial or advertising, print is about communication. Within this broad definition are many subsets of print-based design, each with its own particular structural conventions. For example, the layout of a book is based on standards that have become accepted for organizing information that make the book a functional object. We understand implicitly the function of folios, indices, chapter headings, and so on. What's more, we are able to hold an entire book in our hands and get a sense of its scope and size, as well as easily browse the information contained therein. Magazines are conventionally divided into shorter blocks of reading material that come before and after a feature section of longer articles, and contain layout elements such as callouts, subheads, bylines, and jumps. Newspapers are organized into sections based on content: business, arts, sports, science, local, and international news, for example. We understand the function of structural elements such as grids, jumps, lead-ins, callouts, summaries, and tables of contents. Specialized print formats have specialized structures: the frames of a comic strip, the tabs of a dictionary, the marginalia of an annotated book.

Information graphics is the subset of design whose purpose is to convey information as straightforwardly as possible—to enable the reader to understand abstract data constructs at a glance. Maps, for example, display spatial information using structural elements of color, contour, keys and legends, and scale. Charts, diagrams, and graphs are structured in various forms that have become familiar, such as bar graphs and pie charts. Signage often uses universal symbols and recognizable graphics to give structure to large-scale systems and spaces such as highways, airports, and museums.

STRUCTURE IN TIME-BASED MEDIA

Film, television, theater, and radio are structured according to implicitly linear concepts of scene, shot, frame, stage, act, and the like. These same structural devices are used in producing time-based digital works such as animation, movies, and sound.

NAVIGATION

Essential to the structural design of a project, be it print-based or in another medium, are navigational and other related elements, such as text fields, labels, and graphics, that signify what options are available to the user—the state and scope of the project, the user's "location" in the project, where help information can be found, and the like. The ratio between navigation design and content should be such that the navigation doesn't overwhelm the information that is meant to be conveyed. When more attention is paid to navigation than to content, a wall is erected between users and the information they seek. Imagine your car dashboard painted in neon colors or done up in a kitsch scheme; such overbearing design would make it quite difficult to find the information presented by the various gauges and readouts.

What is important to remember about the underlying support structures that apply to the design of print media is that their seeming constraints allow for an infinite variety of expression that still can be qualified as "book," or "map," or "chart," or "movie." The structural elements that apply to multimedia design function the same way as those that apply to print: they provide reference and aid in navigation. But the big difference with a multimedia project, as opposed to a print one, is that these elements need to be flexible to accommodate constantly changing data while still ensuring a sense of continuity and structure.

CENTER STAGE

Graphic design has always been more or less an anonymous endeavor. Although a few design luminaries with distinctive signatures have made themselves obvious—or obtrusive—most designers remain unknown to the general public. Functional design is neutral; it should be seen and its makers unheard lest they distract from the message to be conveyed.

In the digital realm the designer must also avoid the impulse to make too overt a mark. Invisibility is usually the greater virtue. Nevertheless, digital media offer the designer the capability to be intimately included in an overall design.

Besides adding one's voice to a multimedia project, it is possible to include one's own moving image on screen—a conceit that's hard to resist. Various CD-ROMs include pictures of their authors cavorting on the "stage" as narrators or announcers. For example, the animated figures of Rick Prelinger in *Our Secret Century* and Rick Smolan in *Passage to Vietnam* are used as intelligent agents who explain navigational features or provide supplementary information about the project and its contents. On the Web, too, mini-movies of talking heads are becoming ever more common. And in the not too distant future, interactive cable TV will have live anchorpersons tucked into the corner of the screen.

Designers are called upon continually to solve the problem of how to weave these characters seamlessly into the interface. But they are also being offered the roles themselves. Increasingly, the designer is taking center stage in digital presentations, a further significant distinction between the traditional and new media.

Passage to Vietnam portrays the country through the eyes of many photographers. Navigation is condensed in a floating cube on the screen; occasionally the animated figure of Rick Smolan, the CD's creator, appears as a navigational agent, as at left.

CONTENT

Perhaps the most important aspect of structural design is ensuring that the information a multimedia project contains is made valuable to the user by the way it is integrated into said project. In an interactive work, a static chunk of text is of little informational value in and of itself, but placed within a greater database so that it relates to a larger body of information, and then made dynamic, that same chunk of text attains greater worth because of its flexibility. Thus, multimedia content must be viewed in a different light than print content in the way it is presented. Printed information is literally bound to the medium it appears on; digital information has no such constraints. The standards of encoding data that we looked at previously allow for the free flow and dynamism of digital information. Structural design should equally allow for the dynamic nature of these data. The informational content of a multimedia project is more valuable the more complete and dynamic it is; ideally, it should be supported by, and therefore separate from, the structure that underlies it.

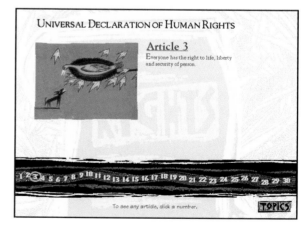

DESIGNED WITH A WOODCUT MOTIF THAT BREAKS AWAY FROM MUCH DIGITAL IMAGERY, THIS CD HIGHLIGHTS AMNESTY INTERNATIONAL'S RECENT WORK IN HUMAN RIGHTS.

TOPICS

Liberia
Libya
Malawi
Maldives
Mali
Mexico
Morocco
Myanmar (Burma)
Nicaragua
Niger
North Korea
Panama
Papua New Guinea
Paraguay
Peru

A B C D E F G H I J K L M N P R S T U V W X Y Z

Morocco

Government:	Constitutional monarchy
Population:	26,708,587
Literacy:	61% male, 38% female
Languages:	Arabic (official); several Berber dialects; French for business, government and diplomacy
Religions:	98.7% Muslim, 1.1% Christian, 0.2% Jewish
Ethnicity:	99.1% Arab-Berber, 0.7% non-Moroccan, 0.2% Jewish
Life expectancy:	63 years male, 67 years female
Infant mortality:	5.6%
Labor force:	7,400,000; 50% agriculture, 26% services, 15% industry, 9% other
Organized labor:	5% of the labor force, mainly in the Union of Moroccan Workers and the Democratic Confederation of Labor

INFORMATION, PRESENTED IN ANIMATIONS, PHOTOGRAPHS, AND INTERVIEWS, IS NAVIGABLE FROM A CENTRAL CONTENTS PAGE, AND ALSO CAN BE ACCESSED CONTEXTUALLY.

TOPICS

she con...
rights. Because of her ...s
still unsafe for Fatima to return to
her own country.

LIBRARIES

The intellectual and monetary value of computer-based information such as that stored in government databases, airline reservation systems, and online news services is derived from its breadth, design, and cohesive structure. Compare data resources like these with the long-lived depository of information we know as the library.

A library provides a complete and continually updated search mechanism for accessing its collection via card catalogs and/or computer databases; it uses various "see also" links to related ideas or concepts, and is organized as a subset of a greater, more complete body of knowledge that can be accessed from other collections of printed material as needed. The value of a library is measured in terms of organization, comprehensiveness, and networks for sharing information; ideally, multimedia projects should aim to satisfy these same criteria of worth.

TECHNICAL DESIGN

The operating system—the software that controls all aspects of a specific computer's way of working—is how we usually define a computer environment; it is what makes the box of silicon chips useful on the most basic level.

Of course, there is no single, universal operating system. And even though one system may have some characteristics in common with another (for instance, the windowed environment shared by the Macintosh operating system and Microsoft Windows) or may allow some cross-platform compatibility (e.g., the Macintosh can read and write to IBM-formatted diskettes), neither has been designed to work exactly like the other. This in turn affects the way software that is meant to run on a given operating system is designed—particularly with regard to how it will work and how it will be used, since different systems process user input dissimilarly.

Because it is yet another layer of programming, off-the-shelf authoring software can mask to a great degree the differences between operating systems. For the designer, this extra layer effectively limits the number of programming choices available, and makes error debugging and troubleshooting that much more difficult. □

EVENTS, MESSAGES, TOOLS, AND OBJECTS

Many software applications rely on an event-oriented paradigm. This means that the user initiates a command (usually by typing the required instruction or code at a prompt) that contains all the information the computer needs to execute that command. The paradigm works the same way regardless of how many levels of dynamism are involved. Computers that run on MS/DOS (Microsoft Disk Operating System), including those with the added layer of software called Windows, work on the event-oriented approach.

The advent of windowed working environments brought a message-oriented software paradigm. In this model, the workings of the computer take place in an event loop, meaning that the computer cycles endlessly, waiting for messages triggered by mouse clicks and drags, keystrokes, disk insertions, and so on. The tool-based approach also appeared at this time, allowing a user to select data—a line of text, a portion of a graphic, a file icon, for instance—and effect some kind of change to it by making a choice presented by a menu or toolbar. As the user selects and makes choices, the rest of the operating system's software cycle shows what options are or are not available at the moment, updating the user environment.

In the 1970s Xerox PARC developed Smalltalk, the first truly object-oriented programming language. Object-oriented programming, or OOP, permits the creation of software data "objects"—discrete modules of code, modeled on real-world objects, that combine function and data and can perform calculations and other data transformations. Unlike a looping control structure, which monitors the overall state of a computer system, object-oriented programming strives to endow individual data

objects with the ability to act independently on a local level, and then pass on information that in turn updates the system on the global level. ▭

PROCESS-ORIENTED SYSTEMS

UNIX, developed at Bell Labs as a tool to help programming research, is an example of a process-oriented operating system. Small, basic programs make up the building blocks of all UNIX-based software. As such, powerful applications can be built on the smaller modules simply and efficiently. Each command issued on a UNIX machine spawns what is called a process, which in turn can spawn further processes. A number of processes can run simultaneously, which allows for multitasking and the use of daemons—processes that run unattended in the background. ▭

THE AUTHORING ENVIRONMENT

On top of the operating system is the authoring environment of the new media project. If an author decides to use a high-level programming language such as C++, then the project is limited only by the capabilities of the operating system used. As discussed previously, however, authoring programs add yet another layer of processing between the user and the computer, and bring with them another set of limitations that have a lot to do with the way the software is set up. For example, HyperCard imposes its index-card metaphor on the way a project can be designed; Macromedia Director, with its linear time-frame metaphor, allows the user to work in only one window or "stage" at any given time.

The choices a designer makes in terms of authoring environment, and even computer platform, have an effect on the subsequent design and structure of a new media project. The further down this software hierarchy the author goes, the freer he or she is to create without constraints. ▭

AT LEFT IS A SCREEN SHOWING THE USE OF THE AUTHORING PROGRAM SUPERCARD, A SUCCESSOR TO HYPERCARD.

HUMAN DESIGN PERSPECTIVES

Equally important to the designer working in multimedia are the considerations discussed below, which reflect the human end of our design equation.

CULTURAL CONCERNS

As markets become global and communications systems move words and images over worldwide networks, more and more attention must be paid to ensuring cultural intercompatibility. It behooves designers to appreciate that worldviews and design sensibilities differ from one culture to another, because only by doing so will they be able to design accordingly. Translating written or spoken words from one language into another is never as simple as a one-to-one exchange; nuance, inflection, and other linguistic variables are all factors a translator must consider in order to preserve, and then clearly convey, the intended meaning of a message. In much the same way, translating design might involve making subtle changes, or sometimes even radical ones.

In an increasingly networked world, it has become more apparent that prevailing paradigms do not always travel cross-culturally. For example, the standard for encoding text is based on ASCII, which is essentially the roman alphabet of the English language.

Extended ASCII character sets take into account most accents of similar alphabets, but left out in the cold are Cyrillic, script languages such as Arabic, and character-based languages such as Japanese. Individual operating systems can easily be configured to handle these languages, but the Internet, for example, is based on ASCII text transfer, which greatly favors the use of English, or at least the roman alphabet.

Care must be taken with the use of certain symbols that we take for granted, since in another culture they may have an entirely different—even obscene—meaning. To Americans, for example, a hand raised with palm out represents "stop"; in Greece, however, this same symbol is an offensive gesture. A designer must acknowledge such cultural variables as the way a page is "read"; the readability and specific meaning of symbols or icons used; and the use of stereotypical references in terms of images, language, and music.

LINGUISTICS

The user-computer interface sometimes has been likened to a conversation. Viewing it that way necessitates that we take a look at language and how it is used.

Human conversation has many levels, depending on context, situation, person spoken to, and so on. For example, the language one uses to address a superior at work is different from the language used to speak to old friends. Certain languages, such as Japanese, have levels of nuance with regard to who is speaking to whom that are difficult for Westerners to grasp. How, then, do we handle the language we use in our "conversation" with the computer?

The biggest problem the designer faces is ambiguity. Subtleties of meaning can cause confusion at best and, at worst, great misunderstanding. If a designer uses language alone or in addition to images to mark navigational elements, for example, then the destinations they indicate should be quite clear; the user should not have to go somewhere first to find out where he or she really wants to go.

The same process that we apply to the grouping of functional elements in an interface applies to the words used to label or structure information in an interactive system. Navigational or other interface elements are best assembled into groups based on semantic equivalence; for example, verbs belong with verbs, nouns with nouns.

Words have nuance and shades of meaning that reflect the dynamic nature of language. For that reason, it is important that the designer take great care in how language is used in a project to make sure that meanings are clear, that semantic problems (in the form of, for example, sexist, racist, or offensive terms, jargon, or dialect) are avoided, and that the particular words chosen for use make logical sense across a system. 🗎

COGNITIVE PSYCHOLOGY

The computer user is not a stock character. Unfortunately, though, much digital design is created as if this were the case. A multimedia work is just as likely to be used by someone who already knows how a computer works as it is by someone using a computer for the first time. Consequently, the designer should not make the user do extra work in order to use any particular system; rather, it is imperative that a multimedia project adapt to the user.

One of the worst crimes committed in the interactive realm is the creation of projects or interfaces that insult the user's intelligence. The computer can in no way match the cognitive abilities of the human being, yet some multimedia projects are put together as if their mere existence as digital products is enough to keep a person interested in them. Digital design should not require the dumbing down of the user; it should be forgiving, allowing for "backing out" of situations, and recovery from "crashes"; it should provide a helping hand only if needed, and not in so overbearing a way that the project becomes inoperable; it should not provide multiple and contradictory sensory information. ⚒

ACCESS

Information additionally has value based on the number of people who are able to access it. The burden is on the designer to provide for all levels of access, which means thinking about users who range from the physically challenged to those who have only low-tech computer systems at their disposal. Perhaps the biggest irony here is the World Wide Web, which as originally conceived was meant to offer worldwide access to information, but is full of sites blaring warnings that they can be viewed only with a specific browser. 🐚

MULTIMEDIA DESIGN: A REAL-WORLD MODEL

The steps a designer must take to initiate and complete a multimedia project—ideally, on time and under budget—are roughly outlined here.

The project starts with a concept and purpose, and a definition of the audience for which it is intended. Marketing concerns—competition, cost analysis—are worked out; copyright issues, rights acquisitions, technical specifications (in terms of what users will need to view the project), and means of product distribution are determined. Designing, prototyping, and testing round out the project's creation.

The designer's role is critical to many of these stages. At the beginning of the development stage, the designer needs to address how well the design integrates with the lower-level programming of the project, as well as how hardwired (static) or generic (dynamic) the computer programming for the project will be. The end user platform(s) the project exists on will also affect the design, and the designer needs to plan for this.

The designer needs to know for whom the project is intended so that he or she can assess cultural issues that might come into play with the target audience (such as possible taboos or biases); user familiarity with the technology, as well as what level of technology is available to the user; and user disabilities.

Next, the designer must examine the data to be used within the project. The design must be flexible enough to adapt to any given set of data, rather than impose constraints on the data. The designer needs to be able to judge how much surface design can safely be added to a project before it begins to interfere with the information being presented. Likewise, the designer must be aware of the ratio of structural design to surface design. If a metaphor is used, the designer should be sure that it is relevant to the project, and consistent in function throughout. A clear distinction also needs to be made between surface or decorative elements and functional elements so that users are not confused.

In terms of navigation, a user should always have an exit. How much freedom the user is given to explore a project—how linear or nonlinear the experience is going to be—must be determined, and the designer should consider differentiating between local and global navigation.

The language used in a new media project must be studied to determine how it may affect the way the project is understood, and whether the language used in similarly grouped parts of a project are semantically equivalent.

By observing user testing, the designer will be able to see the learning curve a new media project requires, what kinds of sensory perception the project brings into play, whether or not the design safeguards against conflicting sensory signals, and what kind of help a new user might need to work successfully with the project.

Multimedia design has many levels, which makes it creatively and intellectually challenging—and at times, frustrating as well. In the end, though, overseeing a project come to life is a very exciting and fulfilling prospect.

For any given task, a set of instructions can be written to indicate the logical steps that must be taken to perform it. In computer programming, this was traditionally accomplished by flowcharting: creating a diagram that shows the step-by-step progression through a particular procedure, with branches arising at decision points. This process is appropriate for the designer who must map out the solution to an information design problem.

Often the initial step is to define a very specific solution to a given problem. Let's take a simple example, such as tying one's shoelaces. We might write the sequence of instructions this way: grab both ends of shoelace; wrap one end over and then under the other; pull tight; grab one end of shoelace and loop it; grab other end; and so on. We would end up with a long list of steps describing how to do one specific thing very well. But what happens when we want to tie a different kind of knot? What if we have a shoelace that's partially knotted? What if we want to tie a square knot instead?

One of the building blocks of software design is the *algorithm,* which can be defined as a set of instructions that make it possible to perform a particular calculation in the fewest steps possible. In computer terms, an algorithm involves some kind of data input that will result in the desired data output. In terms of our shoelace example, the instructions must take us from point A, untied shoelace, to point B, shoelace tied.

The programmer approaches finding the solution to a given problem (task) by dividing it into components. How can we break down our list of instructions? Maybe we set up smaller, component instruction lists to handle the various aspects of tying shoelaces: one set for tying an overhand knot, another set for making a loop, another set for wrapping one lace around the other. In programming-language parlance, these smaller lists are known as either (depending on the software language) *functions* or *subroutines*—discrete sets of instructions that when used in a particular order bring about the desired results.

What if we want to tie a different kind of knot? Perhaps it is possible to break down all knot-tying into a finite list of actions. If we make a function or subroutine for each of these actions, then we've successfully set up a program that can tackle any knot problem and not just shoelace tying. What if we want to make a square knot or tie a bow? If our list of instructions can handle only shoelaces, we are out of luck. But what if we replace the word "shoelace" in our instructions with a word—a placeholder—that represents anything that can be tied? In programming this is referred to as a *variable,* a placeholder for an assigned value; in our case it is whatever knot we define at the start of our program.

Defining our variable to represent "bow," "shoelace," "tie," or "square knot" from the beginning makes our program fairly general at this point; then we add the subroutines needed to accomplish the task of tying each variety of knot. What we are effectively doing is going from a quite specific solution that can handle only one particular task to a more general one that is able to handle many different tasks. Allowing for variance in our design lets us handle many more problems that come along—in this case, different kinds of knots—by generalizing our approach and our programming method. 🖫

WEB DESIGN

The original concept of HTML and SGML was to give computer users universal access to information, regardless of machine, network, or user language. HTML is a means for describing a document so that it can be interpreted with a browser application based not only on the browser's limitations, but also on the information desired by the user. Such encoding provides not only for the visual display of information, but also for data manipulation on the computer side. This dual purpose is the beauty of markup languages. The way the document is described both allows the data to be mutable and gives the document its appearance—its visual cues and surface design. Browser applications vary in their display capabilities with regard to fonts, styles, type alignment, and graphics. In an ideal HTML world, a document's information should still be accessible regardless of these stylistic attributes.

Most designers arrive at Web design with PostScript in mind, a language that describes the placement of graphics and text specifically for the printed page; HTML, on the other hand, is concerned with precisely describing the *structure* of a document regardless of how it is viewed. From a philosophical standpoint, there is a world of difference between these two languages.

Not surprisingly, the initial publishing attempts on the Web mimic their two-dimensional predecessors in bringing old content to a new medium—historically, the starting point of all new media. Shovelware—the mindless repurposing of content for a new medium that afflicts many CD-ROMs—is even more obvious and troubling on the Web, which is not a static storage medium like a CD but a dynamic network that should push the interactive envelope. Instead, thousands of Web pages are created, dated, and left to stagnate in an online wasteland.

Fighting the maturation of the Web are the print design magazines and annuals run by graphic designers with little insight into information design. Such publications are filled with pictures of beautiful Web pages that, with their huge image maps and heavy emphasis on graphics, approach an information throughput of zero. Internet magazines revel in anything flashy coming in over their high-speed data lines. This concentration on the surface look is inappropriate if not antithetical to the online design process, yet if a surface design "looks good" and is full of gimmicks, it receives attention and accolades. Many Web magazines serve up pages that take an unfathomably disproportionate amount of time to navigate for the amount of content presented. The excuse that such pages are designed for the "top-of-the-line" Web connection is a cop-out; in terms of informational value, they are useless and self-serving.

Many misguided incentives are preventing Web design from evolving—corporations and designers harking back to previous paradigms, a graphic design community more concerned with surface gloss than with content, industry hypesters and Net jockeys tied to the software release spigots of Netscape and Microsoft. At present there is not much glory in fighting these incentives, which only makes it all the more important that designers set their sights (and their sites) on the horizon if the Web is to fulfill its promise.

There are many seeming ironies inherent in multimedia design: the emphasis on the general, not the specific; the need for a project to adapt to the user, not the other way around; defining a dynamic "space" via its supportive structure, for example. Working with some of these givens goes against our nature as graphic designers. The learning curve required for designing interactive media is strikingly similar to the one that characterized the early days of Macintosh-based design. When the Mac was first introduced as a publishing tool, the tool drove the designer. Early computer advocates had little or no control over typography, were forced to use a hardly robust graphics format, and had to learn obtuse programming codes. Today, designers have regained the upper hand with their electronic tools, and don't understand why HTML text is uncontrollable, why elements on a 72-dots-per-inch screen don't line up, or why different monitors wreak havoc with carefully chosen color schemes. However, these are wrongly seen as problems to be eventually resolved, not as constraints to work within.

Designers need to lead the way in defining a new paradigm. In today's design industry, it has become apparent that a schism exists between the surface designers and the information architects. The first group concentrates largely on how things look; the second focuses on structural design and the value of information itself. The difference is not a minor one, and requires a major shift in the thinking process of what makes for good design in the digital realm.

In multimedia not even type is static, as exemplified by these screens from Thomas Müller's explorations of its kinetic possibilities in "Liquid Typography." (See page 121).

THE NEW DESIGNER

What is remarkable about the artists and designers interviewed in this chapter is the circuitous route many of them took to get to where they are today in the field of multimedia. Perhaps it can even be said that riding the roller coaster that is the multimedia industry involves a certain amount of serendipity—or at the very least, as the pioneers of this craft attest in the following pages, an acceptance of the multidisciplinary nature of multimedia, and an adaptive mindset that allows one to create and thrive in an ever-evolving realm.

The projects described here vary widely in content and media format, as do the designers' educational and professional backgrounds. Many of our interviewees have migrated from print design and describe their sometimes rocky experiences in making the transition to digital design. They also discuss how they approach digital projects—a work process that perhaps not so ironically is done in a traditional manner. These designers are the last generations to straddle both realms. Most importantly, they are defining the roles that will be played in the constantly expanding field of information design and multimedia.

Sally Ann Applin
The Virtual Museum

Sally Applin received a bachelor of arts degree in conceptual design from San Francisco State University and master of professional studies degree from New York University's Interactive Telecommunications Program (ITP). She was part of the team that in 1992 put together The Virtual Museum, *an exploration of the museum as a virtual space developed by Apple Computer, Inc.*

What did you study to become a new media designer?

My undergraduate major emphasized the process of artmaking over the final project. It drew heavily from other subjects and encouraged us to approach our fine artwork with a design process. We used early personal computers and integrated our fine art with digital work.

ITP provides instruction in the history and context of telecommunications, along with lab experience working with new digital software tools for both the microcomputer and video production.

What has your work background been like?

From 1987 to 1990 I worked for West Office Design Associates, San Francisco, and designed The Hong Kong Science Museum, a 500-exhibit interactive museum in Kowloon. I became interested in observing how people used the exhibits—in the ways they chose to interact or not interact with them. I also noticed, in setting up our studio's computer system, that the designers were having a difficult time learning how to use the "simple" software on the Mac. After some initial research, I went to Apple and interviewed some of the people on the Macintosh team so I could better understand their approach to solving these problems. I realized then that I was more of a practical designer, and so, rather than enroll in a Ph.D. program in cognitive science, I went to work for a software company to learn how software was designed.

I then worked for a while at a start-up software firm called HyperPro, where I learned what went into the production process. A project for Pacific Bell, Smart Yellow Pages, got me interested in the communications end of things; then I heard about ITP, which I attended in fall 1990.

From 1991 to 1994 I worked for Apple Computer, where I designed software user interfaces for products and prototypes. This work included the design of icons, screens, software, and documentation, as well as end-user studies.

Have your working methods changed at all with the advent of computers?

Not really. For the conceptual design process I still rely on index cards, like I did in the museum days. I use the computer to lay out the interfaces once I've designed them. Even back with The Hong Kong Science Museum, I was using the old Mac Plus only to do word processing. The ideas were generated on index cards and sketches. Of course, the technology now exists for creating directly on the machine. But I still sketch on paper a lot and use index cards and Post-it notes.

I am always fascinated by computer people who eschew the computer in favor of nondigital ways of working. Is this something to even think

about, considering how ostensibly good the computer is at arranging information?

When I'm plotting out an interface plan or figuring out elements of art that I'll need for some software, I go straight for the sketchbook. I draw big conceptual maps of what is what, where it's going to fit in the navigation, and what elements are going to be in what parts of it. And I draw lots of arrows between my working pieces to see how they'll fit together. Software tools still can't give me that flexibility. And why do it? HyperCard and other programs like it are a good second or third step for understanding how navigation will flow, but for an overall conceptual map, it's easier just to reach for pen and paper. In cases where I brainstorm with other people on a software team, it doesn't work at all to use the computer for the creative process, because everyone in the room needs to see my conceptual map as a group.

In addition, we might change the map or add Post-it notes to specific sections. This type of creative process is much easier in a nondigital format.

Index cards tend to be my second step. Once I've hit upon an idea I think will work, I take the conceptual map and the pieces of the project I've defined, whether they are ideas or graphics, and create them individually on the cards. I play with how the cards are laid out, test my map, and draw on the cards. Sometimes I shuffle them and try again until the entire thing works for me.

Then I go to the machine. Sometimes I scan in my drawings to use as a digital starting point. But for me the first step in the creative process takes place when I put pen to paper. Even if I were to use an electronic tablet to create my drawings on the computer, the software, as I mentioned before, still isn't flexible enough for my needs.

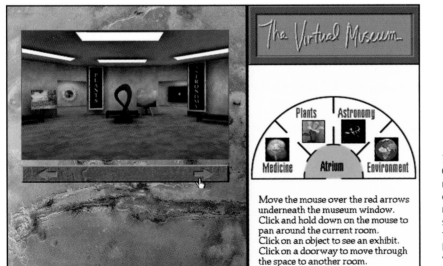

THE VIRTUAL MUSEUM CD-ROM WAS THE FIRST TO EXPLORE THE CONCEPT OF A NAVIGABLE MUSEUM GALLERY SPACE IN AN ELECTRONIC MEDIUM. RENDERED IN 3-D, THE "WALK-THROUGH" CONCEIT WAS AN EARLY FORAY INTO THE USE OF QUICKTIME DIGITAL VIDEO.

What doesn't the computer bring to the creative process?

Creativity. The computer is a tool, like index cards or a sketchbook. I use all of these, but for my preliminary "idea" work, I favor analog media. I wouldn't say I "eschew" the computer; it's just that there is something about typing in front of a machine that takes my thoughts away from my drawing hands.

Tell me about *The Virtual Museum*.

It's an electronic museum where users navigate through a synthetic three-dimensional space and interact with exhibits on medicine, plant growth, the environment, and astronomy. It was the first interactive QuickTime-based project. It was also the *first* CD-ROM that let users actually "walk" through a virtual space with a click of the mouse. Prior to this project, CD-ROMs were merely encyclopedic—not terribly interactive in terms of video or graphics rendered on the fly. I was responsible for conceptual, interface, and graphic design, artwork, and initial scripting in HyperTalk [the programming language used in HyperCard], as well as developing and writing the explanatory text for each exhibit.

The Virtual Museum was featured in 1991 at the International Multimedia Show in Tokyo; in 1992 at Macworld, Tokyo, and Demo '92 in Palm Springs, California; a version designed for a networked multimedia remote server was demonstrated at Supercomm in Atlanta, Georgia, in 1993. It broke the boundaries of what was then possible in new media design and inspired hundreds of software developers. *The Virtual Museum* is also the grandfather of many QuickTime tools and digital virtual reality projects developed by Apple.

What design challenges did you face, and how did you meet them?

VISITORS TO *THE VIRTUAL MUSEUM* INTERACT WITH DIGITALLY RENDERED EXHIBITS ON SCIENTIFIC THEMES SUCH AS ASTRONOMY, PLANT LIFE, AND MEDICINE; USERS CHOOSE THEIR OWN PARAMETERS FOR THESE EXPLORATIONS.

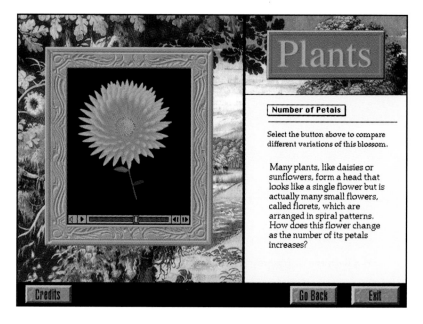

Well, the biggest one was finding a software engine. QuickTime was still in beta [the prerelease testing stage], and the only thing supporting it, or even close to supporting it, was HyperCard. Director wouldn't be supporting it until much later, and we had a deadline of only three months to get something together. The disadvantage of using HyperCard was that it didn't support color. There were XCMDs [programming codes bridging HyperCard and the supporting Mac operating system] that let you put color on the screen, but didn't allow for adding text on top of color. That's why the screen is divided the way it is, with that black line; when you loaded the graphic images, you had to do it in rectangles, and the XCMD lined the rectangles in black. I decided to reinforce that black line as a natural division.

Once in a while I see a resurrection of the "Virtual Museum" idea somewhere—not to mention other "virtual space" metaphors, as well as work generally being done in VRML. Would you agree that the impulse to link information using a museum metaphor is very strong? And, as you look back on your own work, do you see this metaphor as successful, or not? Is it the right way to approach this kind of subject matter?

I think people are strongly inclined to use three-dimensional metaphors—not just for museums, but for shopping malls, communications technology—any type of information space whose content is mirrored in a physical space somewhere in the real world. However, this doesn't mean that I agree with the appropriateness of the metaphor. In fact, one of the things I learned from exhibiting *The Virtual Museum* in public—in galleries,

museums, and conferences—is that people like to browse, but once they've become clued into the interface, there is little incentive for them to continue "walking" around. We walk around in real life; why replicate that on screen? People quickly grasp the gap between the real world and the virtual one, and they need almost no training to get through a simulated 3-D space. Once they have learned how to find their way in that environment, the challenge of the interface begins to fade. At that point, they want the content. Fast. And browsing isn't necessarily going to provide it satisfactorily. About six months after we released *The Virtual Museum,* Silicon Graphics came out with a museum walk-through demo, and about six months after that, a software company based its entire line of products on a walk-through interface. Since then, many other interfaces modeled after the same metaphor have emerged. Now, with The Palace [software that gives users access to 3-D–modeled Internet chat rooms] and VRML, it's getting more and more prevalent. But is it the right way to browse content?

A lot of museums are now going online and are making great plans for their "virtual" spaces on the Web. At a SIGGRAPH conference, everyone on a panel of American and European museum professionals was planning some form of a walk-through interface, but what they seemed to overlook were the more important issues that have an impact on putting museum content into a digital format. Using a 3-D metaphor to replicate its physical structure is certainly one way for a museum to join the digital revolution. But there is a difference between encyclopedic information (video, facts, and figures) and aesthetic information, which is to say that the museum community

has embraced Marshall McLuhan's dictum that the medium is the message. In other words, with art, the size of the canvas or sculpture, the materials, the way a show is curated—all contribute to a coherent experience. So, even though it is possible to curate the same type of show in a virtual gallery, in the digital realm, much of the art's impact can be lost in the reduction of its scale, material dimension, and tactility.

Museums have content, but that isn't the only reason people love and patronize them. For example, people visit museums to see special shows of work that isn't part of the regular collection. Within this category are "media star" exhibitions, which draw, among others, the kinds of patrons who want to be able to say they've been to this or that show, and not necessarily because of the content. People go to a museum to be in an interesting architectural space that is more open than their apartment or house; they go to have lunch at the cafe, to browse in the gift shop or bookstore, to "cruise," even; people go to museums for many reasons besides the obvious one of viewing art. So how do these reasons fit into a walk-around metaphor?

Another question is, how do you archive collections when they become digital objects? How do you "swap" pieces in and out of the three-dimensional metaphor for special shows? What happens when art exists only as flat, digital images and not as physical objects? Is that taken into account? Are we partial to museum objects because we have always known them as physical entities? And if we get to the point at which art exists solely in a digital format, why would we want to walk around a virtual room to get at it?

Where are you working now, and how has your background led into that?

Currently I'm at GVO, Inc., a product design and development company in the Bay Area. GVO's design process has three parts: "discovery," understanding the culture of a company and its customers; "synthesis," translating those new understandings into product concepts and a design language; and "contextual evaluation," assessing customers' perception of and interest in these concepts. Specifically, this merges well with my personal design philosophy in that I believe design is an evolutionary process, a discovery, a blending of ideas, and a way of putting those ideas into a context. That definition of design has permeated my work from my undergraduate days to what I have done since in developing museum exhibit content and design and software interfaces. What's exciting is to find a company that accepts design as a process that can both cross many disciplines and be made stronger by their influences. Although I was hired for my expertise in software interface design, the diversity of the company and its products has given me a broad range of disciplines on which to practice the design process. It's incredibly rewarding to have that kind of freedom to explore design.

Any advice for designers moving into new media?

Remember your roots. The computer makes a lot of prepress techniques easier, but in itself can't create content, design, or expression. It's only a tool. Remember that, and you've got what you need to do good work. Like paper or clay, the computer is a medium, with its own quirks. The screen is always scanning, things are always moving. It's not a static medium; learn its properties.

Bob Aufuldish
ZeitGuys

Bob Aufuldish is a partner in the design firm Aufuldish & Warinner and an assistant professor at the California College of Arts and Crafts, where he teaches graphic design and typography. In 1995 he launched FontBoy, a digital type foundry that manufactures and distributes fonts designed by himself, Kathy Warinner, and others. He has B.F.A. and M.F.A. degrees in graphic design from Kent State University in Ohio.

Where were you predigitally?

Although I am relatively young—I'm thirty-six—my entire undergraduate and graduate education, as well as my early work in the field of graphic design, were completely predigital. I'm from the last generation of designers who were trained with traditional tools and materials. Where I went to school, even technical pens, as opposed to ruling pens, were viewed with suspicion. The first *new* tool that transformed my work was the photocopier—the kind of machine that could reduce and enlarge one's work in one-percent increments.

If you look at the designs I produced from the early to the mid-1980s, you'll see all kinds of evidence of the impact of the copier (in the same way that my work from the early 1990s exhibits the impact of the computer). I had been in the design field for several years before the office where I was working acquired a Macintosh. In fact, it took all of us a while to figure out what to do with the computer.

THIS IS AN IMAGE FROM *SELECTED NOTES 2 ZEITGUYS,* A COLLECTION OF ILLUSTRATIONS ABOUT FRENCH CULTURE. TO EXPLORE THE MATERIAL THE USER BRINGS ITEMS INTO FOCUS WITH THE MOUSE.

How well prepared would you say you were to work in new media?

Reasonably well, because the education I received was oriented primarily toward problem solving, which meant asking lots of questions before starting to find a solution. I also did a lot of letterpress work, which is how I learned typography. Letterpress printing requires a great deal of precision in placing a piece of type in a given position, so it made me work long and hard on my process before going to a final print. Using the Macintosh is very different from my letterpress experience; the computer makes it quite easy to put anything wherever you want it, and consequently, it's very easy to get overwhelmed by the possibilities. I think of the Mac as a letterpress on my desk and try to work with it in a similarly respectful way. With new media, the effort it takes to do something—even something simple—is similar to what letterpress printing demands, so the process and planning have to be in place up front.

Nothing in my education prepared me for scripting [working with programming languages that use English-like syntax], and even today, anything beyond the simplest scripts is beyond me—although I have gotten a lot of mileage out of using simple point-and-click buttons and animation loops. Back when I was still in school, little did I know that classes in computer science could have helped my design work some ten years down the road! However, at that time, if someone had told me I'd need to understand computer programming to be a better designer, I might well have been tempted to choose a different major.

ILLUSTRATED ON THIS PAGE AND THE FACING ONE ARE IMAGES FROM *ZEITMOVIE*, A DISKETTE-BASED PROMOTIONAL PIECE.

Describe the process you follow in working on a new media project. Is it any different from how you worked previously?

New media design requires much more up-front planning than print design does. I can't start tinkering around on the computer to see what happens. The structure of a piece and the way it behaves are set pretty firmly before I start making cast members [graphics used in Macromedia Director]. Conversely, once the structure is in place, I feel I can improvise endlessly with the formal aspects of the design.

What difference do you see between print and new media design?

The role of the computer is fundamentally different in each case. When one is designing for print, the computer is a means to an end. When one is designing for new media, the computer is the means *and* the end. With print, the computer helps you make something whose final form is physical, whereas a new media project always exists digitally.

What do you find fulfilling and, conversely, frustrating about multimedia?

What makes multimedia so interesting is its digital nature, because a given project is, in a sense, never "final," never finished; it's eternally editable and transmutable. Another interesting, and fundamental, feature of digital media is that they can take different forms and be distributed in a variety of ways. Unfortunately, the infrastructure needed to distribute digital work is more expensive and not as extensive as that required for the distribution of print. In other words, on

ZEITMOVIE FEATURES AN ANIMATED ICON FONT DISPLAYED AGAINST BACKGROUND IMAGES OF PIXELATED ICONS.

the most basic level, once a person has a piece of print media in hand, all he or she needs to access the information it contains is the ability to read. But to access a new media piece, a person not only must be able to read, but also must own a computer (and the right *kind* of computer, because of conflicting platforms)—and additionally, must have the proper sound cards, system extensions, and so forth, to make the piece play properly. Digital media also require that users have sufficient enough computer knowledge to be able to troubleshoot when necessary.

This will change if we decide it's important enough. After all, even in the United States, adult literacy remains below 100 percent, to say nothing of how many people don't have access to a computer. Just as we and our ancestors once decided that everyone in the country should have access to electricity, telephone service, and mail delivery, we might now try to ensure that our government build the infrastructure that would allow nationwide access to new media. It's an infrastructure problem.

For me, this infrastructure problem is one of the limitations I design under, and is completely separate from the inevitable problems involving monitor resolution, poor typographic handling of authoring programs, lack of full-motion video, and all the rest. For me, these kinds of limitations are interesting and liberating because they level the playing field. A rich client can buy beautiful printing; a poor one can't. However, a rich client can't buy a higher screen resolution or buy his or her way out of any of the other fundamental limitations. This situation means that the best design and content will rise to the top. There is no glossy printed artifice to hide behind. ⌨

Diane Bertolo
Our Secret Century

Diane Bertolo has a background in fine arts. She has worked as a mostly self-taught print designer, and has recently released an interactive artwork entitled Probing into Science. *Currently, she is working on a piece about memory.*

Did your background prepare you adequately for your work in new media?

My background has been full of sidetracks, tangents, and contradictions . . . perfect training for working in new media! Although art has always been the constant, my first sidetrack was design. Graduating with a degree in painting basically qualified me for a position in line at the unemployment office. But because I had some experience using transfer lettering to make posters for a nonprofit arts space, I consequently found a career—or maybe a career found me!

Some time later, there was a fair amount of press coverage about the new personal computer. I was curious, so I bought a Commodore VIC20 and taught myself BASIC. It was fun, but hardly rewarding as an art or design tool. So I went back to the studio, using traditional tools, for a few more years. This was a short sidetrack, but one that clearly foreshadowed things to come. I now work almost exclusively on the computer for both my own art projects and for design purposes.

Was using the computer as a programming tool early on beneficial to your working in an authoring environment today?

Yes, I do think that using a computer early in my career was a good experience. It forced me to conceptualize in ways that hadn't occurred to me before. For example, it taught me how to put loose, disparate ideas into nice little consumable chunks that could be modified and built upon. This was a provocative concept for me as an artist. There are rare moments in life when you can look back and see a radical change in the way you think. I believe that this was one of those moments.

What sorts of connections do you see between the way you work digitally and the way you work in the fine arts world?

The computer is a great "what if?" machine; it's an amazing laboratory for all sorts of visual experiments. The way I work now relies heavily on "editing" as a means of "making," which is to say that I think process is extremely important. In fact, I think of the finished product—whether it's a design piece or a work of fine art—as an artifact of a process. The nice thing about design is that it is usually clear when to stop; in art, though, you never know for sure.

Please describe your most recent commercial project, _Our Secret Century_.

Our Secret Century, published by Voyager, is a set of twelve CD-ROM disks containing films and related materials from The Prelinger Archive. It is based on the film series of the same name that the film historian Rick Prelinger presented at the American Museum of the Moving Image in New York in 1994. Prelinger programmed the series around what he calls millennial themes. Each

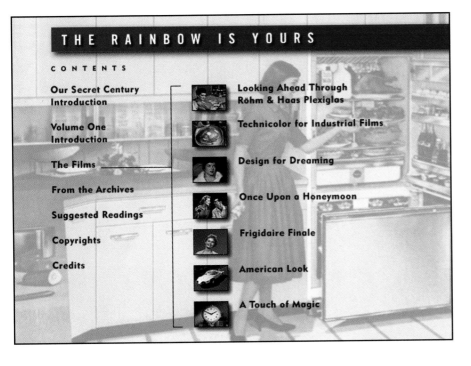

THE CONTENTS PAGE FOR _OUR SECRET CENTURY_ USES ANIMATED ICONS AND A CLEAN, UNOBTRUSIVE DESIGN TO PROVIDE THE ENTRANCE TO THIS TWELVE-DISK FILM ARCHIVE.

INFORMATION IN THE CD SERIES *OUR SECRET CENTURY* IS ACCESSED VIA ON-SCREEN ICONS, AND THE "FIND" FUNCTION WORKS ON TEXT AND PARTS OF THE FILMS.

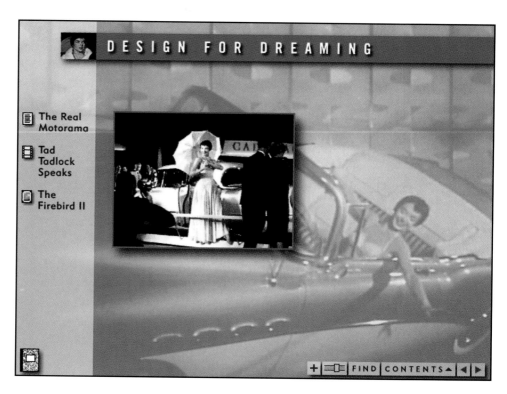

disk represents one of those themes and includes an introduction to the material hosted by a QuickTime Rick, several films from his vast collection (presented in their entirety), and an essay about each film that contextualizes the material from his unique perspective as a social historian, archivist, and media critic. In addition, the disks include a mountain of supplemental materials—such as advertisements, magazine and newspaper articles, and photographs—that add to our knowledge about the films and the times in which they were created.

How did you deal with the challenge of integrating this "mountain" of supplemental materials with the films themselves?

The overall look and feel of the series' design needed to work well for each of the twelve disks, which ranged in content from 1950s fantasy to the dark issues of postwar scarcity and social control. In other words, what worked for the film about the joys of color telephones had to work for the film about propaganda. The next challenge was to avoid a kitschy, nostalgic look. The design had to appeal to a broad audience—for people sneaking a peek into our past for fun as well as for those interested in seriously studying film or pop culture. This reflects the attitude of the author, who concedes that the films certainly have kitsch elements, but who also believes that their strength lies in what they tell us about our collective history.

I met these challenges by creating a modular design in which the mood for each disk is set by background images taken from, and thus reflecting, the films it contains. I used color to emphasize tone as well; for instance, the palette I chose for the darker, more serious subject matter is subdued by comparison to what I used for the lighter-hearted material. The principal fonts I chose—Trade Gothic Condensed and Metro—were commonly used in that time period (serving as a subtle reinforcement, since they are both fairly neutral fonts).

Because there were so many different kinds of information to be presented, I took care to minimize visual confusion. For example, the user can choose whether or not to view Prelinger's essay while watching the film. (Clicking on the icon of a composition notebook brings up the essay.) The backgrounds were designed to work well in either case.

Are there any special features about this project that you would like to point out?

Rick Prelinger's use of supplemental materials in *Our Secret Century* provides an invaluable social context for the films. All of these materials can be accessed by clicking on the small iconic buttons in the left-hand margin of the film screens. My favorites are the ads found on the "Make Mine Freedom" disk, which reveal Madison Avenue as a wheel in the enemy-fabricating propaganda machine. In addition, Voyager provided a fantastic "find" feature for the series: by clicking on the "find" button, the user can input words and jump to key locations in the films, program notes, and supplemental materials to access pertinent information easily.

Dave Bovenschulte
GIST Communications

Dave Bovenschulte has been a professional Web site designer for over two years. Currently, he is the art and interface director for GIST Communications. Prior to working at GIST, he was the senior creative manager for Time Warner's DreamShop. He has also worked for Delphi Internet Services and News Corp./MCI Online Services.

Where were you "predigitally"?

I was a partner in a business that specialized in three-dimensional design. I was also a sculptor. Three-dimensional design was my thing. I was never seriously interested in print.

Did your background prepare you adequately for your work in new media?

No, I had to teach myself the specific skills necessary to working in this field. Nothing in my formal education could have prepared me for any of this. In college I had a few standard computer courses and enjoyed them, but the technology couldn't do anything for me at that point. It wasn't until several years later that desktop computing turned that around.

I find myself evolving with the new media. The pace at which the Internet is growing and the improvements in the technology are lightning fast right now. I find myself constantly trying to keep tuned into the latest advances. Yes, my life-long experience as a human being, my education, and my attention to traditional media prepared me for my explorations into new media. That might sound trite, but it's true.

GIST'S WEB SITE IS DESIGNED WITH
A CONSISTENT NAVIGATION DEVICE
THAT WORKS WITH EDITORIAL PAGES,
SUCH AS THE ENTERTAINMENT NEWS
BRIEF SHOWN HERE.

What are the biggest differences between how you work now and how you were working predigitally?

The tools and the potential. My only tool now is a computer. Computer technology offers us new possibilities; otherwise no one would be interested in it.

Please describe your process in approaching a Web project.

Everyone who knows anything about the Internet expects a lot from it these days. The average person today expects a lot from technology in general. Less than three years ago, a Web site was little more than text on a gray background, with maybe a nice graphic centered on the page. Internet users were so excited about that. Now the stakes are much higher; everyone expects so much more. The parameters of what the technology can do are moving so quickly, creating a lot of chaos, but out of this chaos will come a technically better way to deliver hypermedia to the average person.

I've always approached Web design with the goal of making a site an entertaining and informative experience. The hard part is sorting the priorities out of this chaos of implementation and utilization. I'm trying to design up to the newer

Back | Forward | Home | Reload | Images | Open | Print | Find | Stop
Netsite: http://www.gist.com/prepack/movies.dqg?daypart=Now&genres=29&chanArea=pst

GIST

THIS IS NOT A SUBLIMINAL MESSAGE
Suddenly, you have an uncontrollable urge to click here now!

TV LISTINGS | ENTERTAINMENT | HOME TECH | EXPOSÉ BEAT | INTERPLAY

M O V I E S

Become a member and customize your listings so that every time you log on, you'll instantly get your preferred categories, times and local editions. Click to join now, or for complete guest TV Listings click here.

Thursday 02/06 ▼ | Now ▼ | All Channels ▼ | Grid ▼ | OK

	10am	10:30am	11am	11:30am	12pm	12:30pm	
AMC	<<Stormy Weather (1943) ** (NR) (09:00)	Smoke Signal (1955) ** (NR)			Law and Order (1953) ** (NR)		AMC
BRVO	<Zorba the Greek (1964) *** (NR) (09:30)					The Pumpkin Eater (1964) *** (NR)	BRVO
CMDY	<<Lucky Stiff (1989) ** (PG) (09:00)						CMDY
E!	Stranger in My Bed (1986) ** (NR)						E!
ENCR	<<Shamus (1973) *** (PG) (08:30)	Kroll (1983) ** (PG) (10:15)				Jailhouse Rock (1957) *** (NR) (12:15)	ENCR
ENC+	Flying Tigers (1942) ** (NR) (09:50)			Bad Blood (1982) ** (R) (11:35)			ENC+
IFC	<<Reunion (1989) *** (PG-13) (09:00)	Hammett (1983) *** (PG)					IFC
STRZ	Three for the Road (1987) * (PG)				Hanover Street (1979) ** (PG)		STRZ
STZ2	<<Lorenzo's Oil (1992) *** (PG-13) (09:00)	The Late Show (1977) *** (PG) (11:20)					STZ2
SUND	<<Eight Men Out (1988) *** (PG) (09:00)				Burnt by the Sun (1994) *** (R)		SUND
	10am	10:30am	11am	11:30am	12pm	12:30pm	
TBS	Murderous Vision (1991) ** (R) (10:05)						TBS

Document: Done.

GIST's NAVIGATION ALSO WORKS WITH FUNCTIONAL PAGES SUCH AS THE TV LISTINGS GENERATED FROM A DATABASE; THE USER CAN CONFIGURE LISTINGS AS DESIRED.

browsers these days, specifically for the latest versions of Netscape Navigator and Microsoft Internet Explorer. Part of my reasons for doing this are selfish and part are driven by revenue concerns for the business I'm in. No one can say I don't know how to design for multiple browsers, because I've been doing it already for a few years. I have little sympathy for text browsers on the Web, because graphical browsers caught on more than two years ago. I built Web sites in sixteen colors; now I use millions. I designed for 14.4 modems, and now I design for 28.8 or higher. I don't care if an idea is trendy or not. If it makes sense in the context of what I'm doing, then I'll use

it. I have tried to use every possible tool that promises to make browsing the Web a better experience. Browsers and bandwidth still have a ways to go before the Web can be as interactive as I would like it to be. I consider my work a personal and professional creative challenge that dances and plays with technology. Web publishing is still so new, I just hope what I'm doing can contribute to its evolution.

What particular pitfalls have you experienced in designing for the Web?

Well, browser chaos is probably enough of a pitfall right now. Aside from that, I would say the

biggest pitfall is users. I'm constantly amazed by Web users who refuse to download newer and better browsers when they're *free*. I also marvel at people who think an image on a computer screen looks fine in 256 colors. My one wish is that users experience new Web sites and give them a chance. Let's experiment with hypermedia before we decide what we think it should be.

Another consistent problem in the last few years has been the management at new media companies. No one running the big media corporations that I've worked for or met with has a clue about good Web content. But this will change. Right now, it's the start-ups that have done the best work.

Conversely, what do you find to be the most promising aspect of the Web?
The exchange of ideas, information, and services between people on a much more personal, worldly, and interactive level. And for the near future, I think the Web will mean a lot more to people in other parts of the world than it now does to most Americans.

What advice would you give to a designer or design student looking to move into the field of new media?
Right now in the profession, all of us are trying to do everything. In the next few years, the business will be much more specialty driven. Thus, I recommend that anyone who wants to work in the new media find a particular aspect you're interested in and put your full potential into it. Please use your imagination. The Internet has really offered artists a chance to be socially important again, so don't pass up the opportunity. ⊚

Greg Deocampo
AVX Design

Greg Deocampo currently heads up AVX Design in Providence, Rhode Island. He has worked in collaboration with the performance group Emergency Broadcast Network, creating live multimedia events as well as working on the group's hybrid CD-ROM Telecommunication Breakdown.

How did you become interested in new media?
I got my first computer when I was ten or eleven years old; I started writing graphical and audio software on the Apple II when I was around thirteen, and continued with that through high school. In college I was really into math and molecular biology and spent time building complex models. This brought me back to computer graphics and dynamic visualizations, which in turn brought me into the Brown University hypermedia and computer graphics community. I did some work for Brown's Institute for Research, Information, and Scholarship that was a combination of the Web and HyperCard, and that interactive experience, along with the visualization work that I was doing, turned me on to the computer as an artistic medium.

I particularly fell in love with the qualities of projected versus reflected light, as well as the notion of working with a medium that was responsive to the user. From there I followed this interest to whomever could put the most computers in front of me; at the time, this was the investment banking community. I worked for Salomon Brothers Strategic Technology Group for about a year, until that culture just became

too silly and I didn't want to deal with it, despite all the hardware goodies.

What did you move on to after Wall Street?

I went to a private software development company called Universal Imaging, which specialized in bio-medical image processing and analysis. My experience there got me interested in digital art. Along with my interest in digital video, that led to the creation of the Company of Science and Art (CoSA); the idea behind it was to bring science and art together. This was reflected in a CD-ROM called *Connections,* probably the first electronic magazine (though not widely recognized as such); it was a hypertext audio-video piece that was assembled in an authoring environment we engineered from scratch and that was distributed at a Macworld convention in 1990 to a few thousand people. One of the components of the authoring environment was PACO [PICS Animation Compiler], a platform-independent audio-visual compression and playback system that predated QuickTime by about two years. Using this platform I created some CD-ROMs, in collaboration with bands such as Fish, that were based on the idea of musical/participatory storytelling.

The PACO project led to the creation of the software After Effects [a program for creating and editing digital video effects], and ultimately the demise of CoSA when Aldus bought out the company. [After Effects is now published by Adobe.] At that point I concentrated solely on digital art and performance pieces such as techno raves [live, often spontaneous concert events in various, unfixed locations] in Providence warehouses, using dozens of video, film, and slide projectors to set up immersive installations.

How did Emergency Broadcast Network get started?

I hooked up with Josh Pierson and Gardner Post, the founders of Emergency Broadcast Network, a group of performance artists, and we did installations at Michelangelo's Media Circus [a ravelike

THIS IS THE MAIN SCREEN FOR EMERGENCY BROADCAST NETWORK'S *TELECOMMUNICATION BREAKDOWN* CD-ROM; IT REFLECTS THE VIDEO WALL USED IN THE GROUP'S LIVE PERFORMANCES. A CONTROL PANEL GIVES USERS COMMAND OF VISUAL ELEMENTS SHOWN ON THE SCREEN.

event]. The EBN performances soon became the organizational center of the shows.

EBN at the time was completely analog-based; Pierson and Post had an idea for a video sampler that would parallel audio samplers. Their work seemed to be an ahead-of-the-curve product of high-end, nonlinear digital video equipment, but in fact, they were meticulously hand-editing all of their work using standard analog equipment. I told them they had to go digital and introduced them to digital video, but they remained skeptical and unimpressed by the tiny video window on the computer screen. Nevertheless, the collaboration was started, and we soon merged our respective digital and audio gear and formed a single studio.

The *Telecommunication Breakdown* CD-ROM is impressive in the way it integrates music and the interactive experience. What was your approach? The audio portion of the CD was under way, and I was exploring the idea of the digital video wall — a wall of stacked video monitors. I started to think about how we could organize the material in nonlinear yet linked audio/video samples. One of the constraints we faced was that after the music was on the disk, there wasn't much room left for the video components. The idea I had was to organically link the audio, video, and interactive work into a seamlessly navigable experience, with a key, underlying technological concept: true, real-time interactive audio/video playback, which is the essence of the EBN audio/video sampler. The driving concept was a futuristic notion of visual music, which inspired the creation of this project's technical underpinnings. This required a team and an infrastructure, so I created AVX Design. Our engineering and design team came up with IMP [Interactive Media Player], a core mix of proprietary and industry-standard software components that makes it possible to create fully interactive audio/video applications. The interface concept we were working with is based on the current reality of multiple channels of information input, and on

THE PROPRIETARY CODING OF THE *TELECOMMUNICATION BREAKDOWN* CD ALLOWS VIEWERS TO MANIPULATE DIGITAL VIDEO CLIPS IN VARIOUS WAYS.



VIEWERS CAN FOCUS IN ON SPECIFIC CLIPS ON THE *TELECOMMUNICATION BREAKDOWN* VIDEO WALL; SELECTED ITEMS ARE SHOWN LARGER ON THE SCREEN, BUT STILL WORK WITHIN THE CONTEXT OF THE MULTIMEDIA PIECE AS A WHOLE.

how a user views and selects from this information. The video wall allows for multiple-screen viewing, and the user is able to focus on something by clicking on it.

Today's popular authoring programs make it possible for a user to put multimedia pieces together without knowing much about what's going on "behind the curtain," as it were. How important is it for a designer to have an understanding of how the computer's underpinnings actually work?

On the one hand, I think it's great that page layout programs, and now authoring programs like Director, allow anyone to just sit down and start making "multimedia" stuff, but as an artist working in a technologically intensive medium, I think it is essential to be grounded in the basics of computing. I find that people don't really understand computing, even professionals who design interactive projects. Acquiring solid computer knowledge and skill is no trivial task—I've spent a lot of

time with compilers [programming-language to machine-language interpreters], low-level system toolboxes, and compression algorithms—but understanding how the machine works is as important to creating in this medium as knowing scales and musical theory is to a serious musician. I've spent a lot of time learning how to shoot film, and how to develop it, and how to shoot, edit, and direct video. I've learned the fundamentals of graphic design, and have a background in musical composition. So I am definitely coming from this perspective: if you want to make something that involves software development, audio, video, graphic design, interactive design, and text, you'd better learn how to write, manipulate audio, judge what's good music, good voiceover and soundtrack work, and everything that goes into video. If you are going to take multimedia seriously as art, expect to set aside five years of your life to learn these skills. I see my work as a synthesis of art and hard-core technology.

Many books on the subject of art and technology are written by scientists, not artists; does this perhaps suggest that the computer is a hindrance to the creative process?

It totally influences the creative process! Taking an example I know well, After Effects reflects the thinking of the software engineers who worked on it in a way that is not obvious to the user. They came at it with the idea that the user must control everything quantitatively and express everything numerically. When making the EBN disk, which was done using After Effects, I was struck by the difference between making a tool and using it. The artist using a digital tool is required to go through an artificial technical layer of thinking to arrive at the desired result, which makes for a lack of immediacy. Further diluting the artistic process is the fact that some of this software requires skilled users, which means that people work in teams, and which puts even more distance between the artist and his or her art.

One of the things we are trying to do at AVX is create a culture in which artists and technologists can be happy, communicate, and influence one another. Our video sampler, for example, was an idea that came from people who couldn't have been more technologically naïve, but they set out the specs for how it had to be, and the technology was put together based on those constraints. It isn't always easy to bridge the two worlds.

The history of computer art has been largely about collaborations between artists and engineers. Yet today, even with tools that are easier for artists to work with, using them is still like trying to assemble an aquarium without getting your hands wet. How will these tools evolve?

The development of new technology is the complex synthesis of economic and cultural factors, and the state of science. One thing I see characterizing the future of tools is cheap online technology. Someone is going to put out a suite of tools online, inexpensively. The future will be characterized by the ubiquity of tools and universal access to them. But what constitutes good tools? A lot of software that's out there now is considered top of the line but is directed at a user who is technologically sophisticated. The software industry should probably look to the history of the musical instrument for direction. The computer should be more like a piano—an incredibly sophisticated instrument, yet one that allows for the instant expression of a complex idea. It is this perspective that should drive the future of software tool making.

Any advice for people wanting to get into digitally-based art or design?

Decide what your priorities are. Are you pursuing multimedia work for personal, artistic reasons, or for commercial gain? Both paths are equally valid, but if you are doing it for the art, then you should resign yourself to laboring in relatively uncompensated obscurity—and should realize that you must find your driving creative force from within. If you are pursuing multimedia commercially, then I would say, know your fundamentals. Don't assume you are an expert; you need to understand digital media. Take programming courses, get a handle on how computers work, how data flow, what computing is. Also, have an idea worth expressing, because so much of this industry is based on ideas that basically are *not* worth expressing.

Joshua Distler
Joshua Distler Design

Joshua Distler is the creative director of Joshua Distler Design, a firm located in the San Francisco Bay Area. His background in computer programming has led him to pursue digital and typography design, as well as the design of multimedia projects.

Didn't you begin as a print designer?

My background is primarily in print design, with some experience in product design. For the most part, I have been working in print design and new media in parallel. Before it was a truly applicable medium, I did quite a bit of experimentation in computer animation and illustration.

Have you had to fill in any missing pieces in terms of study or knowledge? If so, what were

they? How did you go about filling in those particular gaps?

I had no formal training in interface design. Most of my contact with it has been from the point of view of the user. But in terms of experience with the computer itself, I do have a good background. At one time I knew how to write Assembly code [low-level computer programming] for eight-bit computer systems. Things have gotten a little more complex since then, but my familiarity with the computer has made the process of learning and understanding the tools easier for me. Even so, the tools are different from day to day, and I constantly find myself filling in "missing pieces." Not only do I need to learn as much as I can about a project, but I also need to learn about what new technological options and limitations exist in relation to that project. There is a constant need to update one's knowledge of the medium that will convey the message.

JOSHUA DISTLER'S DIGITAL PORTFOLIO DEPARTS FROM THE SLIDE-SHOW PRESENTATION OF MANY SUCH WORKS BY EMPLOYING AN INTERFACE MATRIX OF COLORED SQUARES THAT GIVE THE USER FEEDBACK AS HE OR SHE EXPLORES THE PORTFOLIO.

THE MATRIX OF COLORED SQUARES IN DISTLER'S ELECTRONIC PORTFOLIO CHANGES WITH EACH SELECTION TO REPRESENT THE WORKS INCLUDED, CALL ATTENTION TO PIECES THAT ARE SIMILAR, AND DISPLAY PIECES THE USER HAS ALREADY VIEWED.

Can you tell me a little bit about your process in working on a new media project?

The interface is the point at which the user makes contact with the work. For that reason, I feel that it should be a primary source of the piece's visual language. This is where I usually start. If the project permits, I usually try to evolve the piece from a strong interface concept or metaphor.

This is similar to the process I follow when I am working on a printed piece. In print, I also try to define the function of the piece before I do anything else. But with new media work, I try to keep in mind that the user interacts with the piece less as a design, and more as a product. This is what I feel is most fulfilling about the design of a new media piece—there's this whole other level of function to it.

This is also what makes designing for new media incredibly challenging and different. There is a constant element of time and a loss of control on the part of the designer. We can no longer influence the user's experience in the way we could in a book. In the digital portfolio piece, I tried to use this loss of control in a positive way. I thought, why not let users build their own screens according to their navigation choices?

Ultimately, though, I think there should be a purpose to using new media for a project. Is it easier to distribute? A more effective communicator than its print equivalent? In other words, why is this piece being created for and presented in a new media environment? Keeping this in mind, whenever I design an interface, I hope to create something that can be used in a way that is not possible in any other medium.

Peter Girardi
Funny Garbage

Peter Girardi was a senior producer and designer at the Voyager Company for three years, where he worked on such CD-ROM titles as Maus, Painters Painting, Comic Book Confidential, The Beat Experience, Dead Meat *(with Sue Coe), and* Poetry in Motion. *He also created Voyager's Web site, as well as its online font service FOUNT. He left Voyager to start his own company, Funny Garbage, where he concentrates on all aspects of design, digital or otherwise.*

What is your educational background and training? What has been most useful to you in working on your projects?
I graduated from the School of Visual Arts in New York City with a degree in fine art. I worked in an offset/flexographic print factory setting type and assisting on press, which gave me an appreciation for design. My "fine" artwork always had

graphic design elements in it. What I took away from my training in fine art is the ability to tackle every aspect of a particular subject. From start to finish. I was the only person at Voyager to produce *and* design projects; it's usually a four-person operation. On my disks, it was just me. Not having any training in computers has been really helpful to me also. I come at things from a much different angle. It makes it easier to come up with unique solutions to problems.

The multimedia industry changes so quickly; for instance, CD-ROMs, as they come into their own, may be eclipsed by digital videodisks, if not the Web. What are your thoughts on dealing with this ever-changing work environment?
It's all information to me, regardless of the delivery vehicle. The Web does things that CDs can't, and vice versa. It's important to not let the vehicle influence the data too much. I believe that all these different media types will converge anyway—ever notice how much a TV monitor looks

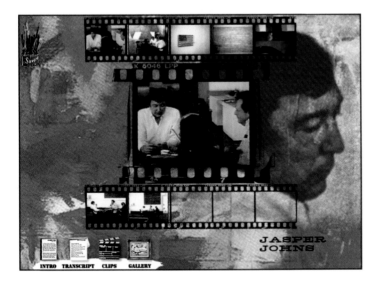

FOR *PAINTERS PAINTING,* A CD-ROM PRESENTATION OF A FILM BY EMILE DE ANTONIO CHRONICLING THE NEW YORK ART SCENE OF THE 1960S AND 1970S, PETER GIRARDI SOUGHT TO DEVISE INTERFACE AND NAVIGATIONAL ELEMENTS THAT WOULD RESPECT THE WORK OF THE ARTISTS INTERVIEWED, AMONG THEM JASPER JOHNS (AS AT LEFT), AND CONVEY THE FEEL OF THE PERIOD. HE ACCOMPLISHED THIS BY PAINTING AND SILK-SCREENING INTERFACE ELEMENTS AND DIGITIZING VERNACULAR TYPEFACES FROM THE ERA.

THIS IS A SCREEN FROM THE EXHIBITION TOUR PORTION OF THE *PAINTERS PAINTING* CD-ROM DESIGNED BY PETER GIRARDI.

like a computer monitor? You have to take many different scenarios and limitations into account when designing for a particular medium. You just try not to let the medium control the message.

What particular problems with multimedia, technology, and design do you see as not being addressed?

Text and typography are the ghetto of interactivity. People are much more concerned with pseudo three-dimensional environments, animations, and other clichés of interactivity than they are with a good-looking sentence. There is no reason that contemporary authoring environments can't have some decent page layout technology built into them. Forget about the Web. Five hundred years of typography down the toilet.

Please describe a recent project of yours.

I just finished a disk called *Painters Painting*. It was a two-hour film by Emile de Antonio about the New York art world of the 1960s and '70s.

What major design issues were involved, and how did you address them?

Keeping the feeling of the period was important, and doing justice with design to the great artists being interviewed. I wanted a really "painterly" and gestural interface. (Gestural really isn't a word associated with interactive media, is it?) So, I silk-screened and painted most of the interface elements. I didn't use a program that simulated painting, I actually got out the gouache and acrylic. Also, I wanted to use a bunch of vernacular fonts from that period that are not available digitally, so I went to Photo-Lettering (a traditional typesetter in New York), got several blocks of copy set, then digitized and cut a font specifically for the disk.

What special features about this project would you like to point out?

I went through a lot of hassle to make the text on this disk look appealing. Rather than using bitmapped text, I set it all as a graphic—a time-consuming process, but worth it in the end.

Craig Kanarick
Razorfish

Craig Kanarick founded and is the head of Razorfish, a New York–based Web design firm.

You entered the digital realm pretty early.

I've been using computers for about fifteen years now, and have had an email address for more than ten. Before Razorfish, I was a freelance interface designer, studied with Muriel Cooper at M.I.T.'s Media Lab, and worked at Bolt Berenek and Newman.

Was your background adequate preparation for working in new media?

Mostly, yes, though it's shallow in "traditional" graphic design. I took a few fundamentals classes but lack much actual experience in things like print, industrial, and package design.

Muriel Cooper might have said that's not such a bad thing! Print design is about structuring information, but it evokes a rigidity that some find hard to break away from in the multidimensional world. How do you approach information design in a dynamic environment?

I've developed a methodology for digital media design that is closely related to design in other media, but requires its own paradigms, due to its unique technical constraints.

What's your working process for a new media project?

It's very detailed. Projects are broken down into a number of areas:

- concept design
- functional design (what will the user be doing?)
- technology design (planning the software and hardware)

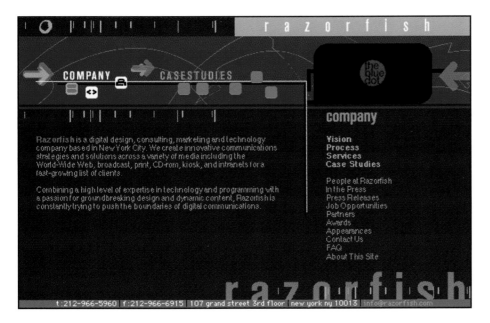

AT LEFT IS THE RAZORFISH HOMEPAGE ON THE WORLD WIDE WEB.

- navigational design
 (organizational structures)
- interface design
- content design
 (not to be confused with interface)
- dynamic information design
- interaction design
 (the nature of the communication mechanisms)

We also create a series of measurable goals for a given project so we can assess success later.

The approach we're developing at Razorfish is unique. The areas listed above overlap a bit, and the general process still needs refining. But we've found it very useful to identify projects this way.

What other disciplines would you say are required to enter new media design?
Obviously, a strong sense of visual aesthetics and traditional design theory. Experience with dynamic media is a must. Technology training is very helpful, as the tools for designing new media are often esoteric. For example, to be a good Web designer it's important to know HTML; to design projects with Director, one should know Lingo.

What do you find frustrating about new media?
Two examples: clients who don't understand the constraints of the medium, and who think new media design is simpler than print design; and the technological limitations with regard to bandwidth, color, consistency, and reliability.

What unique qualities does the World Wide Web bring to an interactive experience?
The Web and other networked media are unique in many ways. For one, that the computer is being used as the interface allows for an enormous amount of "intelligence," in that new media experiences can be fine-tuned for an individual user. Also, the ability of people to communicate with one another via the computer is fantastic. Chat rooms are very popular, evidence of the Web's power to bring people together. Still another wonderful feature of the Web is that it makes it possible to create experiences based on rapidly changing data, such as live news feeds.

But the Web is a hassle, because most people accessing it don't have the speediest connections, monitors that support full color or high-quality printers, and so on. Designing a site that looks different to all viewers because of software and hardware variables is a unique challenge.

That often means setting a cutoff point below which a Web design doesn't work, or creating separate designs for different browser capabilities. What problems does this present to you?
In some cases it means we must produce multiple versions of our products, definitely a big issue. Beyond that, I'm undecided about whether the "multiple browser" issue is a burden or an advantage. We design for a particular browser depending on a site's projected audience.

Where do you see Web design headed?
I think the Web is probably on its way toward becoming a broadband network, with faster connections. I guess it will continue on its path toward offering more sophisticated interactivity and, through an increase in the quality of sound, video, tactility, interface intelligence, and user control, more valuable sensory experiences and interpersonal communication. ▭

Ron Louie
The New York Times On the Web

Ron Louie spent six years working with Paula Scher at Koppel & Scher, and then at Pentagram Design as her senior designer. The clients he worked with included The Public Theater, The American Museum of Natural History, Estée Lauder, Carol Publishing, Byron Preiss Multimedia, and From the RainForest.

In January 1995 Louie joined the multimedia company Tom Nicholson Associates, where he designed the original incarnations of Web sites for Condé Nast Traveler, NJ Online Weather/The Old Farmer's Almanac, and Fodor's. He also spearheaded and designed NBC SuperNet and Intellicast Weather sites for the Microsoft Network.

What did you have to do to adapt the print version of *The New York Times* for the World Wide Web site?

The print version is such a good design: very stable, very logical, very clean. These are the aesthetics we followed as guidelines for the Web site. As to the physical look—the Bookman and Cheltenham typefaces, the rules—my basic thought was that we would take design elements from the paper as long as they worked in this medium, and when they didn't, I felt no hesitation in changing things around and adding different elements.

Once the online version was up and running, how much fine tuning was required? What problems did you face, and how were they resolved?

When we went live for the first time, many of our problems were technical. Going through "dry

THE *NEW YORK TIMES* WEB SITE RELIES HEAVILY ON THE CLEAN AND STABLE DESIGN OF THE PRINT VERSION TO PROVIDE A FAMILIAR ADJUNCTIVE ONLINE SPACE. THE PAGE ILLUSTRATED HERE IS UNIQUE TO THE NEWSPAPER'S ONLINE INCARNATION.

runs" of producing the paper was one thing, but when we had to do it every night, small problems were exposed. Copy coming over from editors wasn't formatted in a consistent way. Programs that were supposed to semiautomate production broke down, so that things had to be done manually. Things just took much longer than we expected they would. And I wouldn't say we've solved all of our problems. We are still updating our procedures.

How are the online and print versions of the newspaper similar, and how are they different? Do you have a Web "wish list"?

As mentioned previously, aesthetically I feel we are similar. We have tried to carry over the heritage of the *Times*. Now we have to push the look further to keep on an equal track with the continuing enhancements technology allows, technology that not only lets us do things we couldn't even imagine a decade ago, but also limits us in terms of speed, visual appearance as it is affected by different browsers, sizes and settings available, and rasterizing typefaces better, among other things. As to a wish list . . . I wish there were more time to do special Web projects on a consistent basis.

Have you changed anything about the online version based on user feedback?

Users are always suggesting new and better ways to do things. They also alert us when things look funny on their browsers. Sure, they are a good source for information and trends, and they keep us on our toes. They'll tell us when they like something, and when they don't. That's good. It's such a singular experience, Web browsing, that

being in contact with our audience will only help us in the long run.

How do you handle branding issues online, especially with a medium that is "boundless"?

Every *Times* Web page has our logo at the top and our copyright line at the bottom. Branding problems occur when we link offsite, whether for advertising, related topics, or complementary articles. These outside links offer no way back to the *Times* site other than via the "Back" button. Part of Web browsing is being able to access something else at any time, instantly. We try to give our pages a unique look, and our logo tells the user that he or she is looking at our pages.

Where do you see the relationship between reader and newspaper headed, and what role does the adjunctive online version play in that?

The newspaper, at least in my lifetime, will always be an integral source for information. The ease of reading it, the convenience of being able to pick it up just about anywhere and take it anywhere, and its in-depth news coverage make it difficult to beat. Television is good for alerting people to late-breaking news and giving them an overview of what's going on. The online version of the newspaper is a bridge between the two, bringing together the benefits of both. We can only hope that the Internet will be more accessible to more people in the future. For that to happen, connections must be sped up and made affordable. We have to be more user-friendly. As the technology and our user base grows, people will begin to see these benefits and will come to rely on us as an integral source for information. That's where we want to be. 💾

Thomas Müller
Razorfish

Thomas Müller received a degree in communication design from the Fachhochschule in Munich, Germany, and then went on to complete a master's degree in graphic design at the Art Center College of Design in Pasadena, California. He is currently the head designer at Razorfish, Inc., in New York.

The four-year program I completed at the Fachhochschule gave me a very traditional design education, especially in typography, as I learned to set type by hand, kern it, space it, open the leading, and so on. This is such an incredible resource and experience to have in one's background. Traditional typography is something you always can lean on in creating many different kinds of visual design.

How do you begin and then work through a new media project?

In the conceptualization phase, I do not see a significant difference between the way I approach a traditional print project and a new media project. What counts is still to clearly define and understand the client's and the project's goals, and then find a unique concept that meets the project's challenges in an intriguing visual way. The process becomes different when I start thinking about which technology is the appropriate one for solving the design problem. This is the time when the concept goes into its second phase and

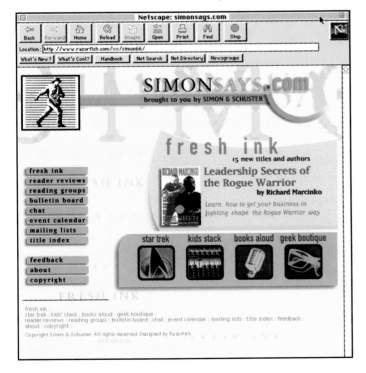

THOMAS MÜLLER'S DESIGN FOR SIMON & SCHUSTER'S WEB SITE PROVIDES A CONSISTENT SHELL FOR THIS BOOK PUBLISHER'S OFFERINGS. THE SITE INCLUDES SYNOPSES AND REVIEWS OF BOOKS, CHAT SPACES, AND BULLETIN BOARDS.

SIMON &
SCHUSTER'S
WEB SITE
EXPLOITS THE
MEDIUM'S
CURRENT
TECHNOLOGIES,
SUCH AS
DOWNLOADABLE
AUDIO FILES
AND UPDATE-
ABLE INFORMA-
TION VIA THE
DEVICE OF THE
SIMON &
SCHUSTER
LOGO.

might change again. The visual design also finds its direction around this point, when the technological path gets established.

You mention the importance of using technology in an appropriate way; do you ever find that you must say to a client, "This would be better suited to a different medium, and not necessarily a digital one"?

Oh yes, certainly, especially when saying so gives me the opportunity to work on a traditional, nondigital project. As I mentioned earlier, my background is in traditional graphic design, so whenever I have the chance to work on a print project, I try to go for it—particularly when the project entails a collaborative effort.

What's most fulfilling about designing digitally?

Despite all the frustrating aspects of digital design, I like feeling that I am helping to define the nature of this medium, establishing it as an art form. In the first half of the twentieth century, photography had to go through the process of establishing itself as a unique, independent art form, not just the craft it was perceived to be. I feel that's where we are right now—on a path to define the medium's independence.

Photography is an interesting example, since it too requires technical proficiency. What are your thoughts on this junction of art and technology?

In a way, every artist is a technologist in his or her method of expression. So it is in the digital

case. As long as technology doesn't overlay artistic inspiration and concept, I think it's a rather normal junction.

Your master's thesis, "Liquid Typography," examined the role of type in a new media environment. Likewise, your project "Understanding Concrete Poetry" [see pages 65 and 89] has a strong typographic emphasis. What are your thoughts on typography as it relates to new media applications?

As my work shows, I have a very strong interest in typography. I love typography as a way to express and enhance content and meaning. The last two years I spent in graduate school I was fortunate enough to study with Simon Johnston and also with April Greiman. Both of them were my final thesis advisers. My master's thesis deals specifically with the issue of what happens to typography and its rules once the medium is no longer static, but is used in a temporal and interactive environment. The body of rules governing the use of typography that have come to be established over the last five hundred years—since the Gutenberg press—must be reexamined so that they can meet the challenges of their new environment.

Please give us an overview of your thesis.

"Liquid Typography" can be summarized roughly like this:

1. Historical overview of typography and reevaluation of terminology used to describe typographic events and form-content relationships.
2. Studies and observations of film from the perspective of a temporal environment.

3. A look at film titles, an initial incidence of typography in time.
4. Study of Karl Gerstner's book *Compendium for Literates*; expansion of his ideas in terms of adding more layers to his morphological systems; development of a four-layered morphological system for a systematic approach to describe typography in a temporal and interactive environment.
5. Series of visual experiments based on the four-layered morphological system; typographic behaviors in temporal situations.
6. Evaluation of these typographic behaviors (basic typographic parameters such as size and spacing plus the element of time) as to how they affect the form-content relationship (here also a case study of concrete poetry).
7. Conclusion: speculations on the future of typography in a temporal interactive environment; effects of a typographic transition on writing, reading, and thinking.

Your work also deals a lot with movement and motion. What does this added dimension bring to the interactive experience?

In a primitive way, it makes viewers aware that they are dealing with something that's different from a static medium. It enhances the relationship between form and content, and opens up possibilities for intriguing storytelling. With regard to typography, I believe elements like motion ultimately will change the way we read, write, and think once we arrive at a typographic form that is similar to my concept of "liquid" typography.

Marianne R. Petit
New Media Artist

Marianne Petit received her bachelor's degree in studio art and education from New York University in 1985, which she quickly followed by earning a master's degree in studio art. She then continued her studies and completed a master of professional studies degree at New York University's Interactive Telecommunications Program. Currently, she works for the nonprofit Fund for the City of New York.

What would you identify as the first influence that sparked your interest in the field of new media design?

After I finished my master's degree, in 1986, I left the country to work for a summer in Italy at the Peggy Guggenheim Collection in Venice. I worked at the Venice Biennale Gardens, at the American Pavilion, where it was my job to guard the Isamu Noguchi slide sculpture and to tell people, in eight different languages, that they had to remove their shoes. The theme of the exhibit, "Art & Science," was my first exposure to the ways art and technology could be combined. I sat in a Brian Eno installation every day during my lunch hour.

From Venice I continued on to Paris, where I worked at an intaglio printmaking studio, Atelier 17, under the supervision of Stanley William Hayter. There, it became evident that printmaking was no longer my medium of choice, and that I was more interested in working with tools that would allow me to create immersive environments and deal with issues of light, color, sound, and time.

After having held many secretarial jobs in the United States and been employed at a computer graphics company in Milan, I attended the Interactive Telecommunications Program at N.Y.U., where I earned my M.P.S. degree.

MARIANNE PETIT DEVELOPS MUCH OF HER IMAGERY USING ANALOG SYNTHESIS OF VIDEO PICTURES. THIS SCREEN IS FROM HER CD-ROM PROJECT *THE MUTANT GENE & TAINTED KOOL-AID SIDESHOW.*

What in particular in your background did you find especially helpful in making the move to new media?

I believe that my background in printmaking has been really instrumental in working with new media, because both genres require that one understand and master a lot of technical skills to work successfully. At the same time, the techniques themselves can become a trap. It's possible to create plates and prints that are technically marvelous, but that ultimately seem static and lacking in life. I think that the same applies to digital tools.

Also, both printmaking and the new media are looked upon and treated as secondary art forms (even though in recent years, this has become less the case with new media works). They do not carry the weight that the "high" art forms, such as painting and sculpture, do—perhaps because of their technical nature, or perhaps because duplication is inherent to them, therefore somehow diminishing the perception of their quality.

New media artworks have, of course, been around for a relatively short time; what do you suppose it will take for new media art to be given the same respect as the so-called higher art forms?

What is it that gives anything "legitimacy"—time? Recognition by the people who are in official places (in other words, curators, collectors, and funders)? I suppose to a degree it's a little of both. After all, where would we be without those people in official places to elevate that which is dominant within popular culture to the status of high art?

Seriously, though, I think that there are a couple of things converging simultaneously. The art world seems to be in a weird place; some call it "crisis." And, people are beginning to see that the new media are not necessarily all about games, megabucks, and advertising. As more people with something to say (and with some talent) create stuff, individual voices within the field of new media art become more visible. At least, this is what I hope for—but then, perhaps I am naïve.

How would you say the computer has altered the way you work?

Added to the issues I was dealing with before—light, color, and composition—are atmosphere, time, sound, and immersion. Those are pivotal issues for me. Recently I've been trying to work with the idea of story and narrative—abstracted in many respects, but following a linear form over time (with beginning, middle, and end). I never would have been able to tackle some of those issues by working with singular images.

Elements of motion, space, and time require a different way of conceptualizing; would you agree? How have you dealt with these issues?

For me, it's a matter of looking at the "big picture" from a general standpoint and developing a basic structure for it. Structure is really the big thing. That gets determined by a few factors: the content, what I see when I close my eyes and picture it, and what tools are available to work with.

Once I draw the structure out, I know that points A, B, and C exist. I have a general idea of how to get between those points. This gives me a big sense of relief and a lot of freedom, because

the structure is still quite loose. I have a lot of latitude in determining what happens in A; perhaps A should really be A-1, A-2, and A-3, or maybe it should also link to points X, Y, and Z. There's a lot of play and intuitive decision making after the basic structure is established.

Would you please describe one or two of your recent projects?

The first such project, *The Mutant Gene & Tainted Kool-Aid Sideshow* CD-ROM, originated in 1993 as a multimedia performance extravaganza that was staged at various New York City venues. It incorporated live and prerecorded video (displayed through multiple monitors and projectors), animation, text, MIDI-sequenced and live instrumental music, dramatic artifacts, and other performance elements. The circus began with the psychodramatic confession of an extraterrestrial being and, from there, journeyed into a series of multicolored entropic video and musical landscapes.

The CD-ROM is a more intimate, nonlinear adaptation of the live performances, with the stage converted into an abstract labyrinth of video, animation, music, and sound.

The second project, *The Grimm Tale (or the story of the youth who went forth to learn what fear was)*, is a Web adaptation of the bizarre Grimm's fairy tale about a young man who does not understand the concept "to shudder in fear," so he goes forth into the world to learn its meaning. The piece can be followed linearly; action is depicted by a series of animations in which characters are represented by handmade puppets, all carried along with a continual MIDI audio soundtrack. As well, there are audience-participatory

sections, in which the viewer can ask questions (for example, "What is your first recollection of shuddering in fear?"), play a "mix & match ghoul puzzle," and take part in a "fear poll."

Describe how you put these projects together.

Both pieces started with handmade objects— papier-mâché masks in *The Mutant Gene*, Sculpey clay puppet heads in *The Grimm Tale*. From there they were videotaped, and the video was then digitized, with audio added afterward.

What particular design challenges did these projects present?

I really wanted them to run on low-tech platforms. I wanted to make sure that the CD-ROM project didn't need a super processor and tons of RAM, and that the Web site would run well over a 28.8 modem and wouldn't require high-speed dedicated access. My work is both graphics and audio heavy, which is a problem in both environments.

For the Web site, I worked a lot with small, looped GIF animations (recycled and resized) and tiled backgrounds, and designed pages with cache in mind. MIDI was used as a continual audio track, in that the files were small and didn't add to download time. I worked with a fantastic Web programmer, John Neilson, who had a million tricks to improve functionality.

You use a lot of analog-based video and sound in your work; where does the digital fit in with that? Do you feel more comfortable in one realm than in the other? And, do you think it is important for an artist working in digital media to have a knowledge of predigital media?

SCREEN FROM *THE MUTANT GENE* CD-ROM. PETIT ADAPTED THIS PROJECT FROM A LIVE MULTIMEDIA PERFORMANCE THAT USED MULTIPLE MONITORS AND PROJECTORS AND COMBINED ANIMATION, LIVE MUSIC, AND DRAMATIC ARTIFACTS.

I like going back and forth between the two worlds, because they both have attributes that make them desirable for different purposes and contexts. For instance, a lot of the video I generate is through analog synthesis, a process I enjoy for its immediacy. I love turning dials and patching cables and seeing instantaneous effects and response. Because of this, I generate a lot of material. I record it all, then sort through it later.

During my residencies at the Experimental Television Center in Newark Valley, New York, I typically generate eight to twelve hours' worth of full-motion, full-screen video with incredible color vibrancy. I do this within five days, which is simply unheard of in the digital realm. Now, obviously the digital realm has its advantages, including random access. I've gotten so used to editing in Adobe Premiere that it's painful whenever I have to do an analog edit. I like the multiplicity of formats to which I can easily port things with simple manipulations. For example, I can take stuff off a CD-ROM, make it smaller to fit on a floppy disk, or make it even smaller still so it can be downloaded easily from the Web.

Does adapting a project for different media formats create problems in terms of the "finished" piece? Do you ever find that you choose not to adapt a piece for a particular medium because of the constraints that medium imposes on the project?

Definitely. And sometimes it gets adapted, with disappointing results. I try not to cling too much to the original piece, though, when I'm adapting it. When you choose to adapt and reinterpret something in another realm, it's going to become a completely different piece, and I try to accept that it has its own separate life. There will always be "losses" and disappointing elements that result from the limits of the medium. On the other hand, there are surprising new elements that come into play as a result of the medium.

My Grimm's fairy tale piece is rather amusing in this way. Its first iteration is as a Web piece. It's very text- and animation-oriented, linear and nonlinear (though interactivity is mostly navigational). It also includes audience participatory areas. The next incarnation of it will be as a live performance piece . . . which will be completely linear, with lots of live elements and a fifty-minute musical score that is not at all present in the Web version. So, while the story is the same in both, essentially the two pieces are so different that they're *almost* unrelated.

There is going to be a transition period during which we will see a lot of work being repurposed for media other than whichever one is actually most appropriate for it. Do you see this as a problem?
Although it's boring, it's probably necessary. People have to apply the methods and metaphors they know first. Then, when they discover that those methods don't work, they invent more appropriate ones. At least, this is what I hope. I've always had this sneaking suspicion, though, that people (in general) might not be all that interested in a lot of the stuff that's being developed today, and really prefer to be entertained (or informed, or whatever) in more traditional formats.

[Video footage for *The Mutant Gene & Tainted Kool-Aid Sideshow* and *The Grimm Tale* was created at the Experimental Television Center, whose programs are supported in part by artists' contributions and by public funds from the New York State Council on the Arts, the Ohio Arts Council, and the National Endowment for the Arts Media Arts Development Fund. *The Grimm Tale* is a 1996 commission of New Radio & Performing Arts, Inc., doing business as Ether-Ore for its Turbulence Project. Its creation was made possible with a grant from the Jerome Foundation.] ⚲

SCREEN FROM *THE MUTANT GENE*. THE DISK INVITES THE USER TO EXPLORE ITS VIDEO, ANIMATION, AND MUSIC FEATURES IN A NONLINEAR FASHION.

Liz Powell
New Media Design Consultant

Liz Powell received a B.F.A. in graphic design and spent the first six years of her career designing print and identity projects for retail, performing arts, and corporate clients. She spent the next thirteen years at Sony, first developing the firm's U.S. graphic design group, then managing and eventually directing its U.S. design center. She spent her final two years at Sony's licensing and merchandising startup, directing graphic design for its products, retail, marketing, and print collateral.

How did you get involved with new media?

Sony's licensing division made heavy use of interactive presentations, CD-ROMs, and a Web site to sign artists and properties and to sell its products. I found the new media work the most interesting, and was lured away to work at iGuide for a year. I am now consulting on new media design projects and design management; right now I'm working with Time Inc. New Media on the redesign of its Web site Pathfinder and some of its constituent sections, as well as the logo/branding system.

Where do you see design fitting into the greater process of assembling a new media project?

I see it as an integral part of new media project development. Designers have skill as "big picture" thinkers about how people use and perceive products, and can contribute greatly to formative discussions about them. Designers are more often known for creating interfaces, graphics, and identities in new media projects, but I think projects benefit from including them throughout the entire process, from concept development to marketing the final product.

How do you balance the needs of design with those of, say, marketing, programming, and other aspects of project building?

Ideally, the writers, programmers, designers, marketers, and other professionals involved in a new media project should contribute equally, debate and resolve their differing points of view in ways that strengthen the end result. In practice, everything depends on the chemistry of the team members, their attitude toward one another, the relative dominance of various members, and on who leads the project.

The best way to balance the needs of the various players is to have the good fortune of a project leader who gets the team members working together, listens well to everyone in the group, and makes sound judgments based on a deep understanding of the ultimate consumer of the new media product. In practice, however, a project leader can skew a project toward his or her own area of expertise or point of view at the expense of other components. Another way to achieve balance is to recruit a *sympatico* team of people who are respectful of one another professionally and secure enough to know how to arrive at good solutions together rather than divisively.

In my experience, two very different scenarios can result in great products: a team process in which the members have lively, constructive debates and resolve differences in ways that make the product better; and a process dominated by one visionary leader with a strong point of view who directs all of the contributors' efforts.

How easy or difficult is it to incorporate company identity into new media projects?

The more closely a company is identified with things buyers *want* from new media, the easier it is to incorporate that company's identity into the product. *Wired* is a popular magazine for the new media audience, so HotWired is a popular Web site; the brand-name carryover is important. Some company identities don't mean anything to the new media audience. People don't go to a movie because it was produced by Columbia Pictures, and they won't flock to new media because of the Time Warner, Hearst, or News Corporation name (unless it's for professional reasons).

The firm's early track record in new media makes a huge difference as well. For example, I bought one of Compton's early multimedia encyclopedias and was very dissatisfied with it; I now have a certain distrust of all their products. So, one of the pitfalls of marketing a less than glorious product with a well-known company identity is that it may forever taint the unhappy consumer's perception of the firm's primary goods or services. On the other hand, brand identity can draw a larger audience to a company's product and therefore make or break it. It's tough to quantify the impact company identity and new media have had on each other—I suspect that none of the new media products other than software, hardware, and telecommunications have yet delivered huge profits to any well-known firm.

You've overseen design teams in different work environments; is there any distinction between the print media and new media models?

I think work models depend more on the spirit of the particular company and the individuals running it than they do on the specific industry or medium.

Design has been a fully respected collaborator, codeveloper, and often leader in product development at companies in a wide variety of industries—Sony, Apple, Black & Decker, Nike, *Wired,* and *Rolling Stone,* just to name a few. But there are as many examples of companies where design is confined to the "pair-of-hands" execution of the vision of marketing, engineering, editorial, programming, or buying departments.

I don't consider myself an expert in the work models of print media companies; I have more firsthand experience with consumer electronics, computer, and software companies. I have heard from fellow designers over the years that some print media companies are driven by writers and editors, while others are based on a more collaborative approach between design and editorial.

Perhaps it's wishful thinking or hubris on the part of graphic, interface, and industrial designers to believe that companies are most successful when they look upon designers as being equals in the product development process. We always point to examples like Apple Computer. I can't really ignore the fact that companies like Hewlett-Packard, Microsoft, and News Corporation that have not appeared particularly attentive to our design disciplines in the past are hugely successful nonetheless, and their products are everywhere. They have been driven by design in a much broader interpretation of the word—engineering design, programming design, design "appeal" to an apparently broad spectrum of the newspaper-reading public.

Kyle Shannon
agency.com

Kyle Shannon is a principal at agency.com, a New York–based firm specializing in Web design and marketing.

With the underpinnings of the Web and its various protocols changing so rapidly, how do you approach Web design?

Very carefully! It's actually pretty simple, though. Like most good design, it isn't really about which tool you use, but what ideas you have. It's the same with technology. It's a tool. It just happens to be a tool that isn't very stable and redefines itself every three months.

So, the first thing I do is ask the difficult questions: Why? What are my (or my clients') goals? Who is my audience? What am I trying to accomplish? Once you have "the big idea," it's then just a matter of figuring out which technology best suits your needs and goals. There is a rampant misconception that because this is a technological medium, it's about the technology. It really gets down to which technology can help you realize your big idea best. It may be Shockwave

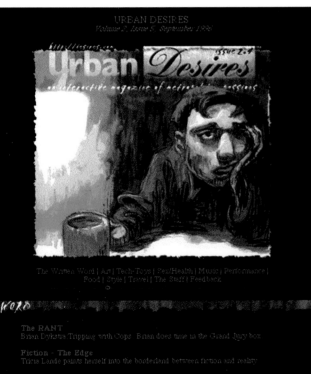

KYLE SHANNON'S *URBAN DESIRES* IS PERHAPS THE ORIGINAL WEB-BASED MAGAZINE TO EXPLORE THE POSSIBILITIES OF THIS NEW MEDIUM.

[Director files created to run over the Web]. It may be Java. But it's also very possible it may be PRE text on a gray background [monospaced fonts on the default background color of the browser]. Anything beyond what you truly need is gratuitous and inconsiderate of users who are paying for connect time to see your site.

In other words: Start with the idea, and the rest will follow.

Many multimedia designers are concentrating on Web design, leaving CD-ROMs and other media behind. Do you foresee a time when some other new medium will eclipse the Web?

It's possible, but whatever it is called, I think it will still be about humans connecting through a network. The genie is out of the bottle. CD-ROM is challenged as a medium because it is static and requires a distribution deal to get something out on any scale. The idea of instant, global, dynamic distribution of bits is here to stay. I certainly think the nature of what we (as designers) do on this thing five years from now will be radically different from what it is today, but it will be an evolution rather than a displacement. The good news for all the CD-ROM developers is that their skills are increasingly usable as the medium matures. We're all pixel mavens deep down.

What do you find most fulfilling about Web design? What do you find most frustrating?

The most fulfilling thing about my experience with Web design is that I didn't plan it. How could anyone have? I have a degree in acting, and yet I am more creatively fulfilled than I have been in a long, long time. For the first time in my life, my "day job" and what I enjoy have merged. Realizing that

ideas can be shared with a huge potential audience almost instantly was a true epiphany.

What I find frustrating is designers who don't acknowledge the Web as a unique medium. There is so much untapped potential, even given current limitations, that it makes my head spin. And yet I see the same navigation models, the same information design, the same interfaces. This is a deep medium that we have only scratched the surface of understanding. Too many people think they have "solved it," just because they did one site that worked. Everything from that point on is derivative.

If ever there was a medium to reinvent every single time you do it, this is the one. My instinct is that there is a twelve-year-old somewhere out there who innately understands the potential of this medium, and when he or she does something that seems obvious, it will, to the rest of us, be revolutionary.

You were there for the early days of Web development; any reflections on where we've been and where we are going?

Yes! We have come a tremendous way since the birth of the industry. It is remarkable. However, there is a shocking—though probably natural— lull in creative thinking because a lot of people believe it is too late for them to "get in." Wrong! There are twenty to thirty years of discovery ahead at a minimum. Those who recognize that and keep questioning what is accepted will be the D. W. Griffiths of this medium. The rest will be forgotten. It is only with a blank, open mind that one can succeed. Where we are going is to a place no one has ever been. Only those looking forward will get there. ✍

Peter Spreenberg
IDEO

Peter Spreenberg works at IDEO San Francisco, where he designs information, imagery, and entertainment for print, broadcast, online, and interactive media.

Before entering the new media field, did you begin as a traditional graphic designer?

I learned to use a lot of technology that is probably a bit hard to find these days, like Photostat machines, typesetting equipment, illustration board, technical pens, and so on. Most of this stuff has been replaced (sort of) by digital equipment. My "crafts" training has been made somewhat obsolete, but my "design" training is still intact and useful. I would hope that this recent shift in form-making technologies has reminded all of us how important an underlying problem-solving structure is to the design process.

Did your background prepare you adequately for working in a digital environment?

Computer Science 101 was required when I was in school. I think one of the basic underpinnings of digital technology is logic (a human invention, after all), so if you understand logic, or if thinking logically is natural for you, then digital technology can be quite satisfying to use. But most of us don't always think logically or procedurally; for times when free-form thought and conversation are most appropriate, computers are still crude.

Has working digitally had an impact on your creative process?

When the design community first adopted computers, there were pronouncements that these machines would reduce a designer's workload, make him or her more creative and productive. We all know now that this is not the case. We may be more productive than we used to be, but I think it's because we're all working harder.

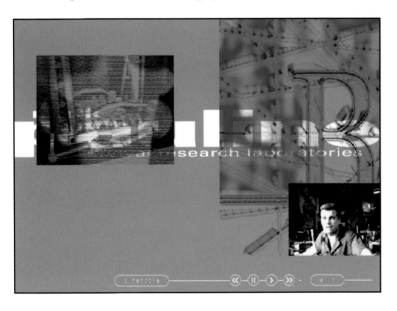

PETER SPREENBERG'S *BAY AREA ART, RANDOMNESS, AND TECHNOLOGY* (BAART) CD-ROM, A SCREEN FROM WHICH IS SHOWN HERE, IS A COMPILATION OF INTERVIEWS WITH SAN FRANCISCO–BASED INNOVATORS DISCUSSING THEIR WORK. IN AN EXPLORATORY USE OF DIGITAL MEDIA FOR DOCUMENTARY PURPOSES, THE ELEMENTS OF THE INTERVIEWS ARE PRESENTED TO THE USER IN RANDOM FASHION.

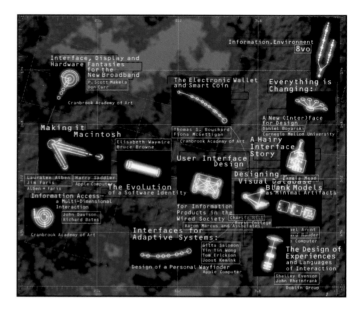

IDEO's interface design for *Interact Journal*, an annual published by the American Center for Design, presents a pervasive and always accessible entrance to the diverse interactive presentations contained therein.

One of the most interesting and, at the same time, frightening, aspects of all this digital stuff is how much it has affected us humans. Digital artifacts have so permeated our lives that our behaviors have adjusted to them in very subtle ways. I think many of us have learned by necessity how to think logically and procedurally. I believe we've adapted to machines more than they have to us.

What is most fulfilling, and most frustrating, about digital design?

A very fulfilling aspect of digital design is its immediacy. Designers now can view the final results of their efforts almost instantly. Also, publishing on the Web gives us immediate access to large audiences. The most frustrating aspect is the technology itself. Installing and maintaining this stuff can consume a large part of your day. How many hours have we all wasted trying to connect incompatible SCSI devices, for example?

Tell me about the American Center for Design's *Interact Journal.*

The American Center for Design, a national organization of design professionals, educators, and students, publishes an annual on CD-ROM of articles and essays devoted to a specific design-related theme. Thirteen practitioners, educators, and students in interactive design were invited to submit text articles and interactive pieces to the 1994 issue; IDEO was asked to edit the journal and produce an interactive component.

What were the specific design challenges?

The intended audience for *Interact Journal* was designers, and it was felt that the design of the project had to appeal to this highly critical and visually sensitized group. The primary objective was to make the interface engaging and provocative, and to require of the user only minimal familiarity with the Macintosh interface.

The contributors submitted material for the interactive portion of the journal in a variety of formats, based on our very loose guidelines—Mac-compatible, eight-bit color, 640 x 480 screen resolution, Director-based. We digitized, animated (where appropriate), and edited these pieces into more complete presentations.

The main challenge was to present interactive work in an editorial context and maintain a nonintrusive layer of commentary or annotation. Unlike the interface conventions of print media, in which peripheral information and navigational controls are familiar and essentially transparent to the audience, the shell interface for this project had to have a consistent control and interaction scheme applied as a secondary layer to many diverse interactive works. This layer had to be pervasive and accessible throughout the publication, rather than isolated in a discrete location as in print media. Additionally, the control layer had to be invisible when not in use and could not intrude on the content. Another goal was to create an interface that would invite exploration and discovery, where the content was not immediately accessible, but allowed the audience to search around a bit, to have fun.

The journal's table of contents is a unique navigation scheme: content is represented as a map or information space. Only a small portion of the entire map is visible at once, but moving the cursor to the edge of the display causes the map to scroll continuously and allows the audience to navigate about the space. Each article is represented as a site on the map. The design or shape of the site image vaguely reflects the structure of the associated interactive piece (hierarchical, networked, linear, etc.). This gives the audience a subtle preview of the piece, making navigation obvious but transcending print conventions.

I'm interested in your thoughts on navigation in new media "spaces," especially because your work breaks away from borrowed print paradigms; are you consciously moving away from previous ways of marking information spaces?
Obviously we want to design appropriately for a specific medium. Simply moving a publication from print to an online format without modifying anything is not especially brilliant. Digital media allow nonlinear structures, including new ways to send and receive information that are not bound by time or space in the traditional sense. The big question is, though: Is there anything better, more useful, or more satisfying about these new forms of communication, or are we just making this stuff because we can?

For years we've been hearing that there's nothing good in new media. But the same was said about television when it was first introduced. Some really fascinating things are happening in digital media, but we should not evaluate them by comparing them to familiar media. No, these recent new media offerings probably aren't things you would want to sit in front of for hours—but perhaps that's not the best way to judge them. Maybe a new medium has new audiences and new perception behaviors as well.

Can you describe the way you search for a navigational paradigm?
Like most forms of design, this is where the "magic" is. If I were to tell you how it's done, I'd be lying. I don't know where good ideas come from, I only know a good one when I see it. ⌨

Janet Tingey
Macmillan Digital

Janet Tingey received an undergraduate degree in illustration from the Rhode Island School of Design in 1980. She worked as an illustrator in New York, then as a book designer and art director for ten years. She continued her studies, earning a master's degree at N.Y.U.'s Interactive Telecommunications Program.

Has your background in graphic design proven important in your new media work?

My background gave me a good understanding of how information must be structured visually; a good design supports a hierarchy of information and presents it in a way that makes the structure of the content invisible but coherent to anyone wanting to use that information. Basic design concepts seem critical to new media design, which is all about structuring information in a way that lets the user work seamlessly and easily through a path to get what he wants.

Are there major differences between how you work digitally and how you worked in print?

The biggest difference is in the tools. Designing for print, I worked with paper, Xerox machines, tracing paper, and other traditional materials. I purchased a computer for designing books, but immediately started messing around with HyperCard. Within just a few months I produced amateur multimedia products. Interestingly, acquiring my first computer triggered my move to new media. But I still rely heavily on paper and pencil to thumbnail ideas for both print and new media design, primarily for speed and flexibility.

The second biggest difference is in the broadening of my responsibilities. In new media, job descriptions are less tightly defined, so I work more with the editorial structure of the information than I did in a well-established print industry, where information was by and large structured and prepared by editors and production editors. In new media, by contrast, "producers" and "project managers" don't have good editorial skills, and don't always understand the best way to prepare information for presentation. So, when I'm working with "nonprint" people, it has become crucial to help them structure their information in a coherent hierarchy that supports the content.

In print, a lot of what is now referred to as "interface design" was handled by editors. I think of interface design as a two-part process: first, organizing and structuring the information into categories that make logical sense; and second, structuring the functionality of an interactive product. Both processes, at least in book publishing, are handled by an editor and author, who together determine the chapters, the organization of the information within them by means of progressive levels of subheads, and the need for, kind, and placement of any illustrations. In addition, an editor makes decisions about a book that have to do with the way it's used: for example, whether or not to have an index, what copy should be included in running heads or feet to provide the easiest access to the information, how detailed the contents page should be.

My experience with new media has been that the designer, working in conjunction with a producer, tackles these tasks, which is why I think it's critical for designers to have a clear understanding of information design and structure as

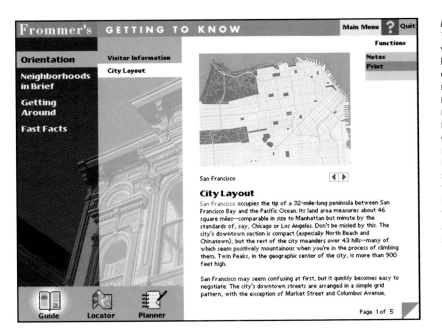

San Francisco

City Layout

San Francisco occupies the tip of a 32-mile-long peninsula between San Francisco Bay and the Pacific Ocean. Its land area measures about 46 square miles--comparable in size to Manhattan but minute by the standards of, say, Chicago or Los Angeles. Don't be misled by this. The city's downtown section is compact (especially North Beach and Chinatown), but the rest of the city meanders over 43 hills--many of which seem positively mountainous when you're in the process of climbing them. Twin Peaks, in the geographic center of the city, is more than 900 feet high.

San Francisco may seem confusing at first, but it quickly becomes easy to negotiate. The city's downtown streets are arranged in a simple grid pattern, with the exception of Market Street and Columbus Avenue,

Page 1 of 5

FROMMER'S INTERACTIVE TRAVEL GUIDES, CD-ROM VERSIONS OF THE FROMMER'S PRINT GUIDES, MAKE IT POSSIBLE FOR USERS TO BROWSE INFORMATION RELEVANT TO THEIR DESTINATIONS AND CUSTOMIZE WHAT THEY NEED TO PLAN A TRIP EFFICIENTLY. THE SCREEN SHOWN HERE ILLUS-TRATES A CITY MAP, USING AN INTERFACE THAT LAYS OUT AVAIL-ABLE OPTIONS CLEANLY AND LOGICALLY.

well as a good knowledge of traditional graphic design and typography. But now I find a blurring of that process, as new media producers come from a wide variety of backgrounds and do not necessarily understand information presentation structure—what I call interface design—in the way that writers, editors, and production editors do. It seems critical for new media designers to have a good understanding of content structure as well as the visual tools to reinforce the hierarchy inherent in that structure. What remains the same is that the concepts of good design apply regardless of the delivery medium.

Does the medium for which you're designing— interactive TV, CD-ROMs, or otherwise—influence the way you work?

The delivery medium definitely affects the design, just as it does in traditional media. For example, the way I'd design a book jacket would depend on the kind of paper and lamination to be used. And a poster is designed differently from a book—different constraints apply, so different design methodologies must be employed.

In the same way, new media design is influenced by the delivery structure. An interactive TV design has to accommodate infrared remote or corded remote technology—which, at best, is difficult to control. So, hot spots [areas that when clicked on produce some effect or change] have to be bigger to give the user a larger target area in which to make choices. Plus, video color constraints apply—for example, there are no hot reds, and yellow looks like mustard. All these things affect the way the final product looks. And, with interactive TV, motion can be employed as a design element much more easily than it can on the Web or a CD-ROM, which makes for a new, fun

THE *FROMMER'S GUIDE* CDs CROSS-REFERENCE INFORMATION SO THAT USERS CAN EASILY TAILOR ITINERARIES AND MAPS THAT ACCORD WITH THEIR TRAVEL PREFERENCES.

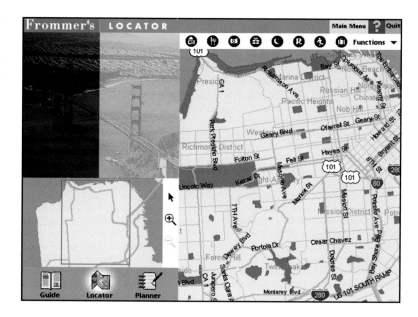

element that was unavailable to me in traditional media, even in other forms of digital media. Web design requires a reduced bit depth, which reminds me of designing two-color versus six-color print jobs. In CD-ROM design, hot spots and type can be smaller than in ITV, because the computer screen has greater resolution than video.

The permanence of the final product also influences the design approach—no less true of traditional design, but worth mentioning in this context. An interactive TV design or a Web page has a life that can be as short as a day or a single broadcast, whereas a CD-ROM has a shelf life of whatever—a millennium or so. Therefore, I can play around and experiment more with products that have a shorter life; it doesn't matter so much if the design reflects the typeface *du jour*. For a CD-ROM, I generally try to create a design that will last a bit longer, since one hopes that the product will be in use for more than a day.

Do you prefer one medium to another?
I don't, actually; each medium has its advantages and limitations. One thing that makes design fun is solving problems within different parameters to make the best use of a given medium.

Do design solutions in one medium carry over to the others at all?
Those that have to do with information hierarchy seem to apply across media. What I like a lot about the new media is that they are consistently more visual than what I have done in traditional design. It's fun to find visual solutions to problems that I would have solved differently in print.

You mention the added factor of motion in interactive TV design. What problems does this fluidity present to the designer?
Essentially, motion is just one more element to consider in the gestalt of a design. So, all of the

same questions that must be answered about any design element have to be applied to motion: for example, Is this gratuitous? Does it add to the design? Is it distracting? Does it support the message? Is it generating the appropriate tone for the work? Solving all those problems is fun. Plus, things that move are cool! It never fails to amaze me that people will stare at a television screen anywhere. We have a television in our office lobby, and even though I don't watch much TV, whenever I have to wait in that space I find myself staring at the screen because things on it move. This makes me realize what an extraordinarily powerful design element motion is; the challenge it presents is to find ways to use it appropriately.

Does the ephemeral nature—the limited shelf life—of all digital design make your work in new media any less fulfilling than, say, book design?
One reason I got out of book design was that I never felt my contribution was terribly meaningful, as people seem to read and enjoy badly designed books almost as much as, if not just as much as, well-designed books. New media work is fulfilling for me because it is inherently more visual, and because I contribute more to the editorial process than I ever did in print. I have the sense that if I don't do my job well, a user might not be able to get what he or she wants out of a given product. There's also what I think of as the community aspect of new media design, meaning that I can contribute to products that actually help people work together better, communicate more efficiently, develop interests, learn, and expand themselves. This is the warm and fuzzy side of new media design that put stars in my eyes as I began to learn about its possibilities.

The actual longevity of a product is not that important to the satisfaction I get from my work; in fact, that question had never occurred to me.

Is there anything you miss about print design?
High-resolution type, and knowing exactly how a design was going to look, no matter who saw it. None of this "Oh, well, it looks terrible in the AOL browser, but great in Netscape Navigator," or making allowances for radical variations in appearance from video monitor to video monitor.

Do you foresee the day when new media design won't involve this "moving target" approach?
Only in my dreams.

You mentioned various roles you've taken on in new media that in print design would be separate jobs. Will these responsibilities become part of the designer's job description?
I see the roles in new media evolving more than those in traditional design, but I think it will be a while before they are clearly defined and the industry settles into procedures that work in a fairly standard way. Everyone entering new media design applies his or her own model—book publishing, film production—so the same job can be called a wide variety of things.

One trend I see developing is a division between interface designers and graphic designers. Interface designers tend to determine functionality, while graphic designers tend to focus on the screen's appearance. It doesn't take good Photoshop or Illustrator skills to work out functionality; actually, I know people with nondesign backgrounds who make great interface designers. However, putting graphics on a screen is best

left to someone with an eye and innate design talent. There can be total overlap here, but it's usually graphic designers who overlap into interface design, rather than the opposite.

Tell us about Macmillan Digital's *Frommer's Interactive Travel Guides.*
They're CD-ROM travel guides based on the successful print guides. The goal of the CD-ROMs is to give the user the ability to look at and get a feel for a specific destination, and create a custom itinerary using planning and mapping tools.

What challenges did you face with this project?
The biggest challenge was to incorporate the complete text of a print destination guide with enhancements the CD medium allows, such as videos and photography to give a sense of place, plus an itinerary planner and a mapping tool so you can compare various listings within the guide. For example, if you choose a particular hotel in a city, you can go to a map that shows its location, then display nearby attractions you want to see and restaurants where you might want to eat. You can then print all of this—customized maps, itinerary, listings—and leave the guide at home, taking with you only the information you decide you need for your trip. Such customization is an advantage for travelers like a friend of mine who, to reduce the weight of his guidebook, would tear out the pages describing spots he'd already visited!

What advice would you offer a seasoned designer or student looking to work in new media?
Think critically! Ask *why*—why this color, why this response to a mouse click, for example. At every turn, if something about a design is troublesome,

listen to the little voice within and resolve it. Also, listen to feedback from novices. Participate in user testing. Remember that a design should support and serve content, that its tone should reflect the content's tone. Remember most of all that design is a service industry, and that it is not content.

What is most lacking in the education of designers and artists who want to move into new media?
Artists and designers who have worked in print or paint generally are not familiar with the constraints a computer imposes. With regard to the resolution of the delivery medium, paper is at the highest end of the spectrum, while a computer screen is at the lowest. Designers must make the adjustment on these terms: How much information can be displayed at a given time? How many choices should be offered to a user? How should typography be handled? The implications here are twofold. On a macro level, a designer must understand that information that previously could be displayed on one page or in one image may now need to be broken into segments for display on several screens. And on a micro level, a designer must realize that the level of detail that can be displayed is greatly reduced on a computer screen. Maps are a good example: it is impossible to scan anything but the simplest print map and get a result that will be stunning on screen, because fine detail won't reproduce. Maps must be created from scratch for screen display, with the designer keeping in mind the limited number of pixels that can contain information.

Designers whose backgrounds are based on print or still images must also learn how time functions in new media, and how to consider it as a design element.

David Vogler
Disney Online

David Vogler is currently the vice president and creative director of Disney Online, where he is responsible for the design, content, and creative direction of the company's online service for kids. Before joining Disney, Vogler was the executive producer and creative director of Nickelodeon Online. He produced and launched all of Nickelodeon's online efforts on America Online, as well as various Nick at Nite Web sites. He has also designed projects for Jim Henson Productions, Children's Television Workshop, and Marvel Comics.

What particular problems come to the fore in designing for children?

The most obvious issue is being sensitive to the levels of reception that are appropriate for kids. The demographic that is simplistically labeled "kids" is actually an incredibly diverse one. The difference between a seven-year-old and a ten-year-old child can be immense in terms of reading level, attention span, motor skills, typing ability, and cultural preconceptions. As a result, a certain degree of focused customization is required in designing for kids.

Another is attitude. Most stuff made for children is rather condescending and conceived with broad strokes. This is because it's usually made by adults who think they know what kids want, and thus second-guess their tastes. Most content for adults assumes that the audience has a pre-existing set of baggage, but for kids, it's the opposite. Their degree of open-mindedness and sense of play can inform the design process. I find most recent design for children dishonest and interchangeable. Kids are far more aesthetically savvy than grown-ups give them credit for. Don't get me wrong, I howl at a good fart joke just like anyone. But gratuitous scatological humor, arbitrary bright colors, and crude typographical treatments don't necessarily make for

DEFYING LIMITATIONS IN BANDWIDTH, NICKELODEON'S AREA ON AMERICA ONLINE, WITH ITS BRIGHT COLORS, 3-D VISUALS, AND GRIDLESS LAYOUT, RISES ABOVE THE MEDIUM'S CONSTRAINTS.
© 1995 NICKELODEON

smart kids' design. Every creative decision should be made with a sense of purpose and contribute to a greater whole. Design for children should never be a "dumbed down" interpretation of the adult version. In fact, I believe that anyone designing and creating content for kids has an obligation to set the bar higher.

What benefits do you think the new media offer to children?

The new media have certainly raised the stakes in a lot of big ways. The best example of this is what I call the three *N*s—that is, Nintendo, Nickelodeon, and the Net. The spirit and product manifestations of these three "platforms" have defined today's children as well as their taste for content better than anything else on the planet. It's a new media trilogy that stands to explode the kid zeitgeist, and I'm proud to have worked with all three. Today's kid audience is weaned on the smart fun of Nick, the fast-paced twitch of Nintendo games, and the instant empowerment of the Web. Because of this, children's expectations are increasingly hyperwired, and there's no end in sight.

One of the most unique benefits of the online medium is that it gives children a tangible degree of power. Being a kid in an adult world is a pretty crummy situation. Kids are condescended to, are often treated with little respect, and are constantly at the mercy of The Adult Machine (which for grown-ups, might be a bit like working for a giant corporation, I suppose!). The online medium, specifically, is the first to have given kids a global voice. It's a place where they can truly stand up and be heard. It's a great social equalizer in the sense that regardless of what age you

are, everyone is the same when reduced to bits and pixels. Better yet, online provides the ultimate kid empowerment. For example, in reality a kid might be beaten up on the playground, but when he comes home from school and logs on, he can be anyone he wants. In these terms, online and new media offer children the benefits of being potent catalysts for fueling their imaginations. For obvious reasons, the online experience can offer the young user a far richer creative experience than vegetating in a beanbag chair and watching *Smurfs* reruns.

On the other hand, what are the pitfalls?

If one of the cores of "new media" is defined as nonlinearity, then the most immediate benefit is choice and participation. But this can be either a blessing or a curse. I've heard this issue debated many times over the years, and the jury is still out. No one denies the validity of interactive entertainment and new media. But frankly, some forms of content are best executed the "old-fashioned" way, with a beginning, middle, and end. Sometimes it's better not to give the user too many choices, but to simply provide him or her with the discovery of an unfolding narrative that can't really be controlled. There are timeless storytelling and communication paradigms that have been working since the dawn of man. In these cases, new media should serve to enhance, rather than replace, the art of effective linear communication. The flip side is that kids' new media actually do live up to the hype. They should be used to enhance the kid experience and take advantage of its unique, intrinsic qualities. The only danger is in evaluating the new media with old criteria. ✒

Iromie Weeramantry
The Chaos Project

Iromie Weeramantry has been a visual artist for more than twelve years, dabbling independently in fine art and computers before finding a synthesis of these two disciplines in digital painting. She has exhibited both traditional and digital paintings, but considers herself primarily a designer, a visual problem solver with professional roots in advertising and editorial design.

How did you enter the new media environment?
I've always enjoyed multidisciplinary activities. The digital revolution has changed the nature of design to include a wider range of skills, and this greatly appeals to me. It's now possible for an individual to bring design, writing, musical, and video skills to the table and synthesize them into a coherent whole. This freedom is empowering.

The digital revolution has also made it necessary for the designer to become technically savvy, absorbing bodies of knowledge that were once the responsibility of specialists. My first transition into the digital world involved learning the technicalities of digital prepress, formerly the province of professional color separators.

Print designers eventually were required to assume digital prepress skills; what such disciplines must a designer of new media consider?
A basic understanding of time-based dynamic art forms such as animation and filmmaking; the role of audio; basic principles and potential applications of new media–related programming languages; current technologies and the limitations they impose; and effective ways to write for the screen.

How important is it to master other disciplines?
Since new media projects are often collaborative efforts, what's most crucial is a solid understanding of the greater issues involved. A cross-disciplinary knowledge base can facilitate team

THE CHAOS PROJECT CD-ROM IS A FANTASY ADVENTURE GAME THAT, THROUGH INVENTED 3-D WORLDS, LETS USERS EXPLORE CONCEPTS OF CHAOS THEORY.

VISUAL MOTIFS TAKEN FROM CHAOS THEORY (SUCH AS THE MANDELBRÖT SET USED HERE) WERE IMPLEMENTED IN THE ENVIRONMENTS PRESENTED TO THE USER.

communication and give the designer the necessary "bigger picture" of the overall project.

Is there a difference between how you work now and how you worked previously?

My initial concepts are still arrived at away from the computer—on paper, on restaurant napkins, while riding the subway. Once I touch the computer, however, curious things happen. While I like to think of the computer as just another creative tool, I have come to recognize in it an element of randomness that sometimes can lead me in unexpected visual directions. I often find that in the digital realm there's a greater leap between starting and ending points than in the nondigital realm. This phenomenon has partly to do with computing power that allows for quick and easy experimentation. The time costs of such experimentation in nondigital media is far greater.

I've also noticed a tendency, because the computer allows such precision, that I arrive at a finished design at an earlier stage than I would in a more traditional medium. The finished quality of the design can then lock me into a visual direction prematurely, especially if a client interprets it as finished. Another danger in having so much freedom to experiment is that it can present infinite possibilities to the designer as well as the client, resulting in endless changes that are often aesthetically inconsequential but expensive.

Many people do their initial work away from the computer. What does this say about how the computer relates to the creative process?

The computer extends, enhances, or even triggers the creative process more often that it initiates it. This is because conceptual thought generally occurs in the recesses of the mind or imagination.

The computer can enter the creative process at a later point and influence it, sometimes in unforeseen ways. It can also be a very efficient tool in the execution phases, but it's not as efficient in the conceptual, brainstorming phase, because it can't make the types of powerful, personal visual and verbal associations the human brain can.

What is *The Chaos Project*?

It's a fantasy adventure game on CD-ROM that introduces the user to chaos theory (which attempts to explain the order hidden in the irregularity of the real world) in an entertaining and visually compelling way. The user advances through nine 3-D–rendered environments by solving chaos-inspired puzzles. Further chaos-related information is presented in a PDA device that's accessible along the user's way.

What design challenges did you face with it?

Chaos theory is not conceptually intuitive, so the whole production team read a lot of books on the subject. We were then able to develop meaningful interface ideas and visual motifs. One of our goals was to present the content in a way that takes advantage of the medium's interactivity. We therefore extracted aspects of chaos theory that lent themselves to time-based demonstrations.

An important content-related challenge was to find ways to present chaos theory in an engaging yet accurate fashion, to find the right balance between entertainment and education. What was seen to be the right balance changed during the course of the project, and this shift had significant design implications.

The biggest creative challenge we faced was to come up with a fictitious world that would be both recognizable yet quirky. For instance, we had to invent chaos-inspired instruments that would look like real, but not identifiable, ones. The visual detail necessary to lend credibility to this world was a constant challenge, requiring high levels of imagination as well as a great deal of picture research and custom texture creation, involving close collaboration among designers, 3-D artists, writers, programmers, and video personnel.

What were the successes and/or failures of this project?

The Chaos Project succeeded in marrying scientific content with an interactive and visually interesting game interface. The final product would have been improved by a better-defined work process. Creating a CD-ROM was a new experience for many members of the team, a journey without familiar guideposts. For instance, much completed design was discarded due to changes of direction. More attention spent on content definition, storyboarding, and other structuring techniques, along with the establishment of a clear approval process, may have saved resources later on.

Do you have any advice for design students looking to move into new media?

Bring along your design knowledge of typography, layout, color theory, and so on, since much of it is applicable. Come up with new strategies for dealing with the time-based aspects of digital design, and for dealing with radiant rather than reflective light. Study constantly evolving technologies. Invent an effective work process. Don't let visuals overpower content; design should reflect content and address an identified audience, or the final product will not be effective.

RESOURCES

nderstanding the new media is not as simple as reading a single, authoritative sourcebook. Keeping abreast of the advancements through school courses, magazines, newspapers, many books, Web sites, Internet newsgroups, and digital design organizations is useful, even mandatory. This chapter is a compendium of valuable information that includes listings of undergraduate and graduate academic programs in digital design; advice about where multimedia jobs are available today; lists of relevant professional and special-interest organizations and publications (both online and in print); a glossary of computer terms; and more.

Okay, we're not talking about brain surgery here. But information about the new media changes even more frequently than what appears in medical journals. Once you've learned the basics, heard what the experts have to say, and tested the waters yourself, surf the materials recommended here to gain an understanding of this quickly changing field.

WHERE THE JOBS ARE

The path a graphic designer takes toward a new media career is often as experimental and unpredictable as the new media are themselves. As in the early days of desktop publishing, when pioneers working in PageMaker and QuarkXPress were paid top dollar for their skills—only to be replaced by graduating students without experience but willing to work for less—multimedia designers today find themselves in great demand, yet face a rollercoaster ride in terms of training, education, and career.

Finding work in the multimedia industry can be a daunting task, mostly because the job titles and descriptions keep morphing. Different industries follow different business models; a television broadcasting or movie-oriented business might have job listings for "producers," whereas a publishing-oriented business might ask for "editors." The confusion only deepens, as start-ups and budget-strapped corporations require the members of their multimedia teams to wear many hats.

For a while, the smart money for places to work in this field was on the San Francisco Bay Area. Since nearby Silicon Valley was already a computer-industry hot spot, it made sense to locate with the technical wizards. New media companies set up shop in the Bay Area as well as in Silicon Valley and San Diego. In a similar evolution, farther up the West Coast, Seattle is home to Microsoft and Nintendo, as well as countless start-up companies that work with these giants and on their own.

It was only a matter of time, however, before the pendulum would swing away from the technical and back in the direction of content, which many feel is the driving force of this industry. Los Angeles and the entertainment industry, and New York City, with its concentration on publishing, advertising, and television, were slow to move but have since caught on. Concentrated along the Northeast Corridor, from the greater Boston area (especially along Route 128 and in Cambridge, thanks to M.I.T.) to Washington, D.C., businesses such as Nynex, Bell Atlantic, AT&T, and America Online, just to name a few, create a multimedia overlay to the existing megalopolitan infrastructure, with signs that this growth might extend to Atlanta and Miami. Synergy between universities and technology corporations is also felt in other parts of the country, such as Austin, Texas, home to the University of Texas as well as Motorola, Texas Instruments, and many other such firms. Pittsburgh, too, with Carnegie-Mellon University as a resource, is moving into high-technology industries.

This is not to say that a geographical move is required to find a job. Despite the prognostications of wired-age adherents heralding the remote office, multimedia work does tend to concentrate in areas of the country offering a telecommunications infrastructure that can support the needs of the field; colleges and universities with resources that can be tapped into for research, development, and ideas; and media companies to provide content and populations high in a technically skilled workforce.

I GOT MY EDUCATION . . .

Not long ago, a designer looking to move into multimedia was hard-pressed to find a school program that addressed the field from a design perspective. But the tides have turned. Most higher-education design schools have multimedia departments, and design has been added to the curriculum of schools that formerly focused on more technological concerns. Still, deciding whether or not school should be part of your future has grown more complex.

Previously, multimedia centers in the few schools that had them were the only places that offered anyone interested in the field the necessary concentration of technology, faculty, and common purpose. Businesses had yet to start up internal multimedia departments, so on-the-job learning was not an option. But as the multimedia boom hit corporate America, it became apparent that the supply of people educated in the field was less than the demand, at which point businesses began to ramp up and invest in infrastructure and workforce. The result is that the technological setups of most businesses today equal or surpass those in some schools. The questions designers face are these: Do you want to go back to school to learn the basic skills needed to find a job in the multimedia industry? Or are you looking to follow a higher education path for the sake of learning and self-exploration?

The job seeker might do best by attending an extension or continuing education program, seminar, or even a course given by a local service bureau. Designers looking for a degree or certificate should keep in mind that the technical learning curve is constant. Each year brings a new suite of acronyms to learn, new software to master, new standards to understand, and old ones to forget. The tools and methods designers use are always being outmoded; the factors that affect design are determined by any number of hardware and software variables.

Many design programs find it difficult to keep up with all of the above, especially equipment and software, and thus often rely on corporate funding—which can skew the program's emphasis. Also, because higher education is based on separation of disciplines, it is often difficult to receive from one program the well-rounded education needed to truly get a grasp of multimedia design. The problem with pursuing further education is that time spent away from the workplace can put one out of synch or seriously behind the times with the state of multimedia.

The focus of a given school is determined by its affiliation within the university and with nearby industry. Art school programs differ in focus from those offered in media or other, more technically oriented schools. Los Angeles schools focus on the entertainment industries, while New York schools emphasize media and publishing. Where you want to work may decide where you should study.

The first step is to educate yourself about education options. What follows is a list of schools, training centers, and programs that offer courses in various areas of multimedia. ⊟

CALIFORNIA

Art Center College of Design
1700 Lida Street
Pasadena, California 91103
Tel.: (818) 396-2200

Center for Electronic Art
250 Fourth Street
San Francisco, California 94103
Tel.: (415) 512-9300

LAB
2948 Sixteenth Street
San Francisco, California 94103
Tel.: (415) 864-8855
This gallery space devoted to experimental music and interactive artworks also provides training in digital sound.

San Francisco State University Multimedia Studies
The New Downtown Center
425 Market Street, Second Floor
San Francisco, California 94105
Tel.: (415) 904-7700

University of California at Los Angeles Extension
10995 Le Conte Avenue, Room 37
Los Angeles, California 90024
Tel.: (800) 544-8252; (310) 825-9064

University of California at Santa Cruz Extension
Video and Multimedia Program
740 Front Street, Suite 155
Santa Cruz, California 95060
Tel.: (408) 427-6620

University of Southern California Human Factors Department
Los Angeles, California 90089
Tel.: (213) 740-2311

Zakros InterArts
614 York Street
San Francisco, California 94110
Tel.: (415) 282-5497

CONNECTICUT

Connecticut College Department of Art/Design Studies Center for Art and Technology
270 Mohegan Avenue
New London, Connecticut 06320
Tel.: (203) 439-2740

GEORGIA

Georgia Institute of Technology
250 14th Street NW, #M14
Atlanta, Georgia 30332
Tel.: (404) 894-4195

ILLINOIS

Illinois Institute of Technology Institute of Design
10 West 35th Street
Chicago, Illinois 60616
Tel.: (312) 808-5300

MASSACHUSETTS

Massachusetts Institute of Technology
77 Massachusetts Avenue
Cambridge, Massachusetts 02139
Tel.: (617) 258-5515
Email: admissions@MIT.edu
Web: http://www.MIT.edu/

MICHIGAN

Cranbrook Academy of Art
Box 801
1221 North Woodward Avenue
Bloomfield Hills, MI 48303
Tel.: (810) 645-3300

NEW YORK

Cooper Union for the Advancement of Science and Art
30 Cooper Square
New York, New York 10003

Interactive Telecommunications Program, Tisch School of the Arts, New York University
721 Broadway
New York, New York 10003
Tel.: (212) 998-1880
Web: http://www.itp.tsoa.nyu.edu/

New York University Center for Digital Multimedia
719 Broadway
New York, New York 10003
Tel.: (212) 998-3519

Parsons School of Design
66 West 12th Street
New York, New York 10011
Tel.: (212) 229-5690

Pratt Institute School of Art and Design
200 Willoughby Avenue, PS40
Brooklyn, New York 11205
Tel.: (718) 636-3631
Web: http://www.pratt.edu/

Rochester Institute of Technology Technical and Education Center of the Graphic Arts
66 Lomb Memorial Drive
Rochester, New York 14623
Tel.: (716) 475-2737

School of Visual Arts
209 East 23d Street
New York, New York 10010
Tel.: (212) 592-2104
Web: http://www.sva.edu/

United Digital Artists
P.O. Box 548
New York, New York 10150
Tel.: (212) 777-7200
Web: http://www.uda.com/
UDA provides seven-day certification programs in imaging, design and publishing, video and audio, multimedia, and Internet areas of study.

PENNSYLVANIA

Bloomsburg University Institute for Interactive Technologies
1210 McCormick Center for Human Services
Bloomsburg, Pennsylvania 17815
Tel.: (717) 389-4506

Carnegie-Mellon University
Design Department
 MMCH 110
 Pittsburgh, Pennsylvania 15213
 Tel.: (412) 268-2828
 Web site: http://www.cmu.edu/

University of the Arts
New Media Studies
 Broad and Pine Streets
 Philadelphia, Pennsylvania 19102
 Tel.: (215) 732-4832

RHODE ISLAND
Rhode Island School of Design
 2 College Street
 Providence, Rhode Island 02903
 Tel.: (401) 454-6100

CANADA
University of Toronto
Information Technology Design
Center
 230 College Street
 Toronto, Ontario, Canada M5S 1A1
 Tel.: (416) 978-0631

NETWORKING IT
Keeping up with the times means keeping in touch with your peers. Like the graphic artists' organizations that came together to fill the role formerly played by guilds, multimedia organizations are springing up to provide the same benefits to their members—credibility, seminars and conferences, insurance, and, just as importantly, schmoozing.

 (Note: The tag http:// that precedes Web URLs has been dropped from the addresses listed here; most Web browsers add it automatically.)

ORGANIZATIONS
The American Center for Design
 325 West Huron Street, Suite 711
 Chicago, Illinois 60610
 Tel.: (312) 787-2018
 Email: acdchicago@megsinet.net
 Web: www.ac4d.org/
The nonprofit American Center for Design develops and disseminates design information and sponsors a yearly conference on Internet design.

American Institute of Graphic Arts
 164 Fifth Avenue
 New York, New York 10010
 Tel.: (212) 807-1990
 Email: aiganatl@aol.com
 Web: www.aiga.org/
The AIGA, with chapters nationwide, is a nonprofit organization that promotes excellence in graphic design.

Association for Computing
Machinery (ACM)
 1515 Broadway, 17th Floor
 New York, New York 10036
 Tel.: (212) 626-0500 (metro N.Y. and international); (800) 342-6626 (continental U.S. and Canada)
 Email: acmhelp@acm.org
 Web: www.acm.org/
The ACM sponsors conferences and discussions relating to computers. Its publication *Communications of the ACM* provides thought-provoking articles on interface design and theory.

Institute of Electrical and
Electronics Engineers
 Web: www.computer.org/
The IEEE is a global organization that promotes study in a wide range of computer topics, including multimedia. The institute publishes papers and CD-ROMs that cover the current standards of all aspects of multimedia production.

Interactive Multimedia Association
 48 Maryland Avenue, #202
 Annapolis, Maryland 21401

International Interactive
Communications Society (IICS)
 101 SW Nimbus Avenue, #F2
 Portland, Oregon 97223
 Tel.: (503) 620-3604
 Email: iicsny@iicsny.org
 Web: www.iicsny.org/
IICS provides conferences, job listings, and other member benefits.

Multimedia Development Group
 2601 Mariposa Street
 San Francisco, California 94110
 Tel.: (415) 553-2300
 Email: MDGoffice@aol.com
The Multimedia Development Group is a nonprofit, market development trade association uniquely serving the business and professional needs of interactive multimedia companies nationally and internationally.

The New York New Media
Association
 55 Broad Street
 New York, New York 10004
 Tel.: (212) 785-7898
 Web: www.nynma.org/
Member-supported, NYNMA is committed to the development of the new media industry in greater New York City. It sponsors symposia and regular "Cybersuds" meetings and publishes a newsletter.

Type Directors Club
 60 East 42d Street, Suite 721
 New York, New York 10165
 Tel.: (212) 983-6042
 Email: typeclub@aol.com
 Web: users.aol.com/typeclub/
TDC is devoted to those interested in typography both in print and on screen. It sponsors conferences such as "Multimedia in Realtime."

World Computer Graphics
Foundation
 6121 Lincolnia Road, #302
 Alexandria, Virginia 22312
 Tel.: (703) 642-3050

World Wide Web Artists Consortium
 Web: www.wwwac.org/
Based in New York City but nationwide in reach, the WWWAC holds biweekly meetings ("Cybersuds") about the Web at the Sony Building. To subscribe to its mailing list, send email to listproc@echonyc.com with the body of the message reading "Subscribe WWWAC" along with your full name.

ELECTRONIC RESOURCES

Much discussion concerning multimedia takes place electronically via various newsgroups, mailing lists, Web sites, and areas in online services devoted to the topic. With these sources you can exchange information, talk about current topics of interest, and ask and answer software and hardware questions.

ECHO
Digital Arts Conference
Tel.: (212) 292-0900
Telnet: echonyc.com
Web: www.echonyc.com/
ECHO, a New York–based bulletin board system, has been around since 1990. Digital Arts is a conference featuring discussions of all aspects of multimedia, prepress and electronic publishing, and digital artworks.

Image Soup
Web: www.dti.net/imagesoup/
This is a digital quarterly magazine for online artists.

MEME
This biweekly online newsletter features discussions of issues affecting those working in new media. To subscribe, send email to listserv@sjuvm .stjohns.edu with the body of the message reading "Subscribe MEME" along with your full name.

Review Online
Web: www.itp.tsoa.nyu.edu/ ~review/
Devoted to design, social, cultural, and technology issues that have an impact on multimedia, this digital magazine is a good source of discussions of humanistic and aesthetic aspects of new media technology.

Rocky Mountain Internet Users Group
Web: www.rmiug.org/rmiug/user groups.html
A list of Internet-related interest groups can be found at this site.

SIGGRAPH
Web: www.siggraph.org/
Sponsored by the Association of Computing Machinery, the Special Interest Group on Computer Graphics is devoted to the exploration of computer graphics and interactive technologies. It holds annual conferences and workshops, and offers publications of interest to the multimedia design community.

Speed
Web: www.arts.ucsb.edu/~speed/
This site is devoted to discussions of technology, media, and society.

NEWSGROUPS

Newsgroups are the vast collection of Internet-based discussion groups. Check with your Internet service provider to see if it supports newsgroups and find out how to access them. The newsgroups listed here are all places to go for design questions or commentary:

 alt.design.graphics
 alt.culture.www
 comp.infosystems.www
 .authoring.cgi
 comp.infosystems.www
 .authoring.html
 comp.multimedia
 comp.music.midi
 comp.publish.cdrom.multimedia
 humanities.design.misc

MAGAZINES

Reading materials on the new media range from industry collections of press releases (see any periodical with "week" in the title) to esoteric magazine articles on the philosophy of multimedia.

Also keep an eye out for trade and special-interest publications, which often feature interactive technology issues—for example, the Business section of Monday's *New York Times* is devoted to the information industry; *BusinessWeek* publishes an annual look at information technology; the *Wall Street Journal* regularly publishes special sections on the telecommunications industry; and *MediaWeek* magazine publishes a monthly look at goings-on in the new media community.

Listed below are print magazines that reflect a design sensibility, and that regularly feature articles on the new media.

Blueprint
Christ Church
Cosway Street
London, England NW1 SNJ
Tel.: 0171 479-8515
Blueprint's primary focus is on architecture and design, but digital design appears more and more frequently in its pages.

Byte
One Phoenix Mill Lane
Peterborough, N. H. 03458
Tel.: (603) 924-9281
Web: www.byte.com/
Byte magazine covers computing technology, providing overviews of current and coming technologies, as well as hands-on help for computer programmers.

Communication Arts
410 Sherman Avenue
Palo Alto, California 94306
Tel.: (415) 326-6040
Email: ca@commarts.com
Web: www.commarts.com/
Communication Arts concentrates on graphic design and related professions; it publishes an interactive design annual on CD-ROM.

Design Issues
Design Department
111 Margaret Morrison
Pittsburgh, Pennsylvania 15213
Tel.: (412) 268-6841
Design Issues, a journal published for Carnegie-Mellon University by M.I.T. Press, covers a broad range of topics that are of particular interest to designers working in the field of multimedia.

Emigre

4475 E Street
Sacramento, California 95819
Tel.: (916) 451-4344
Email: editor@emigre.com
Web: www.emigre.com/

Published by the digital type foundry of the same name, *Emigre* magazine explores issues outside of typography, including information design, communication, and the role and impact of the new media on society.

Eye

151 Rosebery Avenue
London, England EC1R 4QX
Tel.: 0171 287-3848

This international review of graphic design covers multimedia design, with software reviews.

I.D.

440 Park Avenue South
New York, New York 10016
Tel.: (212) 447-1400

I.D. magazine covers architecture and environmental design, and industrial, graphic, and multimedia design. Its annual review includes a CD-ROM that features winners in the interactive media category.

Intelligent Agent

Hyperactive Corporation
333 West 56th Street, Suite 3C
New York, New York 10019
Tel.: (212) 462-9033
Email: hyperact@interport.net
Web: www.intelligent-agent.com/

Intelligent Agent is a newsletter that covers the use of interactive media and technology in arts and education—topics often overlooked in the more commercial magazines about the genre.

Leonardo

236 West Portal Avenue, #781
San Francisco, California 94127
Email: isast@sfsu.edu

The journal of the International Society for the Arts, Sciences and Technology, *Leonardo* accepts submissions from artists and scientists, and provides an overview of what's going on in the more experimental realms where art and science mix.

Metropolis

515 Madison Avenue
New York, New York 10022
Tel.: (212) 832-1199
Web: www.metropolismag.com/

This publication focuses on current issues in architecture and design.

New Media

901 Mariner's Island Boulevard
Suite 365
San Mateo, California 94404
Tel.: (415) 573-5170
Web: www.hyperstand.com/

New Media balances its press release–based blurbs with extensive compilations of tools, hardware, and software, making it just a little easier to keep ahead of the multimedia curve. Annually, the magazine publishes a special Complete Buyer's Guide for Multimedia Pros section.

Online Design

41 Pollard Place
San Francisco, California 94133
Tel.: (415) 296-9702
Email: visonline@aol.com

Print

109 Fifth Avenue
New York, New York 10011
Tel.: (212) 463-0600
Fax: (212) 989-9891
Email: Printmag@aol.com
Web: www.printmag.com/

Print, the oldest graphic design magazine, covers print and new media design, in addition to presenting a critical look at the communications industries. It features a regular new media column and a digital design annual.

The Sober Witness

Web: www.sober.com/

The title of this Web magazine reflects the no-hype stance of its creator, Jason Moore. The site offers an editorial take on current Web design practice, accompanied by reviews, technical tips, and other reference information for the Web designer.

U&lc

866 Second Avenue
New York, New York 10017
Tel.: (212) 371-0699

This periodical is a publication of the International Typeface Corporation.

GLOSSARY OF COMPUTER TERMS

Algorithm
In computer programming, a set of rules for solving a problem in a finite number of steps.

Alphanumeric
Consisting of letters, numbers, and often special characters, such as punctuation marks; refers to a system of computer coding.

Analog
Referring to a method of representing data as a measurement of a continuous physical variable, as of a sound wave or television signal.

Application
A computer program set up to do one specific thing, such as word processing.

ASCII
*A*merican *S*tandard *C*ode for *I*nformation *I*nterchange; a communications code developed in 1963 to represent alphanumeric data.

Bandwidth
The smallest range of frequencies provided by a given means of communication, within which a signal can be transmitted without distortion.

Baud
A unit of data transmission speed (as measured in bits per second), named for its French inventor, J. M. E. Baudot.

Binary
Referring to a system of numeric

notation in base 2, in which each place of a number, either 1 or 0, corresponds to a power of 2; used as the foundation for all computer-based communication.

Bit
Binary digit; the basic unit of computer (digital) information, denoting either an off or an on state.

Bit depth
The display capability of a computer, based on the number of colors that can appear on a monitor simultaneously; determined by the number of bits of information used to describe each pixel.

Bitmap
A graphic format that describes an image in terms of its individual pixels.

Browser
Software application used to view pages on the World Wide Web.

Byte
Eight bits, processed by the computer as a unit.

Cast
In the application Director, the collection of animated graphics used in a project; individual cast "members" are referred to as sprites.

CD-E
Compact disk erasable; proposed optical-disk format in which the disk could be erased and reused.

CD-ROM
Compact disk read-only memory; an optical disk containing information that can be read by a computer but not written to.

CGI
Common gateway interface; the standard used to encode information sent to a World Wide Web server, to allow for information processing, access to databases, other applications, and other calculations on the server end.

Codec
Algorithm for *coding* and *decoding* digital video information.

Compiler
Computer program that translates

a high-level programming language into one the computer can understand, usually machine language: the lowest-level processing language the computer uses.

Compression
Refers to any algorithm used to reduce the size of a computer file.

Dialog box
A particular kind of window displayed on the computer screen to get information from or provide it to the user.

Digital
Refers to a method of representing data in the form of numerical digits, as well as to the measurement of a physical variable with discrete steps; see *analog*.

Director
A multimedia authoring program with a time-line metaphor that is used to create simple animations as well as complex multimedia applications.

Diskette
Floppy disk; a small, plastic-encased magnetized disk that serves as a storage medium for computer information.

Drive
The mechanical part of a computer that reads a given kind of storage medium; e.g., disk drive, CD-ROM drive.

DVD
Digital video disk; a type of optical disk that can store a larger amount of data than a CD-ROM.

Entropy
The measure of disorder or noise in a communications signal.

Flowchart
A graphic map showing the progression of discrete steps through a procedure or system; in computer programming, used to map out all steps, decisions, input, and output of a program.

Format
To encode a computer file so that data are stored in a specific arrangement; also, the general

makeup, size, and shape of a given medium.

FTP
File Transfer Protocol; an Internet protocol used to download and upload files via certain transmission methods

Function
In programming, a reusable list of instructions or algorithm. On a keyboard, the keys that perform various tasks are referred to as function keys.

Gateway
The entrance and exit point for a portion of a greater network.

Gigabyte
A measure of storage equal to one billion bytes.

Gopher
An Internet protocol used to set up menu structures of viewable data files.

GUI
The *graphical user interface* of a computer platform, often based on icons, menus, and windows.

Hardware
The physical components of a computer system (e.g., keyboard, monitor, disk drive, etc.), as opposed to the software.

Highlight
In a computer application, to denote a selection by a change in color or style.

HTML
Hypertext markup language; a method for coding text and graphics for hypertext protocols such as the World Wide Web.

Hypertext
Information within a document that is coded and highlighted in such a way that it allows direct access to related information from its display.

Icon
A pictorial representation of data on a computer, such as a file, folder, or hard drive; the representation of a function in a computer application.

Indexed color
A graphic format that sets the palette of an image to a bit depth of 8, providing for a total of 256 colors.

IP/TCP
*I*nternet *P*rotocol/*T*ransmission *C*ontrol *P*rotocol; used for routing all Internet traffic.

Joystick
An input device hooked up to a computer that allows for navigation and other functions, as used in a videogame.

Kilobyte
A measure of data storage equal to one thousand bytes.

Kiosk
In a digital context, an enclosed (stand-alone) computer with a specific built-in multimedia application such as a touchscreen directory; most often found in museums, supermarkets, trade-show venues, and malls.

Laserdisk
An optical disk onto which analog video signals can be recorded for storage and random-access playback via a laserdisk player.

Lingo
The scripting language used by the multimedia authoring program Director.

Link
A highlighted portion of text in a hypertext document that gives access to related information.

Macro
Abbreviation for *macroinstruction;* a sequence of operations grouped under a single computer instruction.

Megabyte
A measure of data storage equal to one million bytes.

Metaphor
A symbol for on-screen actions based on real-life objects; e.g., the metaphor for a Macintosh computer screen is a desktop.

MIME
*M*ultipurpose *I*nternet *M*ail *E*xtensions; allows for email encoding of non-U.S. character sets, images, sounds, PostScript, and other definable file types.

Modem
*M*odulator + *dem*odulator; a hardware device that permits transmission of digital information over analog telephone lines.

NAPLPS
*N*orth *A*merican *P*resentation *L*ayer *P*rotocol *S*yntax; a system developed in the late 1970s for storing the data of an image in a small file.

Navigation
The method of moving around or through an on-screen "space" or multimedia project.

Network
Computers connected over any distance by various kinds of communication links; also, to connect computers in such a manner.

New media
The so-called newer means of communication, as opposed to "old" media, such as print, television, and radio.

OCR
*O*ptical *c*haracter *r*ecognition (or *r*eader); the method for converting printed pages to computer text using a scanner.

Operating system
The software instructions that determine how a computer system is used.

Page
On the World Wide Web, a discrete body of text, graphics, and associated links.

Palette
The colors available for use on a particular computer, determined by the bit depth.

Pixel
The smallest element of an image that can be processed individually in a video display system.

Platform
A hardware and software computer system requiring that software be written to work on that particular system; e.g., Apple Macintosh platform vs. IBM PC–compatible platform.

Plugboard
In computer programming (as in older accounting machines), a means for manipulating data via a board into which wires are plugged into rows of connectors.

PostScript
The computer language supporting all current electronic publishing, allowing for mathematically precise placement of graphics and text on a two-dimensional page.

Protocol
Rules governing the exchange of information between computers.

Punched card
In reference to older computers, a card with holes punched into it by a typewriterlike machine in specific positions to represent computer data; the encoded card was then fed into the computer.

QuickTime
A format developed at Apple Computer that allows for the recording, playback, and editing of encoded digital video.

RAM
*R*andom-*a*ccess *m*emory; the temporary, or "short-term," memory storage available for programs and data when a computer is on.

Random access
Describes data that can be accessed from anywhere within a data structure, as opposed to linear data, such as video on videotape.

Raster-based graphics
Computer graphics made up of individual pixels drawn on a display screen line by line.

ROM
*R*ead-*o*nly *m*emory; computer instructions or data that can be accessed but not changed.

Resolution
In terms of a computer screen, refers to pixels per inch; in terms

of a sampled sound, refers to the sampling rate.

Sampling rate
The number of times per second that a given point of a sound wave is recorded.

Script
In certain authoring software, the computer programs that control the events of that application.

Serial
Referring to the transmission of digital information one bit or byte at a time, as opposed to parallel.

Server
A computer that sends stored data to other machines on a network.

SGML
Standardized general markup language; a specification for defining hypertext documents, a subset of which is HTML.

SMTP
Simple Mail Transfer Protocol; an Internet protocol that encodes ASCII text as email and breaks email data into chunks that email gateways can handle.

Software
Computer programs.

Surf
In Internet terminology, to go from Web page to Web page.

Terminal
A computer that cannot operate independently but runs via a network that ties it to a central computer.

Toolbox
In computer programming, any set of basic algorithms used by software on a particular hardware platform.

Vector-based graphics
Computer graphics drawn on a display screen based on mathematical calculation and location of points in Cartesian space.

VRML
Virtual reality modeling language; a programming code for creating three-dimensional, hyperlinked spaces on the World Wide Web.

Videotext
A system of electronic data retrieval in which information is sent by means of telephone or cable television lines for display on a video terminal.

Window
In some operating systems, the part of the screen created for viewing a specific kind of information.

SELECTED BIBLIOGRAPHY

Go into any major bookstore's computer section and you'll find shelves stocked with thick "how-to" books of every kind for using any popular software program. Some are truly useful, some are duds. Most are expensive, so take this advice: make sure you've exhausted the tutorial that came with your software before looking for a "how-to" book. Next, look for a book published by the company that produced the software you're trying to learn; chances are, someone with inside knowledge wrote it. Beyond titles offering instruction in software applications and programming languages are books that reflect the many facets of multimedia design; the list that follows comprises many such useful references.

SURFACE AND STRUCTURAL DESIGN

Abrams, Janet.
"Muriel Cooper's Visible Wisdom." *I.D.,* September/October 1994.

Bierut, Michael, and William Drenttel, Steven Heller, and DK Holland, eds.
Looking Closer: Critical Writings on Graphic Design. New York: Allworth Press, 1994.

Bolt, Richard.
The Human Interface: Where People and Computers Meet. London: Lifetime Learning Publications, 1984.

Buchanan, Richard, and Victor Margolin, eds.
Discovering Design. Chicago: University of Chicago Press, 1995.

Caplan, Ralph.
By Design. New York: St. Martin's Press, 1982.

Forester, Tom, ed.
Computers in the Human Context. Cambridge, Mass.: M.I.T. Press, 1991.

Fowler, Susan.
"Banking on a New Interface." *I.D.,* September/October 1993.

Heaton, Nigel, and Murray Sinclair, eds.
Designing End-User Interfaces. Oxford: Pergamon Infotech Ltd., 1988.

Helfand, Jessica.
Six Essays on Design and New Media. New York: William Drenttel, 1996.

Heller, Steven, and Julie Lasky.
Borrowed Design. New York: Van Nostrand Reinhold, 1993.

Horton, William.
The Icon Book. New York: John Wiley and Sons, 1994.

Ivins, William M., Jr.
Prints and Visual Communication. Cambridge, Mass.: M.I.T. Press, 1953.

Kahn, Paul.
"Visual Cues for Local and Global Coherence in the WWW." *Communications of the ACM,* August 1995.

Kristof, Ray.
Interactivity by Design. Mountain View, California: Adobe Press, 1995.

Laurel, Brenda, ed.
The Art of Human-Computer Interface Design. New York: Addison-Wesley, 1990.

Lester, Paul Martin.
Visual Communication: Images with Messages. New York: Wadsworth Publishing, 1995.

Lupton, Ellen, and J. Abbott Miller, eds.
The ABCs of ▲■●: The Bauhaus and Design Theory. Princeton: Princeton Architectural Press, 1996.

Manzini, Ezio.
The Material of Invention. Cambridge, Mass.: M.I.T. Press, 1986.

Papanek, Victor.
Design for Human Scale. Chicago: Academy Chicago Publishers, 1983.

——.

Design for the Real World. Chicago: Academy Chicago Publishers, 1985.

——.

The Green Imperative. New York: Thames and Hudson, 1996.

——.

How Things Don't Work. Chicago: Academy Chicago Publishers, 1977.
Patton, Phil.
"Making Metaphors." *I.D.,* March/April 1993.
Petroski, Henry.
To Engineer Is Human. New York: Vintage, 1992.
Rand, Paul.
Design, Form, and Chaos. New Haven: Yale University Press, 1993.
Steiner, Henry.
Cross-Cultural Design. London: Thames and Hudson, 1995.
Thüring, Manfred, Jörg Hannemann, and Jörg M. Haake.
"Hypermedia and Cognition: Designing for Comprehension." *Communications of the ACM,* August 1995.
Wellmer, Albrecht.
The Persistence of Modernity. Cambridge, Mass.: M.I.T. Press, 1991.
Wildbur, Peter.
Information Graphics. New York: Van Nostrand Reinhold, 1989.
Wurman, Richard Saul.
Information Architects. Zurich: Graphis, 1996.

SYSTEMS DESIGN

Arnheim, Rudolf.
Entropy and Art: An Essay on Disorder and Order. Berkeley: University of California Press, 1971.
Benedikt, Michael, ed.
Cyberspace: First Steps. Cambridge, Mass.: M.I.T. Press, 1992.
Campbell, Jeremy.
Grammatical Man. New York: Simon and Schuster, 1982.

Casti, John L.
Complexification. New York: HarperCollins, 1995.
Charniak, Eugene.
Introduction to Artificial Intelligence. Reading, Mass.: Addison-Wesley, 1985.
Dewdney, A. K.
The Armchair Universe. New York: W. H. Freeman, 1988.
Diagraphics II.
Tokyo: JCA, 1994.
Dreyfus, Hubert.
What Computers Still Can't Do. Cambridge, Mass.: M.I.T. Press, 1994.
Gleick, James.
Chaos. New York: Penguin, 1987.
Holmes, Nigel.
The Best in Diagrammatic Graphics. London: Quarto, 1993.
Kosko, Bart.
Fuzzy Thinking. New York: Hyperion, 1993.
Mainzer, Klaus.
Thinking in Complexity. New York: Springer-Verlag, 1994.
McNeill, Daniel.
Fuzzy Logic. New York: Simon and Schuster, 1993.
Pickover, Clifford A.
Chaos in Wonderland. New York: St. Martin's Press, 1994.

——.

Computers and the Imagination. New York: St. Martin's Press, 1991.

——.

Computers, Pattern, Chaos, and Beauty. New York: St. Martin's Press, 1990.
Prigogine, Ilya.
Order Out of Chaos. New York: Bantam, 1984.
Resnick, Mitchell.
Turtles, Termites, and Traffic Jams. Cambridge, Mass.: M.I.T. Press, 1994.
Tufte, Edward R.
Envisioning Information. Cheshire, Connecticut: Graphics Press, 1990.

——.

The Visual Display of Quantitative Information. Cheshire, Connecticut: Graphics Press, 1983.

Woolley, Benjamin.
Virtual Worlds. New York: Penguin, 1992.

TECHNICAL DESIGN

Clayson, James.
Visual Modeling with LOGO. Cambridge, Mass.: M.I.T. Press, 1988.
Harvey, Brian.
Computer Science Logo Style Volumes I-III. Cambridge, Mass.: M.I.T. Press, 1987.
Kaelbling, Leslie Pack.
Learning in Embedded Systems. Cambridge, Mass.: M.I.T. Press, 1993.
Kurzweil, Raymond.
Intelligent Machines. Cambridge, Mass.: M.I.T. Press, 1992.
Laing, Jonathan R.
"Proceed with Caution." *Barron's,* 24 October 1994.
Nardi, Bonnie.
A Small Matter of Programming. Cambridge, Mass.: M.I.T. Press, 1993.
Newman, William M.
Principles of Interactive Computer Graphics. Tokyo: McGraw-Hill, 1981.
Sola Pool, Ithiel de.
Technologies Without Boundaries. Cambridge, Mass.: M.I.T. Press, 1990.
Waldén, Kim.
Seamless Object-Oriented Software Architecture: Analysis and Design of Reliable Systems. New York: Prentice Hall, 1995.
White, Jan V.
Graphic Design for the Electronic Age. New York: Watson-Guptill, 1988.
Yourdon, Edward.
Techniques of Program Structure and Design. Englewood Cliffs, New Jersey: Prentice Hall, 1975.

HUMAN FACTORS

Arnheim, Rudolf.
Visual Thinking. Berkeley: University of California Press, 1969.
Barrett, Edward.
Sociomedia. Cambridge, Mass.: M.I.T. Press, 1992.
Barry, John.
Technobabble. Cambridge, Mass.: M.I.T. Press, 1991.
Berger, John.
Ways of Seeing. New York: Penguin, 1972.
Bolinger, Dwight.
Language: The Loaded Weapon. New York: Longman, 1980.
Brand, Stewart.
The Media Lab. New York: Penguin, 1987.
Cassirer, Ernst.
The Philosophy of Symbolic Forms. New Haven: Yale University Press, 1953.
Crary, Jonathan.
Techniques of the Observer. Cambridge, Mass.: M.I.T. Press, 1991.
Dizard, Wilson P.
The Coming Information Age. New York: Longman, 1982.
Drennan, Daniel.
"Smoke and Mirrors on the World Wide Web." *AIGA Journal of Graphic Design* 13 (1996), no. 2.
Forester, Tom, ed.
Computers in the Human Context. Cambridge, Mass.: M.I.T. Press, 1991.
Franke, H. W.
Computer Graphics, Computer Art. London: Phaidon Press, 1971.
Gifford, Don.
The Farther Shore. New York: Vintage, 1990.
Goodman, Cynthia.
Digital Visions, Computers and Art. New York: Harry N. Abrams, Inc., 1987.

Hall, Kira, and Mary Bucholtz, eds.
Gender Articulated: Language and the Socially Constructed Self. New York: Routledge, 1995.
Jacobson, Linda, ed.
Cyberarts: Exploring Art and Technology. San Francisco: Miller Freeman, 1992.
Kawasaki, Guy.
"Let the QuickTimes Roll." *Macworld,* May 1992.
Kranz, Stewart.
Science and Technology in the Arts. New York: Van Nostrand Reinhold, 1974.
Krueger, Myron.
Artificial Reality. Reading, Mass.: Addison-Wesley, 1983.
Lakoff, George.
Metaphors We Live By. Chicago: University of Chicago Press, 1980.
Lakoff, Robin Tolmach.
Talking Power: The Politics of Language. New York: HarperCollins, 1990.
Lubar, Steven.
InfoCulture. New York: Houghton Mifflin, 1993.
McLuhan, Marshall.
Understanding Media. Cambridge, Mass.: M.I.T. Press, 1964.
Mehta, Gita.
Karma Cola. New York: Vintage, 1994.
"Multimedia: About Interface."
MacUser, March 1989.
Ong, Walter J.
Interfaces of the Word. Ithaca, New York: Cornell University Press, 1971.
Ortony, Andrew.
The Cognitive Structure of Emotions. New York: Cambridge University Press, 1988.
Pacey, Arnold.
Technology in World Civilization. Cambridge, Mass.: M.I.T. Press, 1990.
Papert, Seymour.
Mindstorms. New York: Basic Books, 1980.
Pinker, Steven.
The Language Instinct. New York: HarperCollins, 1994.

Postman, Neil.
Amusing Ourselves to Death. New York: Penguin, 1985.
———.
Conscientious Objections. New York: Vintage, 1988.
———.
Technopoly. New York: Vintage, 1992.
Prueitt, Melvin L.
Art and the Computer. New York: McGraw-Hill, 1984.
Roszak, Theodore.
The Cult of Information. New York: Pantheon, 1986.
Schaff, Adam.
Language and Cognition. New York: McGraw-Hill, 1973.
Schiller, Herbert I.
Information Inequality. New York: Routledge, 1996.
Yelavich, Susan, ed.
The Edge of the Millennium. New York: Whitney Library of Design, 1993.

GENERAL

Brand, Stewart.
How Buildings Learn. New York: Penguin, 1994.
Hiss, Tony.
The Experience of Place. New York: Vintage, 1990.
Holtzman, Steven.
Digital Mantras. Cambridge, Mass.: M.I.T. Press, 1994.
Kroll, Lucien.
An Architecture of Complexity. Cambridge, Mass.: M.I.T. Press, 1987.
Mandelbrot, Benoit B.
The Fractal Geometry of Nature. New York: W. H. Freeman, 1977.

CREDITS

Numbers refer to pages on which images appear.

12: *Cause and Effect*
Client: Curium Design
Producer: Joy Johnson
Designer: Evan Sornstein
Art Director: Evan Sornstein
Illustrator: Evan Sornstein
Photographer: Joy Johnson
Program: Director

13, top: TeamDesign internal company newsletter
Client: TeamDesign

13, bottom: *Pinch*
Client: Brad Johnson Presents
Producer: Brad Johnson
Designer: Brad Johnson
Art Director: Brad Johnson
Illustrator: Brad Johnson
Programmer: Jeff Stafford

14: *Beyond Cyberpunk! A Do It Yourself Guide to the Future*
Producer: Gareth Branwyn
Program: HyperCard

15: BlindROM
Client: The Blind Trust/Mediamatic
Producer: Gerald Van Der Kaap
Designer: Gerald Van Der Kaap
Art Director: Gerald Van Der Kaap
Illustrator: Gerald Van Der Kaap
Photographer: Gerald Van Der Kaap
Music: Leo Anemaet

16: *Stale* homepage
Producers: Daniel Radosh, Michael Tritter
Illustrator: Mike Gorman

17: Feed homepage
Designer: Mark Matcho
Art Directors: Steven Johnson, Stefanie Syman
Program: Photoshop

18: *Inquisitor* Mediarama
Designer: Daniel Drennan
Illustrator: Daniel Drennan
Programmer: Daniel Drennan

19: *Bust*
Client: *Bust*
Producers: Laurie Henzel, Debbie Stoller
Designer: Laurie Henzel
Art Director: Laurie Henzel
Program: PageMill

20: *Review* **Web page**
Client: Interactive Telecommunications Program, N.Y.U.

Producer: Michael Cosaboom
Designer: Lisa Cavender
Art Director: Lisa Cavender
Programs: Photoshop, HTML

21: *Paper* **Web page**
Producer: Paper Multimedia
Art Director: Brigid De Socio

22: *Blender* **(edition 2.5)**
Client: Felix Dennis
Editor: Dale Hrabi
Creative Director: Jason Pearson
Programmer: David Cherry
Program: Director

24, 25: Daniel Pelavin Web site
Client: Daniel Pelavin
Producer: Daniel Pelavin
Designer: Daniel Pelavin
Art Director: Daniel Pelavin
Illustrator: Daniel Pelavin
Programs: Illustrator, Photoshop, GIF Builder, Netscape

30, 31 (bottom): *Wired,* **December 1993, pages 8-9**
Client: Wired Ventures
Producer: *Wired* magazine
Creative Directors: John Plunkett, Barbara Kuhr
Illustrator: Fred Davis
Programs: Photoshop, QuarkXpress

31, top: *Mondo 2000,* **issue #4, pages 50-51**
Client: *Mondo 2000* magazine
Art Director: Bart Nagel

34: *The Mackerel Stack*
Client: Mackerel
Producer: Mackerel
Designer: Mackerel
Art Director: Mackerel
Illustrator: Kevin Steele
Programs: SuperCard, Photoshop, Illustrator
© 1993 Mackerel, Inc.

35: Soul Coughing Interactive Press Kit
Client: Warner Brothers Records
Design Firm: Aufuldish & Warinner
Art Director/Designer: Bob Aufuldish
Art Director: Kim Biggs, Warner Brothers Records
Creative Director: Jeri Heiden, Warner Brothers Records
Graphics: Video stills, photos, illustrations provided by Warner Brothers Records
Illustrator: Steve Wacksman
Photographers: Anthony Artiaga, Annalisa, Bob Aufuldish
Music: Soul Coughing
Video Director: Mark Kohr
Programming: David Karam, Bob Aufuldish

36: *The Residents: Freak Show*
Producer: Michael Nash
Designer: Jim Ludtke
Publisher: The Voyager Company

37: *Earth*
Client: NASA
Producer: Alain Jehlens
Executive Producer: Ted Sicker
Designer: Joe Kenny
Art Director: Juliet Jacobson
Illustrator: Susan Levan, Levan/Barbee Studio
Programmer: Michael Miller
Developer: WGBH New Media
© 1994 WGBH Educational Foundation

38: *The War in Vietnam*
Client: Macmillan Digital
Producer: Michael Enright
Designer: Laura Hough
Art Director: Janet Tingey
Developer: Meetinghouse Technologies

39: The News Exchange
Client: Time Inc. New Media
Producer: Jeffrey Solari
Designers: Matthew Fass, Jim Granger
Art Director: Yu-Ling Wang
Program: Ikonic custom C++ application

40: Newsday Direct
Client: Newsday Direct
Producer: Ed Maloney
Designer: Tom Bellissimo
Art Director: Tom Bellissimo
Illustrator: Tom Bellissimo

41: *Yorb* **images**
Illustrator: Dan O'Sullivan
Photographer: Dan O'Sullivan
Programmer: Dan O'Sullivan

42: *Burn:Cycle*
Client: Philips Media, Inc.
Producer: TripMedia Ltd. in association with Media Investment Club (Media Programme of the European Community)
Designers: David Collier, Jeremy Quinn, Tomas Roope
Music: Simon Boswell

43: *Rodney's Wonder Window* **by Rodney Alan Greenblat**
Producer: Rodney Alan Greenblat
Designer: Rodney Alan Greenblat
Art Director: Rodney Alan Greenblat
Illustrator: Rodney Alan Greenblat
Publisher: The Voyager Company

48: GTE networked kiosk
Client: GTE VISNET
Producer: Rhonda Barzon

Designers: Leah Novaes, Matthew Fass
Art Director: Sara Ortloff
Animator: Ian Swinson
Program: Ikonic custom Visual Basic application

52: *Books That Work: 3-D Kitchen*
Producer: Eric Raymond
Designer: Amy Phillips
Art Director: Amy Phillips

53: *Macbeth*
Producer: Michael Cohen
Designer: Brian Speight
Publisher: The Voyager Company

56, 57: Rock and Roll Hall of Fame and Museum interactive computer programs
Client: Rock and Roll Hall of Fame and Museum
Producer: The Burdick Group
Designers: Bruce Burdick, Susan Burdick, Jerome Goh, Stuart McKee, Christian Anthony, Aaron Caplan
Art Directors: Bruce Burdick, Susan Burdick
Program: Director

59: Lisa computer
Photograph courtesy of Apple Computer, Inc.

64: *Mania One*
Client: Multimania
Producers: Michelangelo Capraro, Mathias Friis, Stefan Kosel
Designers: Michelangelo Capraro, Mathias Friis, Stefan Kosel
Art Directors: Michelangelo Capraro, Mathias Friis, Stefan Kosel
Programs: Photoshop, Director, Illustrator, Truespace, Premiere, SoundEdit

65: "Understanding Concrete Poetry"
Producer: Thomas Müller
Designer: Thomas Müller
Creative Director: Thomas Müller
Programmer: Thomas Müller

67: The Hoefler Type Foundry Web pages
Client: The Hoefler Type Foundry, Inc.
Producer: Jonathan Hoefler
Designer: Jonathan Hoefler
Art Director: Jonathan Hoefler
Illustrator: Jonathan Hoefler
Photographer: Jonathan Hoefler
Program: BBEdit

68: Wayfinder (training product for *Planet SABRE***)**
Client: SABRE Travel Information Network, Inc.
Producer: John Armitage

Designers: John Armitage,
Edward Guttman
Design Director: Aaron Marcus
Illustrator: Mike Devarenne
Programmer: David Dantowitz

**69: Elektra Entertainment Web
homepage**
Client: Elektra Entertainment
Designers: Matthew Pacetti,
Bryant Wilms
Creative Director: Peter Seidler
Photographer: Paul Colliton
Programmer: Ricardo Tarrega

**70: *A Passion for Art: Renoir,
Cézanne, Matisse, and Dr. Barnes***
Producer: Curtis Wong
Assistant Producer: Eileen Monti
Art Director: Pei Lin Nee
Developer: Jim Gallant

71: Star Trek Omnipedia™
Producer: Liz Braswell, Simon &
Schuster Interactive
Associate Producer: Denise Okuda
Interface Design: Michael Okuda
Interactive Architecture: Peter
Mackey, Imergy
Imergy Project Managers: Marshall
Lefferts, Stephanie Triggiani
Program: Director
Imergy® is a registered trademark of
The Imergists, Inc., New York City.
Published by Simon & Schuster
Interactive, a division of Simon &
Schuster Inc., the publishing opera-
tion of Viacom Inc. © 1995 Simon &
Schuster Interactive. STAR TREK
marks and related material: ™, ®,
and © Paramount Pictures.

72, 73: *The Language of Koga Hirano*
Client: F2 Co., Ltd.
Producer: Fumio Kurokawa
Designer: Hirokazu Mukai
Art Director: Hirokazu Mukai
Photographer: Hiroshi Tsukinoki
Programmers: Tadahiko Satoh,
Masaaki Yamada

75: *Gearheads*
Client: Philips Media Games
Producer: Brian Loube
Design Consultant: R/GA Interactive,
New York
Game Concept and Design: Frank
Lantz, Eric Zimmerman
Animation Director: Susan Brand
Programs: Softimage 3-D,
Photoshop, Illustrator, Fractal
Painter, Infini-D, Debabelizer, Kaos
Tools Terrazo, KPT Vector Effects

76: *Scrutiny in the Great Round*
Producers: Tennessee Rice Dixon,
Jim Gasperini

Designers: Tennessee Rice Dixon,
Jim Gasperini
Art Director: Tennessee Rice Dixon
Artist: Tennessee Rice Dixon
Sound: Charlie Morrow (composer),
Jeff Rabb (assistant)
Programs: Director, Photoshop,
After Effects
Publisher: Calliope Media
Distributor: Maxis (1-800-33-MAXIS)

79: *Passage to Vietnam*
Client: Against All Odds/Interval
Research
Producer: Rick Smolan
Designer: Meagan Wheeler
Art Director: Meagan Wheeler
Illustrator: Meagan Wheeler
Photographers: 70 of the Best
Program: Director

80, 81: *Amnesty Interactive*
Client: Amnesty International USA
Producer: Ray Kristof
Designers: Ray Kristof, Eli Cochran
Art Director: Ray Kristof
Illustrator: Nancy Nimoy
Photographer: Nadav Kander (photo
of Fatima Ibrahim)
Programmers: Eli Cochran,
Chris Thorman

89: "Liquid Typography"
(M.F.A. thesis)
Client: Self/Art Center College
of Design
Producer: Thomas Müller
Designer: Thomas Müller
Creative Director: Thomas Müller
Programmer: Thomas Müller

93, 94: *The Virtual Museum*
Client: Apple Computer, Inc.
Producer: Apple Computer, Inc.
Designer: Sally Ann Applin
Art Directors: Eric Hoffert,
Gavin Miller
Program: HyperCard
Additional Programming: Dean
Blackketter, Ken Doyle, Libby
Patterson
3-D Modeling and Rendering: S. Eric
Chen, Jim Hanan, Gavin Miller,
Steve Rubin
Software Design: Derrick Yim
Sound: Libby Patterson

97: *Selected Notes 2 ZeitGuys*
Design Firm: Aufuldish & Warinner
Designer: Bob Aufuldish
Icon Design: Eric Donelan and
Bob Aufuldish
Writer: Mark Bartlett
Programmers: David Karam,
Bob Aufuldish
Sound: Bob Aufuldish
Publisher: ZED: The Journal of The

Center for Design Studies at Virginia
Commonwealth University

98, 99: *ZeitMovie*
Client: Emigre
Design Firm: Aufuldish & Warinner
Designer: Bob Aufuldish
Icon Design: Eric Donelan and
Bob Aufuldish
Writer: Mark Bartlett
Programmer: Bob Aufuldish
Program: Director
Sound: Scott Pickering,
Bob Aufuldish

101, 102: *Our Secret Century*
CD-ROM by Rick Prelinger
Producers: Melanie Goldstein,
Beth Strauss
Designer: Diane Bertolo
Publisher: The Voyager Company

104, 105: GIST Web pages
Producer: GIST Communications
Art Director: Dave Bovenschulte

**107, 108, 109: *Telecommunication
Breakdown***
Producer: Emergency Broadcast
Network
Engineering: AVX Design, Inc.

111, 112: *Joshua Distler Portfolio*
Designer: Joshua Distler
Photographers: Edric Alunan,
Joshua Distler
Programmer: Joshua Distler
Programs: Director, Photoshop,
Illustrator

113, 114: *Painters Painting*
Client: Voyager
Producer: Peter Girardi
Designer: Peter Girardi
Art Director: Peter Girardi
Programs: After Effects, Photoshop,
Debabelizer, Director

115: Razorfish Web homepage
Client: Razorfish Inc.
Producer: Thomas Müller
Designer: Thomas Müller
Creative Director: Craig Kanarick
Programmers: Marc Timkler,
Oz Lubling

117: *The New York Times* On the Web
Client: The New York Times Company
Art Director: Ron Louie

119, 120: Simonsays.com Web site
Client: Simon & Schuster
Producer: Craig Kanarick
Designer: Thomas Müller
Creative Director: Craig Kanarick
Programmers: Oz Lubling,
Steven Osman

**122, 125, 126: *The Mutant Gene &
Tainted Kool-Aid Sideshow***
Client: M. R. Petit
Producer: 1-800-WEIRDOS
Designer: M. R. Petit
Art Director: M. R. Petit
Illustrator: M. R. Petit
Photographer: M. R. Petit
Progammer: M. R. Petit

129:*Urban Desires* Web homepage
Client: *Urban Desires*
Producer: agency.com
Illustrator: Tim Carrier

**131: *Bay Area Art, Randomness, and
Technology***
Client: IDEO
Producer: Angels Bronsoms
Designer: Peter Spreenberg
Videographer: Angels Bronsoms
Programs: Premiere, Director,
SoundEdit

132: *Interact Journal*
Client: American Center for Design
Producer (CD-ROM): Peter
Spreenberg/IDEO
Designer (CD-ROM): Peter
Spreenberg/IDEO
Print: Tanagram
Programs: Director, SoundEdit,
Freehand

**135, 136: *Frommer's Interactive
Travel Guides***
Producer: Jonathan Fishel
Designer: Tom Nicholson Assoc.
Art Director: Janet Tingey
Photographer: Corbis
Publisher: Macmillan Digital USA

139: Nickelodeon Online site
Client: Nickelodeon Online
Producers: David Vogler, Barbara
Borsch
Designer: David Vogler,
Blue Brick Design
Art Director: David Vogler
Creative Director: David Vogler
Program: Photoshop

141, 142: *The Chaos Project*
Client: HarperCollins Interactive/New
York University
Designer: Iromie Weeramantry
Art Director: Iromie Weeramantry
3-D Modeler (instrument image,
page 141): Wen-Chen Chao

INDEX

Edited by Marian Appellof
Designed by Mirko Ilić

Text set in MetaPlus, designed by
Erik Spiekermann; FF Dingbats designed by
Johannes Erler and Olaf Stein; produced by
FontShop International.

The griffin illustrations that appear
throughout this book were created by Mirko Ilić.
A fabulous animal of ancient origin, with the head
and wings of an eagle and the body of a lion, the
griffin frequently appeared in heraldry and in
the applied arts. German woodcut illustrations
of printing shops often show this creature holding
a pair of ink balls. Numerous printers adopted
the griffin as an identifying device, apparently
as an emblem of pride and
self-confidence.